On Public View

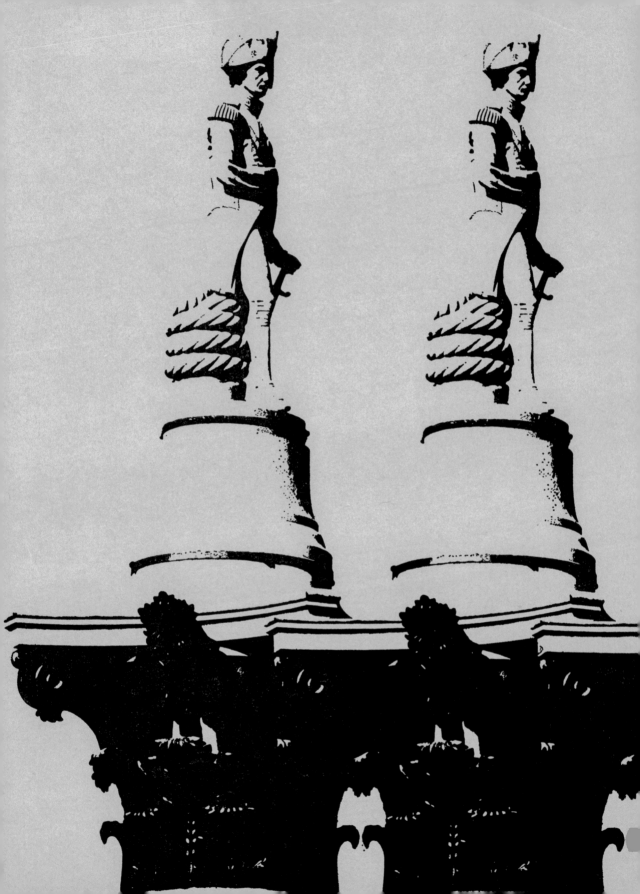

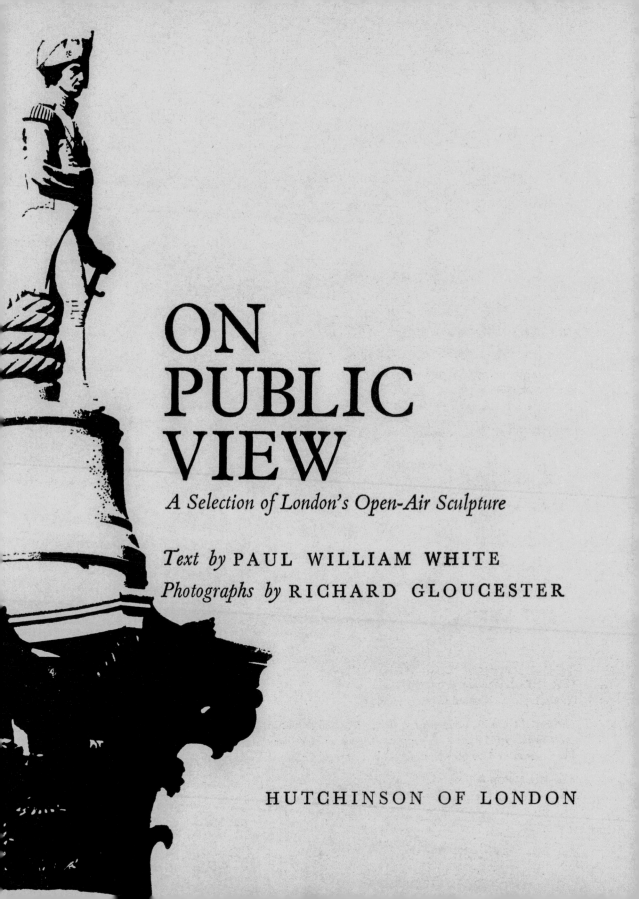

ON
PUBLIC
VIEW

A Selection of London's Open-Air Sculpture

Text by PAUL WILLIAM WHITE

Photographs by RICHARD GLOUCESTER

HUTCHINSON OF LONDON

HUTCHINSON & CO (*Publishers*) LTD
3 Fitzroy Square, London W1

London Melbourne Sydney Auckland
Wellington Johannesburg Cape Town
and agencies throughout the world

First published 1971

Text © Paul William White 1971
Photographs © Richard Gloucester 1971

The text of this book has been set in Bembo type and printed in
Great Britain on Antique Laid paper by Benham and Company Limited, Colchester
The illustrations have been printed by The Cotswold Collotype Company Limited

ISBN 0 09 109030 X

Contents

Preface 9

Introduction 11

SECTION 1: *Royalty* 31

SECTION 2: *Statesmen* 75

SECTION 3: *Commanders* 111

SECTION 4: *Arts* 147

SECTION 5: *Public Service* 171

SECTION 6: *War Memorials* 203

SECTION 7: *Monuments* 219

List of Sculptors 245

List of Sculpture and Sites 249

To A.J.W. and V.L.W.

Preface

On Public View was originally written by Richard Gloucester and myself and presented in 1969 as separate theses for the Postgraduate Diploma at the Cambridge University School of Architecture. The scope of the work has been confined to free-standing, open-air sculpture in London. It does not include sculpture which has been used to decorate buildings.

This book contains our personal selection from the many statues, memorials and fountains in London. Everybody has his own favourite statue, and so instead of intruding our own subjective judgments we have given as much information as possible on each of the works we have selected so that readers can form their own opinions. I am indebted to Miss J. M. Clarke of the Department of the Environment for much of this information, and, especially, to three books published on the subject in the twenties, namely Lord Gleichen's *London's Open-Air Statuary*, Longmans, 1928; C. S. Cooper's *The Outdoor Monuments of London*, Homeland Association Ltd., 1928; Osbert Sitwell's *The People's Album of London Statues*, Duckworth, 1928.

Works have been classified by topic as well as by sculpting style, so that the book is as much a commentary on English history as a cross-section of English sculpture. The sections are arranged in approximate chronological order. While the book illustrates the myriad qualities of English sculpture, it especially highlights the competence of Victorian works, many of which are now little known. The tradition of erecting sculpture in London is still a living one, as recent work by Henry Moore testifies. One hopes many more

contemporary works by English sculptors will be erected, or at least exhibited in the city or in the parks of London.

I would like to thank all those people who have assisted me, or given me hospitality while working on the book, especially Roger and Mary Gilliatt, Evvy and Mary Hambro, Rex Nan Kivell, and the Duchess of Gloucester. I would also like to thank the following: Betty Kimble, Suzy Menkes, my sister Marie-Anne, Alison Cameron, Liz Walker, Gabrielle Pitti, Gilles Cremonesi, Victoria, David and Sonja Nolan, and above all the photographer, who often had to work in difficult lighting and traffic conditions.

<div align="right">PAUL WILLIAM WHITE</div>

Introduction

'Sculpture can fit into an ordered environment by providing something to touch, feel and see at a human scale.'

From earliest times to the present day, sculpture has been placed in open spaces. Its purpose is best defined by the quotation above by Theo Crosby in his book *City Sense*. The Egyptians erected great obelisks, monuments and sculptured figures to commemorate the Pharaohs. In ancient Greece, sculpture was used to enhance architecture and planning. When the Parthenon was built, sculptures were not only used in the frieze but placed in free-standing positions so that they had a logical relationship in plan and perspective to the adjacent buildings. The Romans also made sculpture an integral part of their formal planning and their great axial ways. Most of the forms used in commemorative sculpture until this century were derived from these Greek and Roman models: columns, statues on pedestals, large equestrian groups and monumental arches form basic patterns which have lasted for centuries.

In the Middle Ages many of these patterns fell into disuse, although monuments such as the medieval cross were erected in important positions; for example, the original Charing Cross which commemorated Queen Eleanor of Castile (page 225). But with the Renaissance interest in antique forms revived, and the tradition of erecting free-standing sculpture has flourished ever since. Formal gardens decorated with statues became popular again, inspired by such Roman precedents as Hadrian's Villa, and Neo-classicism in eighteenth- and nineteenth-century England encouraged the erection of statues in public parks, streets and squares.

The English have never developed their towns and cities in grandiose formal plans, and sculpture in London, although based on

Neo-classical forms, is full of incidental and often accidental effects. This lends its own special interest, and gives English sculpture a more intimate nature than public sculpture in other great European cities. Often, statues have simply been placed in those streets most used by people or in gardens where paths cross, or against backgrounds of shrubbery in quiet, peaceful corners.

In the eighteenth and nineteenth centuries the great English landlords laid out the streets and squares of their town estates in a fairly formal manner, but still on a more intimate scale than other European cities. The focal points of many of these squares are the statues erected in their centres. Great commanders were frequently commemorated in the nineteenth century, and the battles of Waterloo and Trafalgar were celebrated not only in verse and painting but by memorials squeezed into the irregular plan of London.

In the Victorian period statues sprang up everywhere. The Victoria Embankment, laid out in 1864, provided picturesque homes for much commemorative sculpture in the gardens created on reclaimed land along the banks of the Thames. The Albert Memorial reached a new level of picturesque achievement. A new setting was created for the Victoria Memorial (page 62) when it was erected and unveiled in 1911: the Mall was remade, Buckingham Palace was refaced and Admiralty Arch, given a semi-circular plan to surmount the difficulty of entering Trafalgar Square at an angle, was built. The road plan has justified itself in use, even if the actual memorial sometimes only provides a haven from traffic and a viewing stand for tourists and pedestrians.

Time, change in use and enlarged volumes of traffic often completely alter the nature of an open space and, therefore, the appearance of its memorials. Some have gradually been surrounded by barriers, such as the stone statue to Richard Cobden, 'the Apostle of Free Trade', which was originally erected in Camden High Street surrounded by market stalls in 1868. Others have been marooned on deserted traffic-islands, or have become guardians of tiny fragments of pavement where pedestrians shelter while crossing the road, as in Whitehall, where the Duke of Cambridge, erected in 1907 (page 134), appears to swagger on his horse above the traffic and where Earl Haig appears sadly isolated (opposite).

Looking down Whitehall past the statue of Earl Haig and the Cenotaph

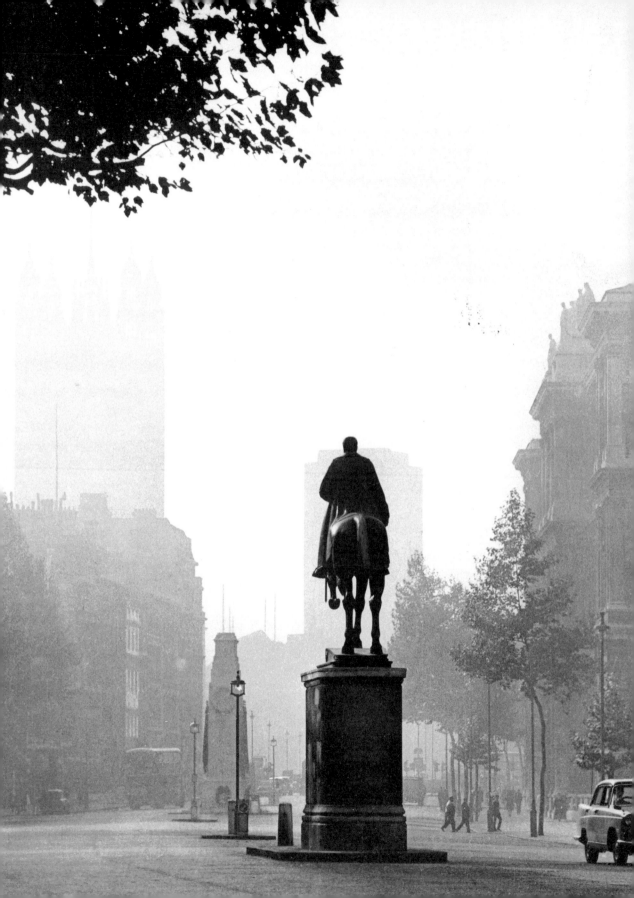

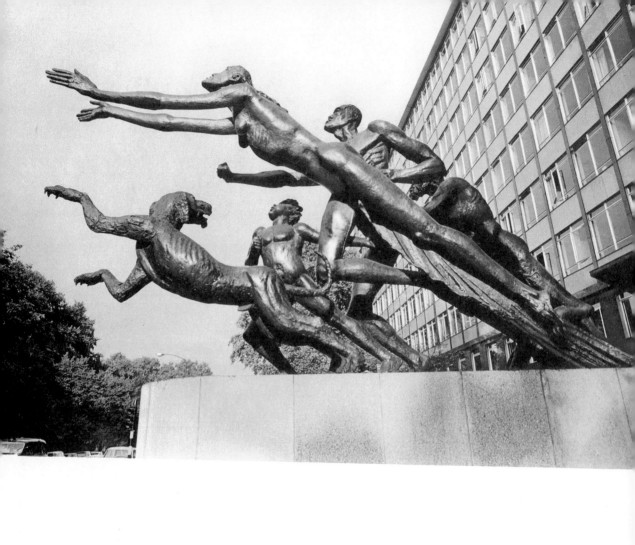

The monuments at Hyde Park Corner seem mere historical flotsam left over by the high tide of the traffic and can only be approached by pedestrian tunnels underneath the road. Yet the space is fascinating and worth the effort of walking there.

One of the interesting examples of twentieth-century sculpture in London is the bronze group of a man, woman, child and dog at Bowater House (page 14), which was designed in scale to the traffic. This is sited between the two carriage-ways which go under the building and link Knightsbridge with the park. It has been made and positioned to be seen from motor-cars rather than by pedestrians.

During the Regency, the architect Nash designed one of London's few formal progresses, from Carlton Terrace to Regent's Park, in which sculpture formed an integral part and which included works in the centre of Portland Place. The sculptures there are now fenced by parking-meters which spoil the appearance of their surroundings.

Ideally, a sculpture is specially related to its site; to erect a work in an existing situation calls for discretion. Despite traffic problems it is interesting to see how well this discretion has been exercised in the past, especially as it was difficult to find sites for many statues. Those urban spaces which have been embellished with sculpture would, no doubt, function in the same way if they were stripped of the work which decorates or generated them, yet many works have their own mythology associated with their sites. For example, the stone statue of Queen Anne (1665–1714) is said to come to life on the eve of her anniversary and walk around Queen Anne's Gate, while the statue of Richard Green (erected in 1866) trapped one small boy who was climbing over him in order to retrieve a pair of swimming-trunks thrown there by another (page 178).

Epstein group by Bowater House, Knightsbridge

The statue of Queen Elizabeth I which is now in Fleet Street is one of the earliest surviving statues in London. It was originally erected in the sixteenth century on King Lud's Gate, which gives its name to Ludgate Circus. Although by the beginning of the seventeenth century English painting and architecture had been transformed by Van Dyck and Inigo Jones, no contemporary Englishmen had emerged to equal their achievements in sculpture. New classical ideas had been introduced in England in the early sixteenth century by foreign artists such as Torrigiano, who designed Henry VII's tomb in Westminster Abbey. Until the end of the seventeenth century much important work was designed by artists from abroad. King Charles I was interested in sculpture and had some antique Roman marble statues in his collection. Charles brought to England a French sculptor, Hubert le Sueur, who made a brass equestrian statue of the king which is one of the earliest important works to be seen in London (pages 19 and 34). It was first erected in 1648 at Charing Cross. Le Sueur was instructed to study the king's horses and the king riding in order to make a realistic monument. Although, for some time, Englishmen had been travelling abroad on the 'Grand Tour' in order to appreciate the ideas of the Renaissance and to see works of antiquity, the new ideas did not begin to emerge until the Restoration, when sculptors like Cibber (1630–1700) Gibbons (1648–1721), Nost (d. 1729), and Bird (1667–1731) began to produce designs which influenced their contemporaries who had not travelled abroad themselves. At this time, despite their awareness of Roman Baroque, English sculptors were more influenced, especially during the reign of King William III, by Dutch sculpture; although Caius Gabriel Cibber had been to study in Rome at the expense of King Charles II.

In 1674 Cibber carved a grand allegorical relief on the Monument (pages 20 and 221), the memorial to the Great Fire of London; a commission which carried considerable prestige. It was a competent but provincial variation of the baroque, in which Cibber shows King Charles II in Roman armour directing Architecture and Sculpture to comfort the mourning figure of the City of London, while the king rises towards Peace and Plenty in the clouds. Sir Christopher Wren, who designed the Monument, also commissioned Cibber to work on

the rebuilding of St. Paul's Cathedral, which had been destroyed in the Great Fire. Wren also commissioned work from Grinling Gibbons, who became associated with the other Court artists and had established a large practice by the end of the seventeenth century. Among a number of statues of royal figures, Gibbons was responsible for the bronze figures of King Charles II at Chelsea Hospital, and King James II, now outside the National Gallery, which were both completed in 1686. The Dutch sculptor Arnold Quellin (1653–1686) was working with Gibbons at this time and it is thought that Quellin did most of the work on these two figures. King Charles II and King James II are both crowned with laurel and wearing Roman armour, which was a classical convention used for the first time for royal statues in England. King Charles is shown moving forward and turning his head while King James stands in a relaxed pose. Both statues were remarkably competent. Quellin died not long after these works were completed. After his death, Wren used Gibbons mainly as a wood-carver and decorator, and employed Francis Bird as his sculptor for St. Paul's Cathedral. John Nost, however, was a pupil of Quellin's and he carved a stone figure of King George II in 1722 which was based on King James II. It is now in Golden Square, but has weathered badly and looks soapy (page 46).

By the early eighteenth century English sculpture became far less provincial and far more generally accomplished. Improved chisels were used for better pointing techniques and a higher standard of quality and taste was established. Wren had previously complained that English craftsmen lacked a basic knowledge of drawing, as training facilities were limited for many artists whose work fell below continental standards. However, an academy was founded in 1711, under the directorship of Sir Godfrey Kneller, and a sculptor was included as one of the directors. (This academy is not to be confused with the Royal Academy which was not founded until 1768.) Sixteenth-century Italian work and antique copies became more generally known in England, but a duality of influences between the antique and the baroque was still noticeable as artists, sculptors, architects and patrons brought back a mixture of influences from their studies abroad. The architects Kent and Gibbs, who had studied under Fontana, a pupil of Bernini's, were working in a modified Roman–Baroque style, while two Flemish sculptors, Rysbrack and Scheemakers, who were in England by 1720, were also

influenced by contemporary Roman sculpture as well as the antique.

The leading English sculptor in the transition period between the seventeenth and eighteenth centuries was Francis Bird, who was included as a director in the foundation of Kneller's Academy in 1711. The quality of Bird's work varies although he had a large practice and had studied in both Italy and Flanders. He completed a group called 'The Conversion of St. Paul' for Sir Christopher Wren in the West Pediment of St. Paul's Cathedral. Bird generally worked in the Roman–Baroque style and was especially influenced by Bernini. His most successful and prestigious work, also commissioned by Wren, was the statue of Queen Anne surrounded by figures of England, Scotland, Ireland and France, erected outside the west front of St. Paul's in 1712 (page 42). It was subsequently maliciously damaged and was replaced by a nineteenth century copy of lesser quality. Once Bird's classical skill had been demonstrated at St. Paul's, it was more firmly established by Scheemakers and his fellow Flemish immigrants, Rysbrack and Roubiliac.

Michael Rysbrack (1694–1770) succeeded Francis Bird as the leading sculptor between 1720 and 1740. Altogether he spent over fifty years in England. His work became very popular and he received commissions from William Kent and Lord Burlington, who was assuming by now his position as an influential patron. His marble statue of Sir Hans Sloane in Chelsea (page 173) is only one of a large number of statues, busts and tombs he executed. It has weathered badly since 1737 when it was first erected.

Peter Scheemakers (1691–1781), a pupil of Francis Bird, had also studied assiduously in Rome and made plaster copies from the antique. He was Rysbrack's rival and competed against him for commissions. His later work moved away from the antique and became more baroque. This includes a statue of King Edward VI erected in 1737 in the quadrangle of St. Thomas's Hospital, and his most famous work, the monument to Shakespeare in Westminster Abbey, a copy of which was made in the nineteenth century and erected in Leicester Square gardens (page 150). The Westminster Shakespeare marked the peak of Scheemakers's career and for a short time he was more popular than Rysbrack, until both were eclipsed by Roubiliac. The bronze statue of Thomas Guy in the forecourt of

King Charles I by Le Sueur

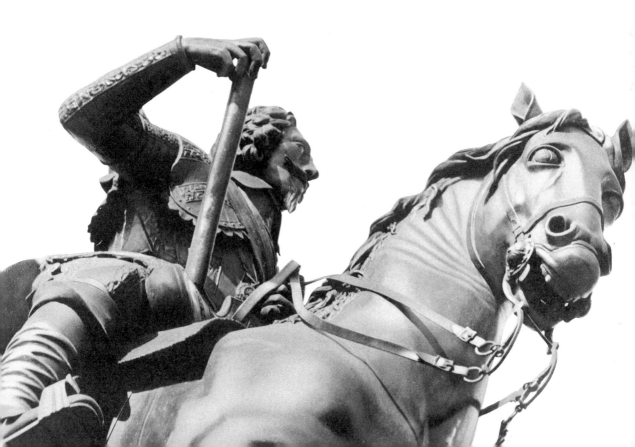

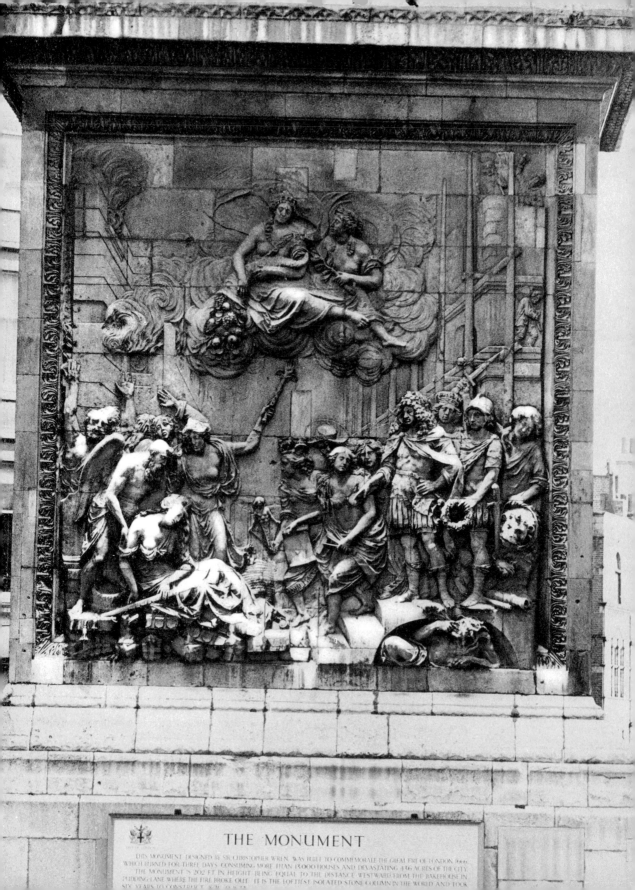

THE MONUMENT

THIS MONUMENT, DESIGNED BY SIR CHRISTOPHER WREN, WAS BUILT TO COMMEMORATE THE GREAT FIRE OF LONDON 1666
WHICH BURNED FOR THREE DAYS CONSUMING MORE THAN 13,000 HOUSES AND DEVASTATING 436 ACRES OF THE CITY.
THE MONUMENT IS 202 FT. IN HEIGHT, BEING EQUAL TO THE DISTANCE WESTWARD FROM THE BAKEHOUSE IN
PUDDING LANE WHERE THE FIRE BROKE OUT. IT IS THE LOFTIEST ISOLATED STONE COLUMN IN THE WORLD AND TOOK
SIX YEARS TO CONSTRUCT. ACTU 30 31 52.

Guy's Hospital (erected in 1734) marks the period when Scheemakers's work was shifting in style and makes a break from the accepted convention of Roman costume.

Louis François Roubiliac (1705–62) was probably the most accomplished foreign sculptor ever to work in England. His work was free, light and finely modelled. His terra-cotta bust of Hogarth in the National Portrait Gallery, reproduced by Durham in Leicester Square (page 149), was one of his most successful. He was a friend of Hogarth's and had the time to observe and capture the painter's personality. The bust is lively and has a sharply turned head and a fierce expression. Durham's reproduction manages to capture some of this feeling. As with Rysbrack and Scheemakers, fine examples of Roubiliac's work can be seen in Westminster Abbey. The foundation of the Royal Academy in 1768 did much to raise the general standard of sculpture in England. The establishment of the Academy schools was closely followed by the rise of Neo-classicism which was replacing the baroque style and which became the most important influence on English sculptors by the end of the eighteenth century. This influence can be seen in the work of John Bacon (1740–99) and his son, who was known by the same name. The elder's bronze group of King George III (page 50), erected in 1789 at Somerset House, failed to please Queen Charlotte. Margaret Whinney has remarked in her history of sculpture in Britain that 'George III in his toga appears about to drop food to an expectant lion'. The equestrian statue of King William III (page 41) in St. James's Square, which was designed by the elder Bacon and executed by the younger, was a more successful work. It was erected in 1808.

In the nineteenth century, John Flaxman (1755–1826) became the best-known English sculptor and his work was most typically Neo-classical. Unfortunately, there is not an important example of his work in the streets of London. Flaxman was the first Professor of Sculpture at the Royal Academy, an appointment which emphasised the ever-increasing status of the sculptor in the nineteenth century when England went on a sculptural spree and spent many thousands of pounds erecting public statues and memorials.

The Elgin Marbles, imported from the Parthenon in Athens in the early nineteenth century, were installed in the British Museum in

Bas-relief on the Monument to the Fire of London

1817. They had a great influence on sculpture in England and gave a greater understanding of Greek sculpture. Friezes on the Athenaeum and on Burton's Arch at Hyde Park Corner were based on the Parthenon frieze, although their Neo-classical sculptors were still unable or unwilling to re-create the natural quality of the original. Sir Richard Westmacott's (1775–1856) work provided characteristic examples of Neo-classicism in London. His father, also a sculptor, sent him to study in Rome under Canova and not in the Royal Academy school. His work is sometimes disappointing but sometimes verges on greatness. As well as a number of monuments in Westminster Abbey he received a number of commissions for memorials and statues in London. The largest of these is the 18-foot bronze of Achilles in Hyde Park, executed as a monument to the Duke of Wellington from the Ladies of England (page 23). In 1822 the *Literary Chronicle* described it as 'the public gaze and the public laugh of the last week . . .'; the so-called Achilles was in fact a *tour de force* imitation of one of the antique 'Dioscuri' on the Monte Cavallo, but without the horse. Westmacott was said to be pompous and conceited and very sure of his own judgment. His other work in London includes the memorial statue to the Duke of Bedford (page 77), erected in 1809 in Russell Square, which is not as strong or successful as his statue of Charles James Fox (1816), a seated figure in the dress of a Roman Senator (page 78). The statue of George Canning, erected in 1832 in Parliament Square, was also dressed as a Roman to create an image of great dignity (page 82). Westmacott became Professor of Sculpture in 1827 after the death of Flaxman and was knighted by King William IV. A later rival to Westmacott was Sir Francis Chantrey (1781–1841), who had great natural ability but less imagination than his predecessor. Chantrey was born in Sheffield and had not studied abroad on the Grand Tour, which might explain his simple approach and use of contemporary dress in his statues. He became popular quite early in his career and was much admired at Academy exhibitions. Chantrey became much in demand for public statues such as the figures of King George IV (page 53) and William Pitt (page 81) in Hanover Square, which is a more original and lively creation than Westmacott's contemporary statue of Canning. Like Westmacott, Chantrey also set up his own foundry

The Achilles statue in Hyde Park

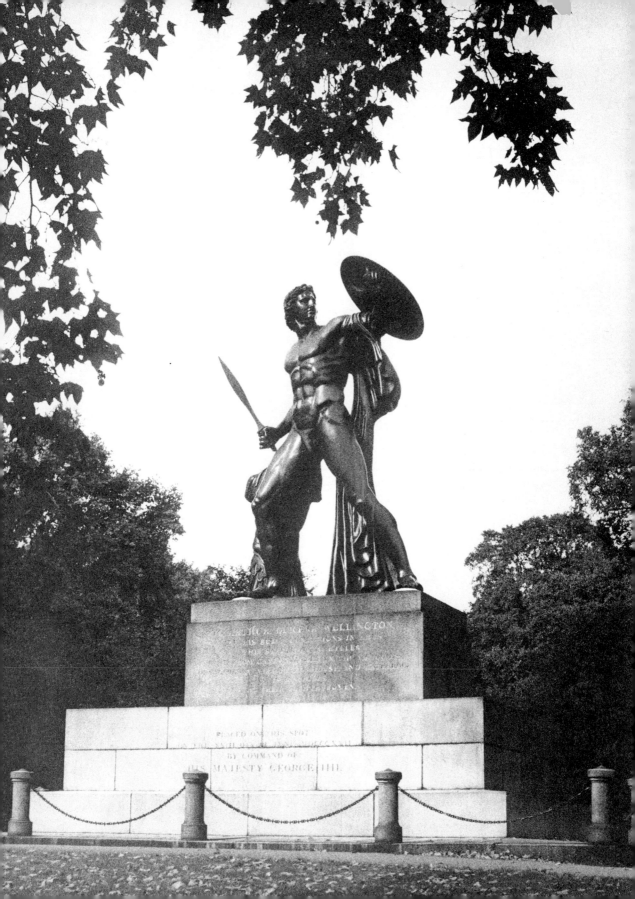

PLACED ON THIS SPOT
BY COMMAND OF
HIS MAJESTY GEORGE IIII.

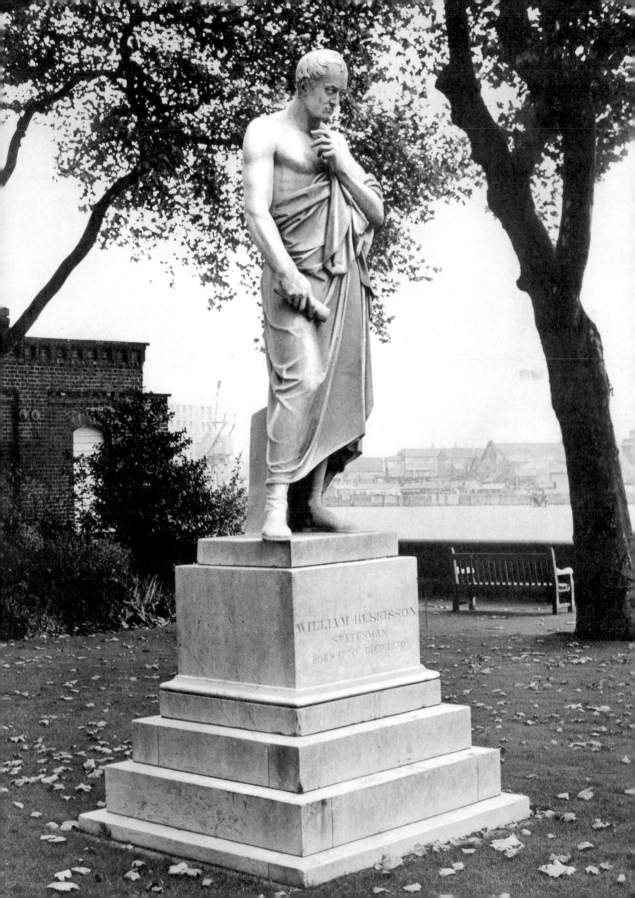

WILLIAM HUSKISSON
STATESMAN
BORN 1770 DIED 1830

where his two equestrian statues in London were cast. For the equestrian statue of King George IV, made in 1829, Chantrey showed the king sketches of the horse in various positions so that the king could make his own choice. The similar statue of Wellington outside the Royal Exchange (page 117) was also in contemporary dress, which surprised a public more accustomed to classical dress. Few nineteenth-century artists were to think as clearly or as independently as Chantrey, whose emphasis on simplicity was not developed by the decorative artists of the Victorian period. His work struck a balance between classicism and the naturalism inspired by the Elgin Marbles, and he was the only sculptor whose work pointed towards the twentieth century.

John Gibson (1790–1866) inherited the classical tradition but spent most of his working life in Rome working under Canova with only a few brief visits to England. A number of works were commissioned by travellers and one of these was a classical statue of Huskisson (page 24), wearing a toga and showing a bare arm (in Pimlico Gardens), which seems a strange memorial to a man killed by a train.

By the beginning of the Victorian period commemoration of leading public figures as well as monarchs had become popular, and statues to engineers, statesmen and generals were erected in hundreds, not only in the streets but also in Westminster Abbey and St. Paul's Cathedral. The Victorians resurrected historical figures who appealed to their imagination, and statues were erected to Queen Boadicea (page 229), Cromwell (page 98) and Richard the Lion Heart (page 54), whose statue was a star of the Great Exhibition of 1851. The heroes of the battles of Trafalgar and Waterloo, the engineers of the new railways and, eventually, the leaders of the Indian and African wars were all commemorated. In 1838 a competition was held for the national monument to Lord Nelson (pages 125 and 126), which was won by William Railton, who proposed the Corinthian column with its bas-reliefs and four lions. The sculptor, Edward Baily (1788–1867), who came second in the competition, was commissioned to put a statue on the top. Several columns had already been built in Britain since the Fire of London Monument, and in 1834 the Duke of York had been placed on top of a column in Waterloo Place. With the profusion of memorials and

William Huskisson, a marble statue by John Gibson

monuments erected in the nineteenth century criticism also became profuse and often abusive. *Punch* usually had a humorous verse to publish as each statue and memorial was unveiled. Of the Duke of York they remarked that:

> Small reason have the Royal Family
> Their kinsman's position to deplore;
> He now stands higher in the public eye
> Than he ever stood before.

Adverse criticism led public opinion to reject the Wyatt's equestrian statue of the Duke of Wellington at Hyde Park. It was 30 feet high and aroused so much resentment it was eventually removed to Aldershot in 1883. Edgar Boehm (1834-90) was commissioned to erect the equestrian group to the Duke of Wellington which now faces Apsley House (pages 110 and 118). It was a competent work, consistent with other examples of Boehm's work in London, including figures of Lawrence, Napier, Burgoyne, Carlyle (page 157) and Tyndale (page 185).

When Queen Victoria came to the throne there were only about twenty major statues in London, but when she died there were over 200, a figure which has since doubled. The queen herself was very keen to commemorate the Prince Consort with the Albert Memorial (pages 57 and 58). The competition for the memorial was won by Gilbert Scott (1811-78) and completed by 1876. The memorial, inspired by the Gothic spirit, was the culminating success of Scott's career and achieved great popularity. Workmen on the project were said 'to be temperate and rarely swore'; but Kenneth Clark in his book *The Gothic Revival* dismissed the memorial as 'pure philistinism'. It 'appeals to people who like a monument to be large and expensive looking, and to show much easily understood sculpture, preferably of animals'. Jacob Epstein, however, is said to have raised his hat each time he passed by, as he said he had the greatest respect for the memorial.

The Victorian sculptors were extremely capable and had the facility to achieve great realism. They were also highly confident. John Henry Foley (1818-74), who made the large figure of Prince Albert in the Memorial, and Baron Carlo Marochetti (1805-68), a Piedmontese refugee who was a protégé of Prince Albert's, both produced highly efficient work. The bronze equestrian figure of

Richard the Lion Heart, erected in 1860, was Marochetti's best work and exemplifies Victorian taste (page 54).

As the profusion of sculpture grew, so did the number of capable sculptors, who were turning to historical and mythical conceptions as well as manufacturing portrait sculpture. Thomas Thornycroft (1815–85) was lent horses as models by Prince Albert for his major work, the group of Boadicea (page 229). Hamo Thornycroft (1850–1925) produced the bold historical figure of Cromwell (page 98) as well as his confident memorial to Gladstone in the Aldwych (page 101). The competence of both Thornycrofts was equalled by Adrian Jones (b. 1845), whose expert veterinary knowledge was well used in his equestrian figure of the Duke of Cambridge (page 134) and the flamboyant Quadriga (page 237) on top of Burton's Arch. Thomas Brock (1847–1922) also excelled at realistic work, producing many fine portrait statues such as those of Bartle Frere (page 94) and Robert Raikes (page 182). Brock reached the climax of his career with the Victoria Memorial (page 62), which really amounted to a twentieth-century imitation of the work of Michelangelo at a time when the Renaissance had again become a direct inspiration to English sculptors. Derwent Woods's (1871–1926) Machine Gun Corps memorial is an example of this taste (page 213).

Modern movements were slow to take root in England until the appearance of Jacob Epstein and, later, Henry Moore. *Art nouveau* only had a limited influence but can be seen in the detailing of Peter Pan by George Frampton (1860–1928), who also produced the inferior sculptural collage to Edith Cavell (page 197) and the Eros Fountain to Lord Shaftesbury in Piccadilly Circus (page 230). The best late example of *art nouveau* is the memorial to Queen Alexandra at Marlborough Gate (page 69). The impetus behind realistic work disappeared in the 1920s in the wake of self-conscious works such as the Cavell Memorial or C. S. Jagger's (b. 1885) Royal Artillery Memorial (page 214). Isolated pieces of traditional work continued to appear by Sir William Reid Dick of Alfred Drury, who produced statues of King George V and the statue of Sir Joshua Reynolds at the Royal Academy. Rodin's (1840–1917) Burghers of Calais (page 238) had already been erected in Westminster by this time (1915), and Epstein was commissioned to erect the Hudson Memorial, a figure of General Smuts (page 29), and eventually the group at Bowater House (page 14), which indicated that the tradition of

erecting sculpture was beginning to find new direction. It is to be hoped that the erection of works by Henry Moore, such as 'Knife Edge, two Piece' (page 242), and by other leading contemporary English sculptors will continue.

Smuts, a bronze figure by Epstein in Parliament Square

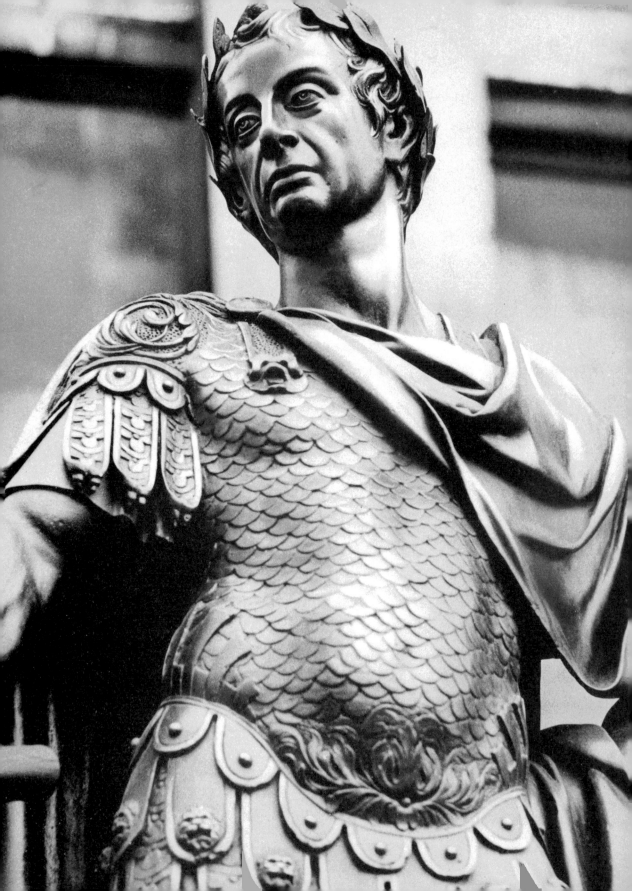

Royalty

The earliest statues in London are figures of kings and queens which were erected to commemorate their reigns. One of the best royal figures is the statue of King James II which portrays the king in Roman armour according to the contemporary seventeenth-century tradition by which sculptors endowed royalty with a classical appearance. This particular statue was said to be an excellent likeness of his face, and it successfully illustrates the theme of royal dignity as well as presenting a realistic portrait of the man.

Detail of the statue of King James II by Grinling Gibbons and Arnold Quellin

Queen Elizabeth I

1533–1603
Sculptor unknown
Now stands over the doorway of St. Dunstan's in the West, Fleet Street

The carved stone figure, one of the oldest statues in London, was originally erected on the New Lud's Gate in 1586. When the gate was pulled down in 1760 in order to widen the street, the statue was placed by Sir Francis Gosling over the vestry door of St. Dunstan's. The church was demolished in 1831 and the statue sold for £16, but it was re-erected over the school-house door of the new church in 1839.

Ludgate had existed since 1100, and by 1378 was a debtors' prison. As well as Queen Elizabeth, King Lud (a mythical figure) and his two sons in Roman costume decorated the east side of the gate. They were consigned to the parish mortuary when the gate was demolished, but rescued by the Marquis of Hertford and taken to Hertford Villa in Regent's Park.

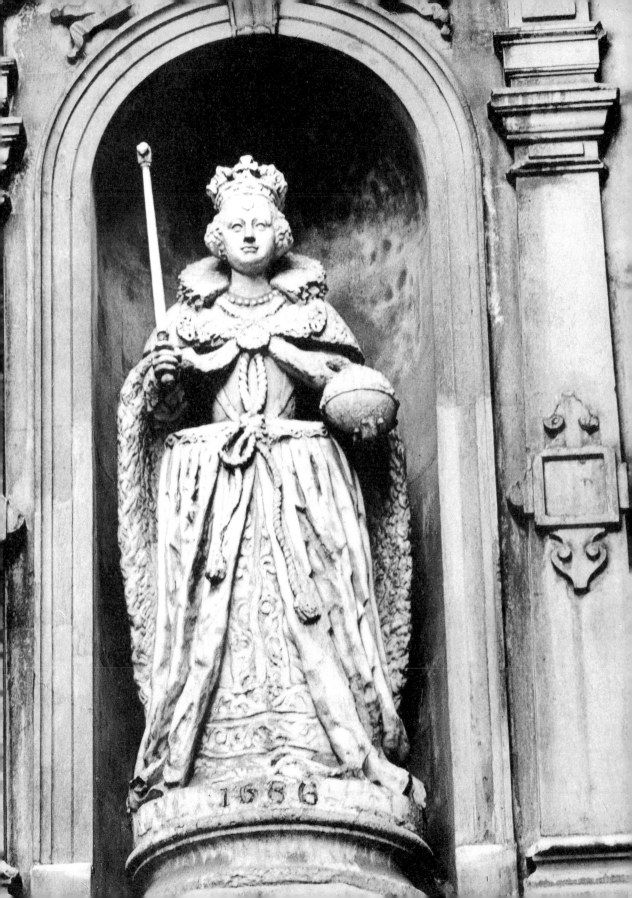

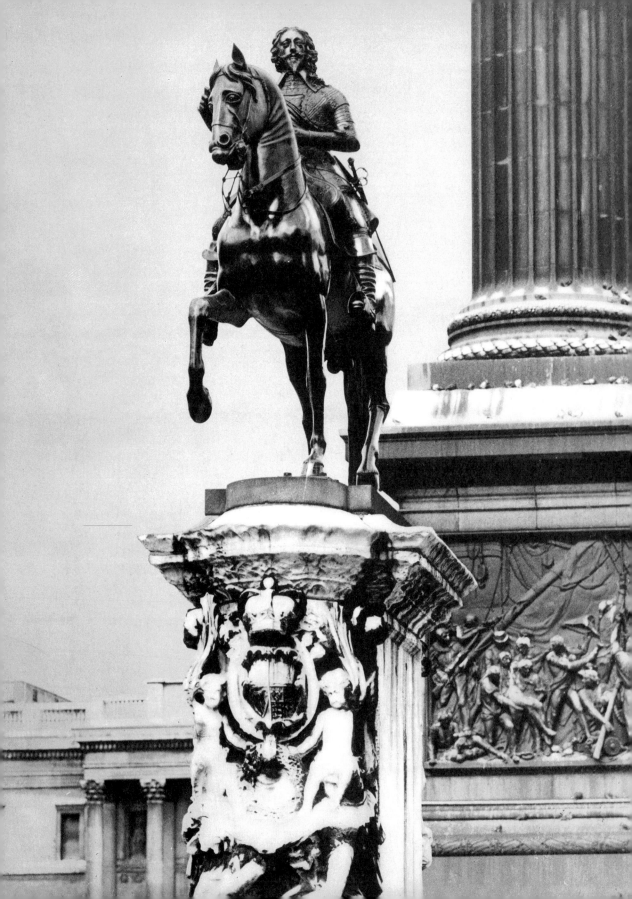

King Charles I

1600–1649

Sculptor: Hubert le Sueur

Erected between 1675 and 1677 on the site of the old Charing Cross near Trafalgar Square

The earliest equestrian statue to be seen in London stands on a Portland Stone pedestal, said to have been designed by Sir Christopher Wren and carved to a design by Grinling Gibbons.

The statue was commissioned in 1630 by the Earl of Portland, the Lord High Treasurer, at a cost of £600. After taking eighteen months to complete, it was originally erected in London in 1648. During the Commonwealth the statue was sold by Parliament to a brass merchant, John Rivet of Holborn, with orders to destroy it. However, Rivet simply buried it, and sold knife-handles made of old brass as alleged relics of the statue. On the Restoration the statue was presented to King Charles II, who re-erected it on its present site facing the Banqueting Hall in Whitehall, where his father was executed. The sword and Order of St. George were stolen from the figure when it was surrounded by temporary seating in 1844, when Queen Victoria was opening the Royal Exchange.

Since then it has been kept in good condition and during the last war was protected by a barricade of sandbags costing £500. The anniversary of King Charles's death is commemorated each year on 30 January by placing flowers at the base of the statue.

King Charles II

1630–1685
Sculptors: Grinling Gibbons and Arnold Quellin
Completed in 1676 and later placed in the Centre Court, Chelsea Hospital

This vigorous bronze figure and the statue of King James II (see overleaf) were commissioned by Tobias Rustat, Keeper of Hampton Court, who was an ardent Royalist. Both figures are portrayed in Roman dress, according to the new classical conventions. The two statues cost £1,000.

On the anniversary of the founding of Chelsea Hospital (Oak Apple Day) the custom survives of decorating the statue with oak boughs and leaves—a reminder of the legend that Charles hid from the Roundheads in the Boscobel Oak after the Battle of Worcester.

There is a weathered statue of Charles in Soho Square which is said to be by Rysbrack, and he is also commemorated by the relief on the front of the Monument (see pages 20 and 221).

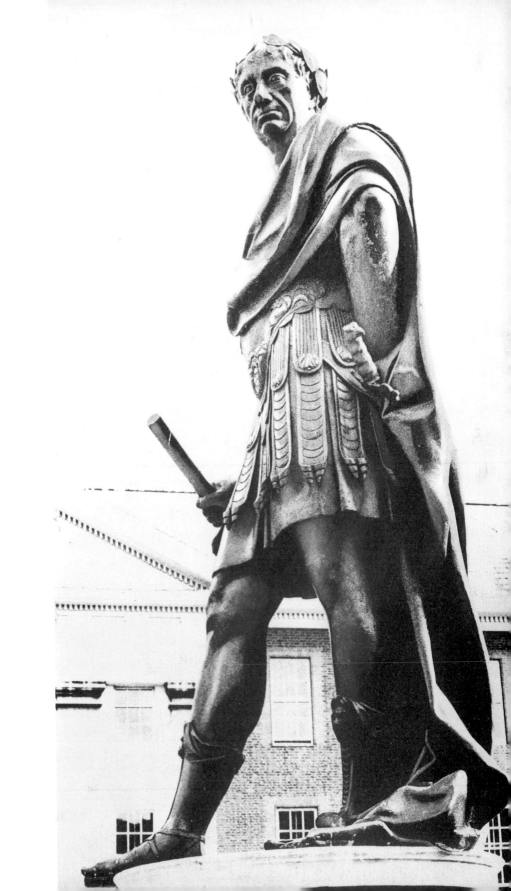

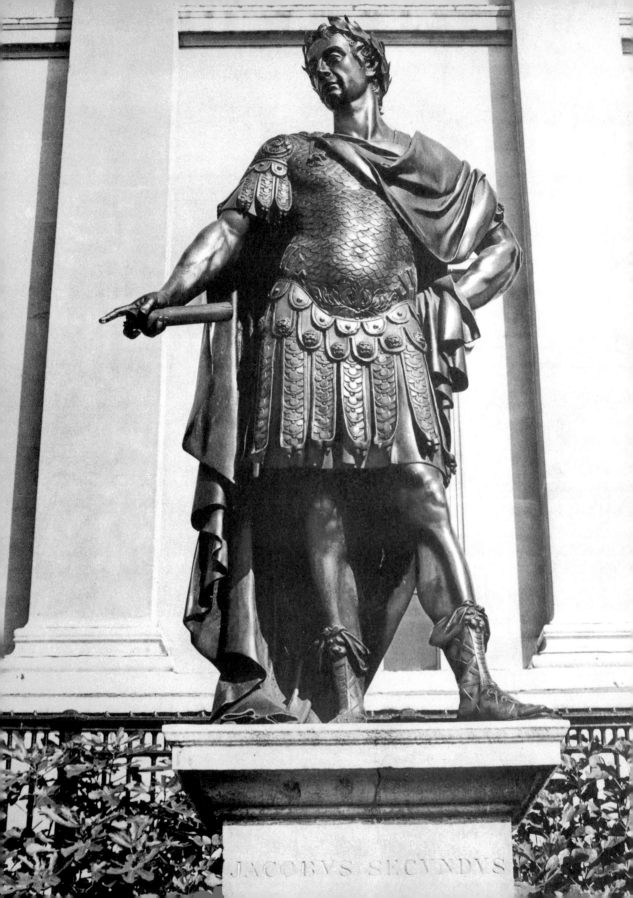

JACOBVS SECVNDVS

King James II

1633–1701

Sculptors: Grinling Gibbons and Arnold Quellin
Now in front of the National Gallery

This statue is one of the finest bronze figures in London. It was originally erected in the Palace of Whitehall in 1686 and was moved several times before it reached its present site. During the early years of this century it stood in front of the Admiralty.

Like the statue of King Charles II, James wears Roman armour, but he stands in a much more relaxed pose. The face is said to be an excellent likeness of the king, and it is interesting to note the marked family resemblance to the statue of his brother by the same sculptors (see previous page).

For many years Gibbons was thought to be solely responsible for these two figures, but the Dutch sculptor Quellin, who worked for Gibbons, is now credited with most of the work on them.

King William III

1650–1702
Sculptor: John Bacon, junior
Erected in 1808 in St. James's Square

An equestrian statue modelled in the Baroque style, showing King William in Roman armour and toga.

Plans for a statue of William had existed since 1700, but nothing was done until 1724 when a Samuel Travers bequeathed some money for the purpose. At this stage a pedestal was made and placed in the centre of the square, where a fountain had been—in fact the pedestal stood in a pool of water. It was not until 1806 that the legacy was discovered to have accumulated and the commission for the statue was given to John Bacon, junior.

There is also a statue of King William III by Baucke in Kensington Palace Grounds, which was presented by the German Emperor William II to Prince Edward VII for the nation in 1907.

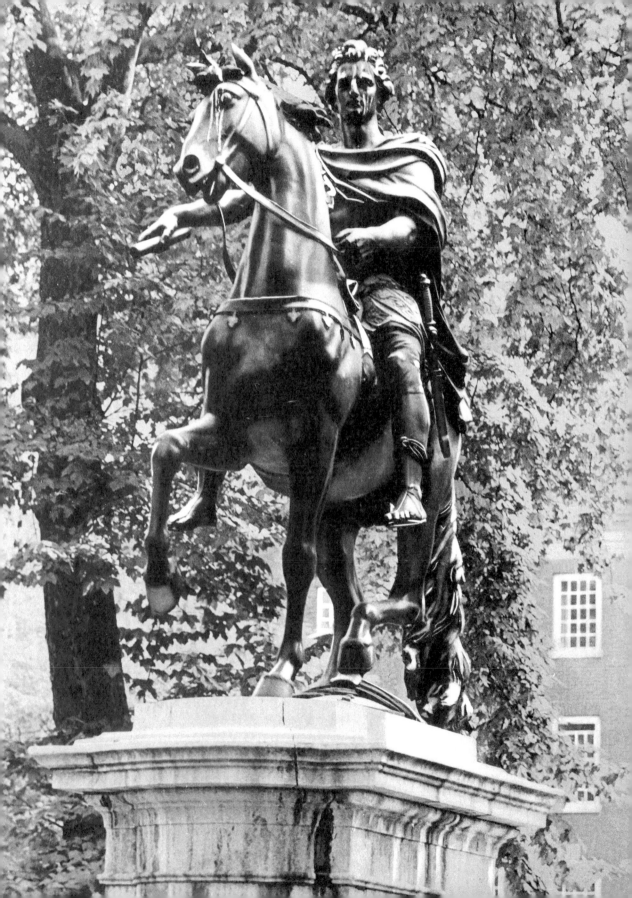

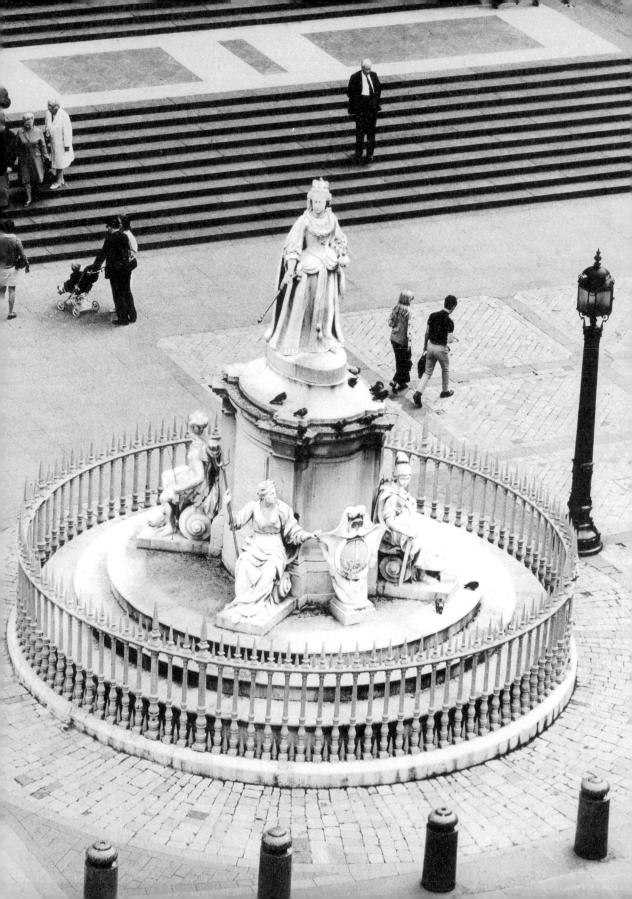

Queen Anne

1665–1714
Sculptor: Francis Bird
This replica of the original was placed in 1886 at the West Front of St. Paul's Cathedral

The original statue of Queen Anne was erected in 1712 to commemorate the completion of St. Paul's Cathedral. It was badly damaged by a mad boy with an axe, who thought the figure was in some way an insult to his mother. It was removed and placed in the private park of Holmhurst by Augustus Hare.

The replica by Richard Belt was unveiled in 1886 and was regarded as an unsatisfactory copy of the imposing and magnificent original, which had cost £1,180 in 1712. The 1886 replica cost £1,800.

Carved from Sicilian marble, Queen Anne holds a sceptre and orb above allegorical female figures of England, Ireland and N. America.

A contemporary verse ridiculed the queen's alcoholic tastes:

> Brandy Nan, Brandy Nan,
> You have been left out in the lurch,
> With your face to the gin shops
> And your back to the church.

There is another statue of Queen Anne in Queen Anne's Gate, near St. James's Park, which is now in poor condition. It is thought to have been erected by William Patterson, founder of the Bank of England, and was probably taken from the portico of the church of St. Mary-le-Strand. Traditionally, this statue of Queen Anne comes to life on the eve of her anniversary and walks round Queen Anne's Gate three times. It has been known as Bloody Queen Mary by local children, who would throw stones at the statue when she refused to descend from the pedestal.

The photograph opposite shows an attractive lead statue of Queen Charlotte, consort of King George III, in Queen Anne's Square, Bloomsbury. This has sometimes been thought to be of Queen Anne, as the date and time of erection of the statue are unknown.

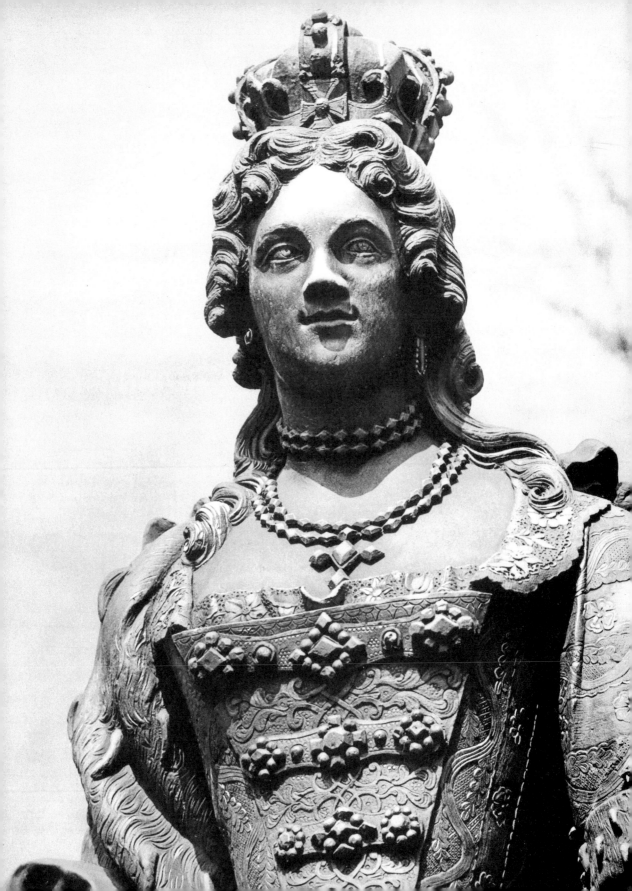

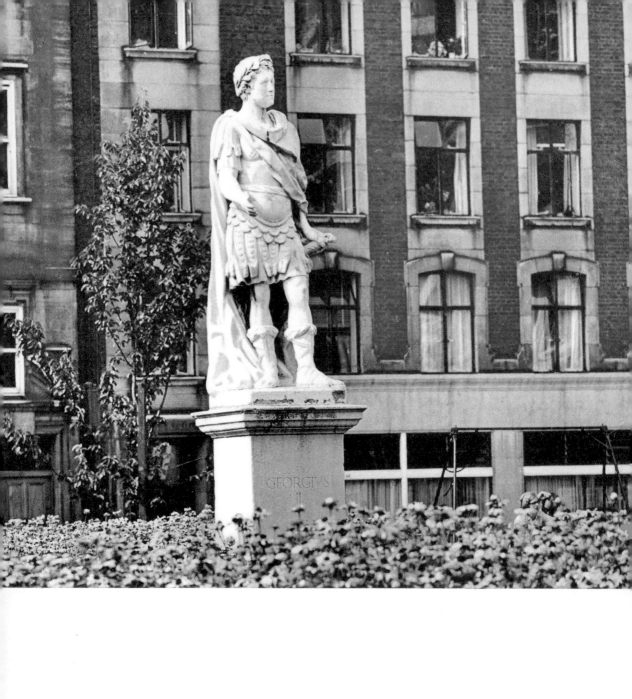

King George II

1683–1760
Sculptor: John van Nost
Erected in Golden Square, Soho, 1753

The stone figure of King George II in classical dress was one of many carved by van Nost in 1722 for Canons, the magnificent mansion of the Duke of Chandos at Edgware. When Canons was demolished in 1747 the statue was auctioned and finally found its way to Soho.

The sculptor was well known for his garden figures, and was responsible for the lead statue of a 'blackamoor' supporting a sundial which originally stood in Clements Inn and was subsequently moved to the gardens of the Inner Temple.

Another statue of George II is a bronze figure by Rysbrack. It stands in the centre of the River Terrace Quadrangle at Greenwich Hospital (now the Royal Naval College).

King George III

1738–1820

Sculptor: Matthew Wyatt

Unveiled in 1836 in Cockspur Street, facing New Zealand House

The equestrian bronze figure of King George III is well made and was said to be a good likeness of the King. The cost of the figure, which was paid by public subscription, was £4,000. It was the subject of contemporary criticism which ridiculed the King's small wig, his thin pigtail, and the horse's pointed tail:

> Here stands a statue at which critics rail
> To point a moral and to point a tail.

Rumours stated that the sculptor of this statue, and also the sculptor of the equestrian statue of King Charles I, committed suicide because they omitted the horses' girths. Both girths do, in fact, exist.

King George III became incapacitated in 1811, by what is now considered to have been an incurable disease, and his eldest son became Regent until his succession in 1820.

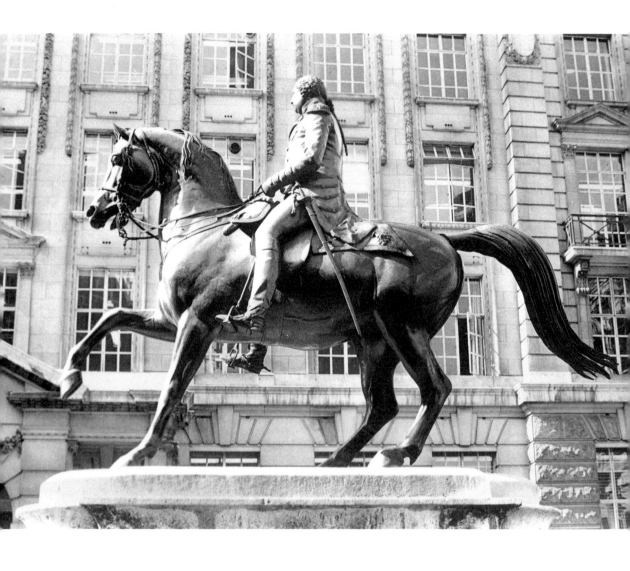

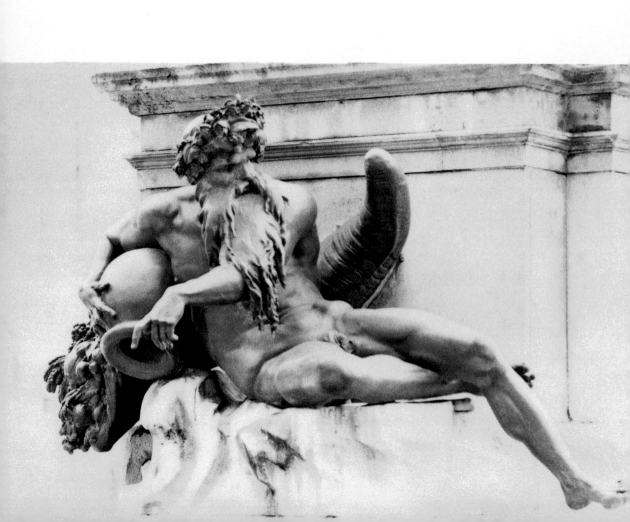

King George III

1738–1820
Sculptor: John Bacon, senior
Placed in the Courtyard of Somerset House in 1780

A Baroque-style bronze represents King George holding a Roman rudder, with the British lion on his right hand a ship's prow on his left. Below, Father Thames or Neptune (the detail illustrated) reclines with a water-jar under his arm and an immense cornucopia behind him. There was a pool of water in the cavity in front of the statue when it was first erected.

The group suffered contemporary criticism because it flouted the accepted idea of Regal dignity, and because of the feminine appearance of the king. Queen Charlotte is said to have asked the sculptor: 'Why did you make so frightful a figure?' To which John Bacon replied: 'Art cannot always effect what is ever within the reach of nature—the union of beauty and majesty.'

King George IV

1762–1830
Sculptor: Francis Chantrey
Made in 1829, and now in Trafalgar Square

A noted patron of the arts, the king himself commissioned this bronze equestrian figure, which was originally intended for the top of Marble Arch. The semi-classical dress has been described as the king's drawers and dressing-gown, because the sculptor advocated simplicity to the point of eliminating boots, saddle, stirrups and other details.

Chantrey was a leading exponent of Neo-classicism and the statue is similar to his equestrian figure of the Duke of Wellington in front of the Royal Exchange (page 117). He was also responsible for the statues of Canning (page 82) and William Pitt (page 81).

King George IV reigned as Regent from 1811 and ascended the throne in 1820. His friends described him as 'the first gentleman of Europe', and he was indeed gifted, cultured and artistic. He outlived his only child, his daughter Charlotte, and was succeeded by his brother, William IV.

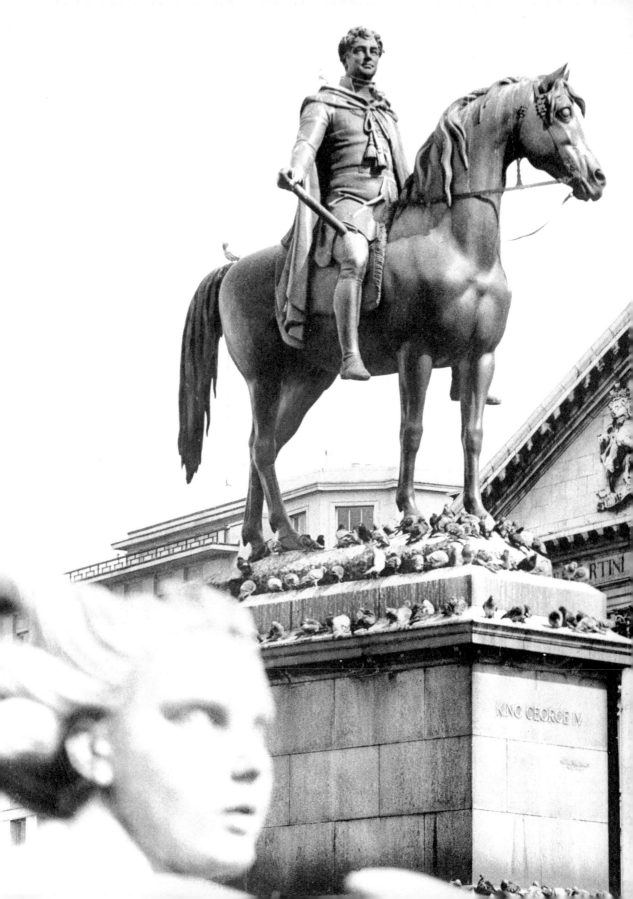

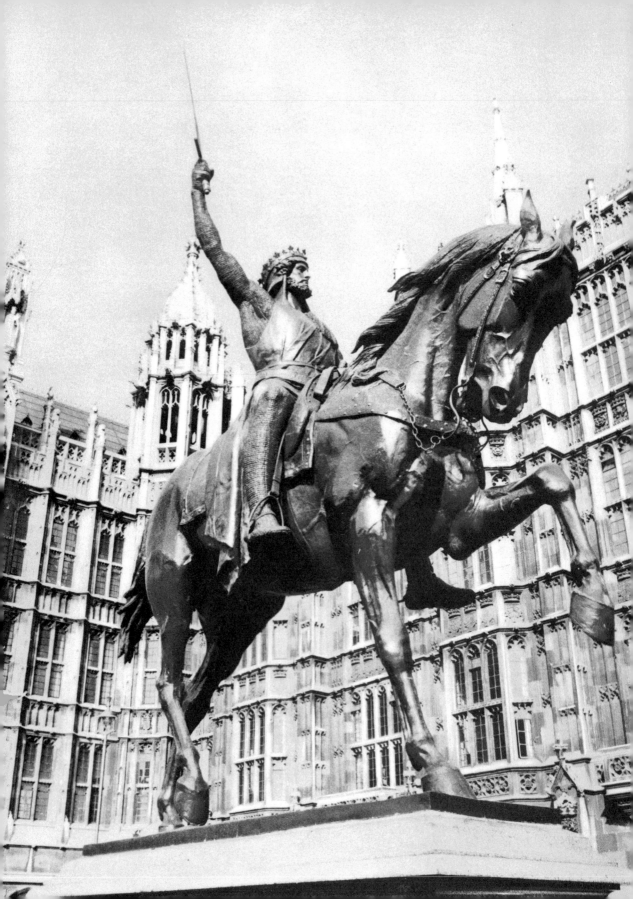

King Richard I

1157–1199
Sculptor: Carlo Marochetti
Set up in 1860 in Old Palace Yard, Palace of Westminster

The story of Richard Coeur de Lion greatly appealed to the romantic Victorian sense of history, and his life of crusades, capture and ransom was spiritedly evoked by Marochetti, an Italian sculptor patronised by Prince Albert.

The original plaster model of this statue attracted much admiration when it was shown at the Great Exhibition of 1851. The bronze figure shows the king in skin-tight mail, raising his sword over his head, while his horse prances in best nineteenth-century style. The pedestal carries two reliefs: one of crusaders fighting the Saracens, and the other of the king on his death-bed interrogating Bertrand de Gourdon, who gave him his fatal wound. This great romantic work cost £3,000, which was met by public subscription; the cost of £1,650 for the pedestal was paid by Parliament.

Prince Albert

1819–1861

The Albert Memorial, designed by George Gilbert Scott

Unveiled in 1876 in Kensington Gardens

The bronze seated figure of the Prince Consort, by J. H. Foley, is gilded, and covered by a large square canopy, 175 feet high. Prince Albert is shown holding a catalogue of the 1851 Exhibition, which he was of course influential in arranging.

A frieze in high relief, of 178 portrait figures representing the arts since the ancients, decorates the base of the memorial. The architects and sculptors on the north and west sides of the frieze were modelled by J. B. Philip, and the poets, musicians and painters on the south and east sides by H. H. Armstead. Four groups, representing Agriculture by W. Calder-Marshall, Manufacture by H. Weeke, Commerce by T. Thornycroft and Engineering by J. Cawler project from the corners of the pedestal.

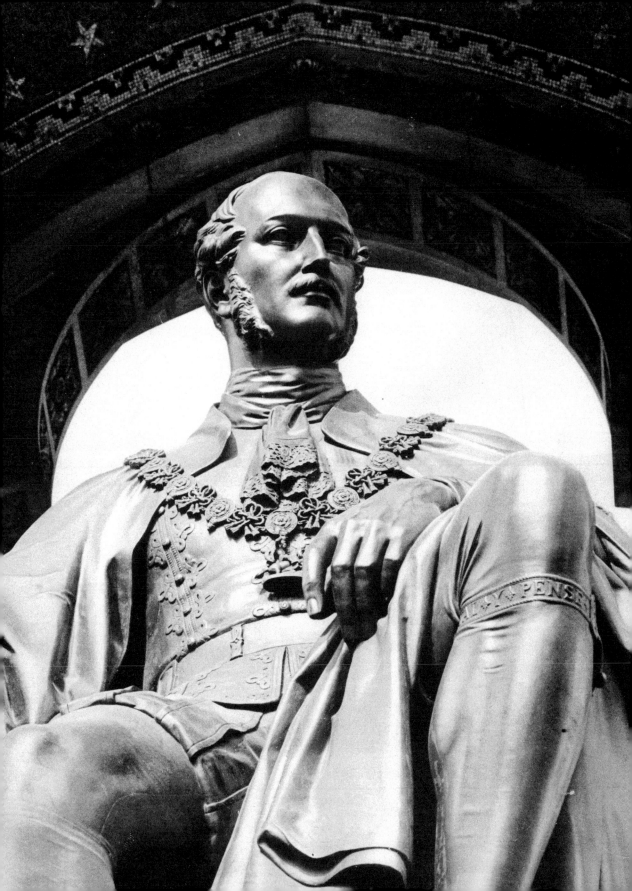

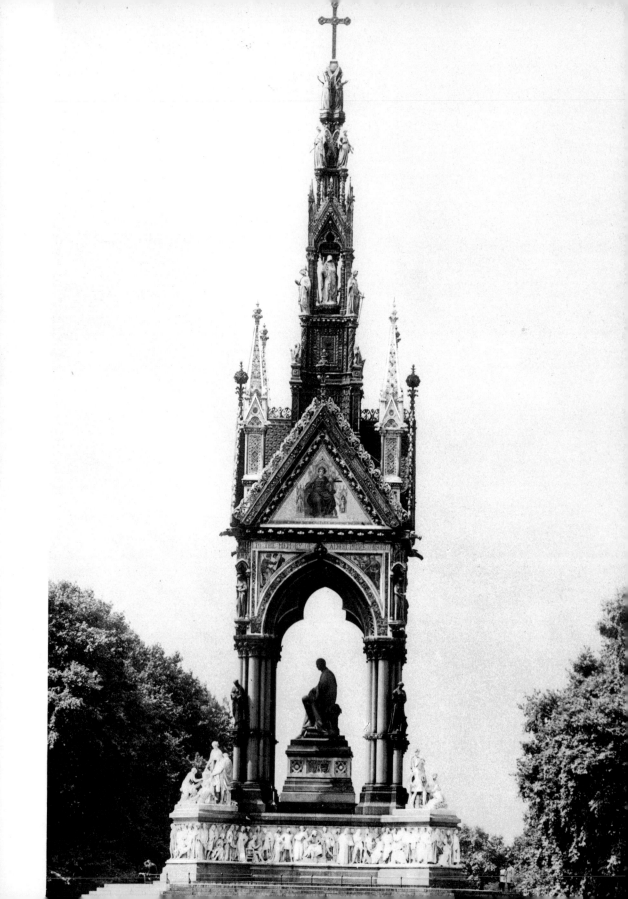

The monument rests on a spacious black, white and pink platform, approached by four large white marble groups symbolising Europe, by P. Macdowell, Asia, by J. H. Foley, Africa, by W. Theed and America, by J. Bell.

Gilbert Scott won the design competition for the memorial, which took ten years to construct. Queen Victoria made suggestions about the form it should take, but contributed least to its cost. This totalled £120,000, of which the public subscribed £56,765, the Society of Arts £12,000, Parliament £50,000 and the Queen £1,300.

Reaction to the memorial has always been extreme, whether of approval or criticism—but it remains the supreme example of High Victorian decorative art. The quality of the sculptural work is very varied, but that by J. H. Foley (Asia, and Prince Albert himself) is the most distinguished.

Prince Albert

1819–1861

Sculptor: J. Durham

Erected on the south side of the Albert Hall in 1899

A bronze figure of the prince stands 42 feet above the ground on top of a pink granite column. Below this are eight more columns and four larger statues representing Europe, Asia, Africa and America. This monument was originally intended to commemorate the Great Exhibition, but was subsequently dedicated to 'the memory of the great author of that undertaking'. It cost £8,000, subscribed by the public.

The illustration shows a detail of the monument: the figure of a negress which represents Africa.

Another statue of Prince Albert, an equestrian bronze, stands in Holborn Circus. These three memorials, and the five erected to Queen Victoria, came to a total cost of £500,000.

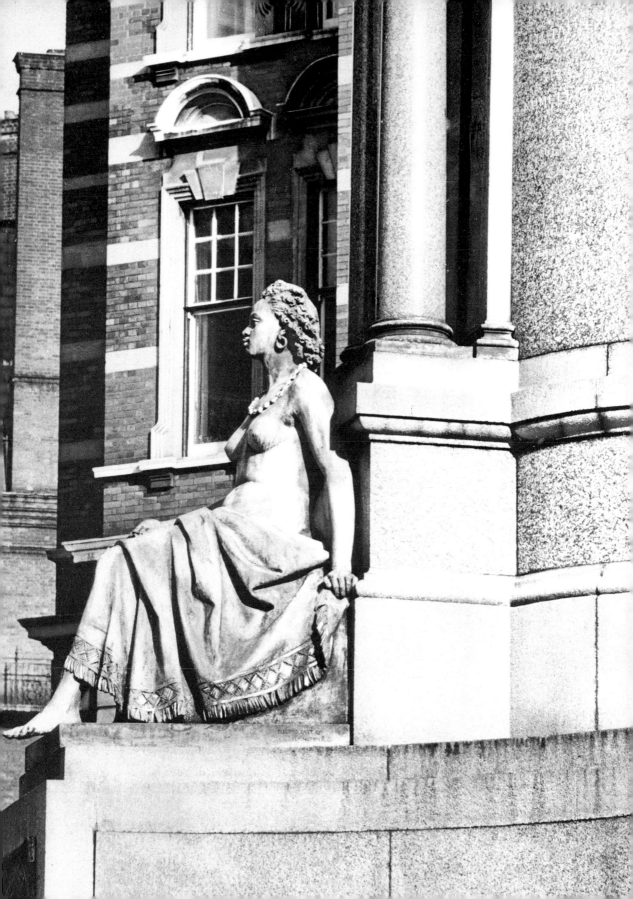

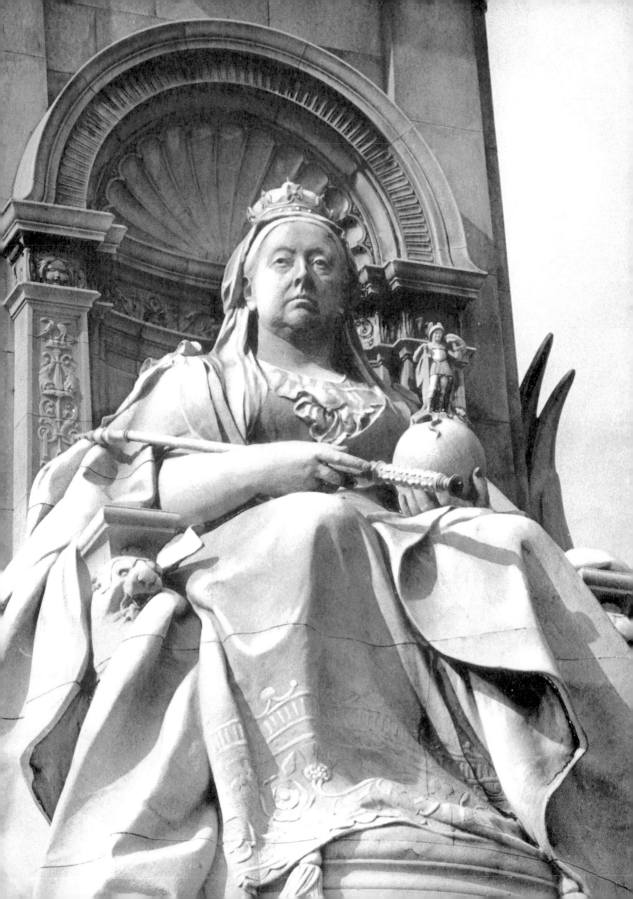

Queen Victoria

Victoria Memorial
Architect: Aston Webb. Sculptor: Thomas Brock
Unveiled in 1911 in front of Buckingham Palace

The memorial in front of the Palace was only part of the scheme commemorating Queen Victoria. The work took over eight years to complete and included refacing the palace itself, widening and landscaping the Mall and erecting Admiralty Arch, at a total cost of £325,000 raised by public subscription.

The main feature of the Memorial is the large-scale seated figure of Queen Victoria herself, wearing robes of State and facing down the Mall. Ironically, the face resembles that of Harold Wilson.

Favourite Victorian abstractions throng the structure. A winged gilt figure of Victory is on a marble pedestal behind the throne; figures of Courage and Constancy are at the queen's feet, and the other three sides of the Memorial are filled by marble groups of Truth, Justice and Motherhood. Motherhood, at the time, was thought to be 'particularly charming'.

At the corners of the plinth supporting the pedestal are four classical prows. The plinth stands on a circular podium, approached by a wide flight of steps guarded by four bronze figures with lions. A well-proportioned figure of Progress, a man with a torch, and a female figure of Peace face up the Mall.

Ironically, Manufacture, a smith with a hammer, and Agriculture, a woman with a sickle, face Buckingham Palace on the west side. The northern and southern side basins carry friezes of sea nymphs and marine deities with recumbent bronze figures representing Painting and Architecture on the north, and War and Shipbuilding

on the south side. These are derived from Michelangelo's figures of Dawn and Dusk.

The Monument was unveiled by King George V in the presence of the German Emperor and Empress and a large crowd in 1911. The sculptor, Thomas Brock, was knighted during the ceremony. The semi-circular space in front of the Palace surrounding the Memorial was filled with flower-beds of herbaceous borders, at the suggestion of King Edward VII, 'to add a note of splendour to the scene'. Three of the five exits to the area are flanked by stone pillars surmounted by 'Amorini' (youths) displaying shields of Dominions and Colonies. Contemporary critics admitted that there were faults in the Memorial: perhaps Her Majesty's right arm was a trifle too large; two of the imaginary shields above Motherhood and the Victorian Virtues included bend sinisters, and the faces of the sea people were 'a bit flaccid'. The whole composition was based on Michelangelo's work but executed on a larger scale and without his genius, to the point of burlesque.

A seated marble figure of Queen Victoria, by her daughter Princess Louise, stands in Kensington Gardens. It is reproduced opposite.

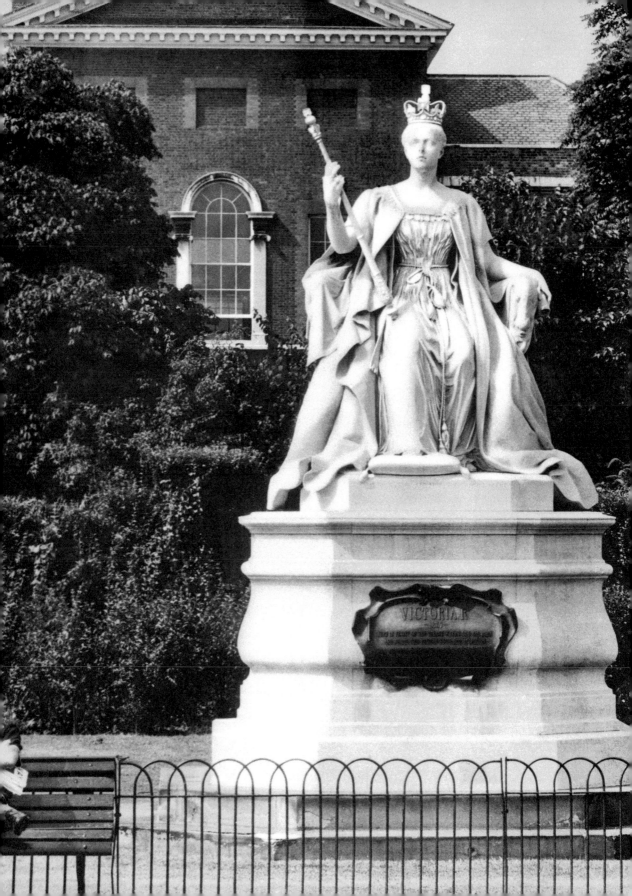

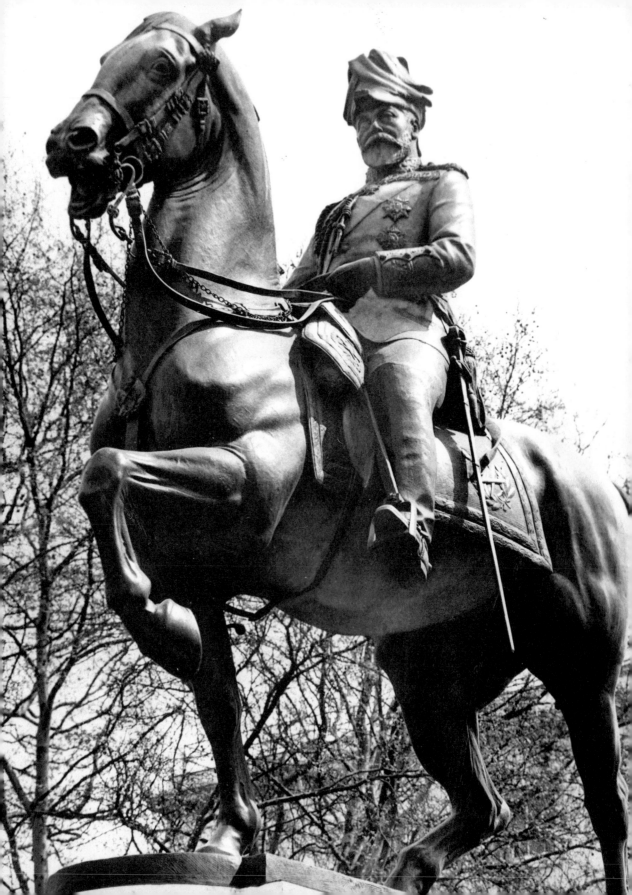

King Edward VII

1841–1910
Sculptor: Bertram McKennal
Unveiled by King George V on 20 July 1921, in Waterloo Place

The equestrian bronze statue of King Edward VII is lively and vigorous, yet its critics complained that it lacked regal character, partly because it represented the king as a military commander. The site has also been criticised as unsuitable for a monarch—a similar statue of Lord Napier was moved to Queen's Gate to make room for the king. The statue is set with naval and military figures in the middle of Waterloo Place, opposite the Crimea memorial.

It is possible to walk from Waterloo Place, through Carlton House Terrace to the Duke of York steps and down into the Mall, a pedestrian link designed by Nash which joins Regent Street to St. James's Park.

Queen Alexandra

1844–1925
Sculptor: Sir Alfred Gilbert
Erected at Marlborough Gate in 1932

This memorial, which has a fountain in its base, was erected to the memory of Queen Alexandra, the Danish Princess who married the Prince of Wales, later King Edward VII.

The statue is inscribed:

Faith, Hope and Love, the virtues of Queen Alexandra.

It was dedicated as 'A tribute of the Empire's Love'.

The memorial is one of the few successful examples of *art nouveau* in public sculpture in London.

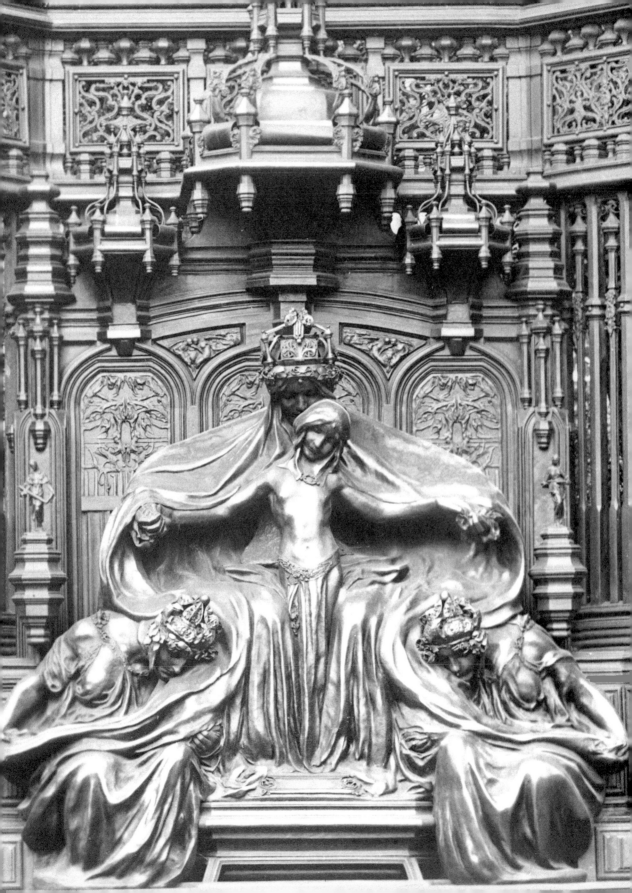

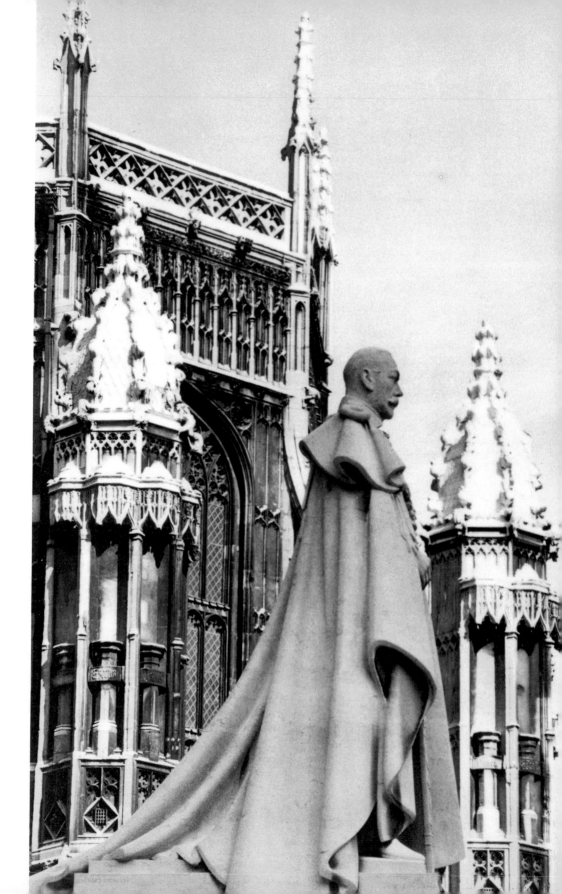

King George V

1865–1936
Sculptor: W. Reid Dick
Near the east end of Westminster Abbey in Old Palace Yard

The plainly carved stone figure of King George V, with its austere base, provides effective contrast to the intricate detailing in the ornament of Westminster Abbey's Henry VII Chapel and the elaborate decoration it inspired on the Houses of Parliament opposite.

King George VI

1895–1952

Sculptor: William McMillan

Erected in 1953 outside the Foreign Secretary's residence in Carlton House Terrace

A traditional and competent bronze figure of King George VI wearing the robes of the Order of the Garter over the undress uniform of an Admiral of the Fleet. The statue is set on top of a flight of steps which lead down into the Mall, and looks over St. James's Park.

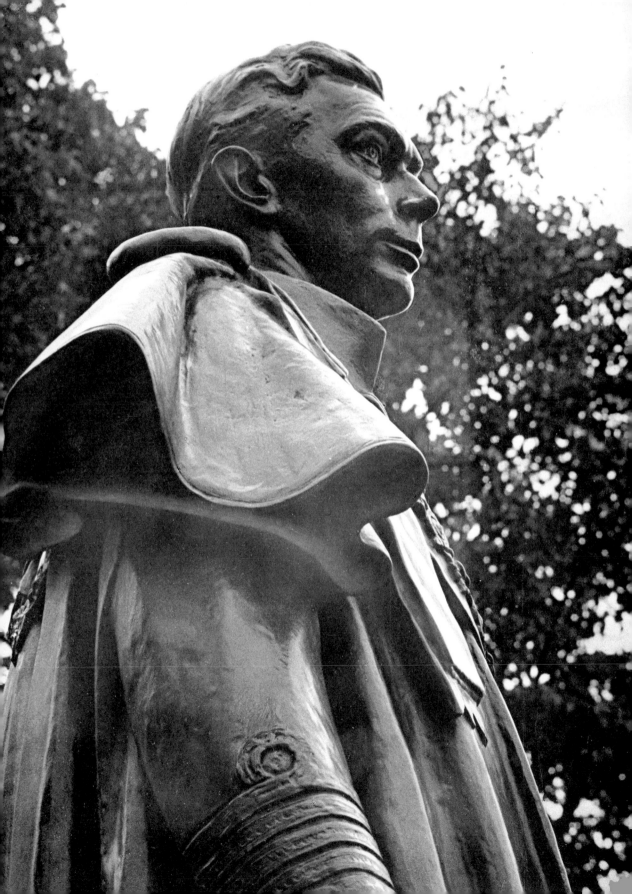

Statesmen

Appropriately, statues of statesmen seem to congregate in Parliament Square, but one can find these imposing figures still exercising an air of authority in various parts of London.

The tradition of commissioning statues to commemorate statesmen began early in the nineteenth century, when Neo-classicism was at its height. Some eighteenth-century parliamentarians are represented as Roman senators, while later men of affairs appear in peers' robes, uniforms or ordinary formal dress. Despite these trappings of statesmanship most sculptors were able to produce lively, realistic portraits of their subjects.

A child representing one of the seasons, at the feet of the statue of the 5th Duke of Bedford

Francis, 5th Duke of Bedford

1765–1805
Sculptor: Richard Westmacott
Unveiled in 1809 in Russell Square

A delightful rococo statue in bronze pays tribute to the Duke's interest in agriculture. (He ran a model farm at Woburn Abbey.) He is shown with one hand on a plough and ears of corn in the other; the gambolling children at his feet represent the seasons and the bas-reliefs on the pedestal show scenes of rustic labour. The Russell family mansion still occupied one side of Bedford Square when the statue was erected in the centre of their Bloomsbury estate.

An associate of Fox, the Duke of Bedford criticised the grants made to Burke in Parliament in 1796; Burke retaliated by reminding Bedford of the Royal grants made to the Russells since the time of King Henry VIII, which he said 'were so enormous as . . . to stagger credibility'. A contemporary rhyme commented on the event:

> Then Leviathan, on ocean's brim,
> Hugest of things that sleep and swim,
> Thou, in whose nose, by Burke's gigantic hand,
> The hook was fixed to drag thee to the land.

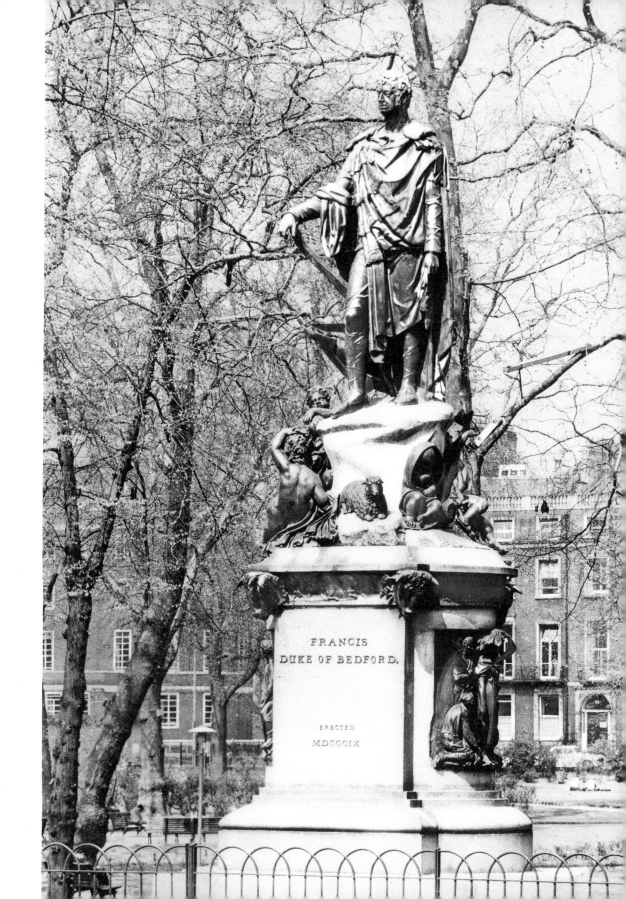

FRANCIS
DUKE OF BEDFORD.

ERECTED
MDCCCIX

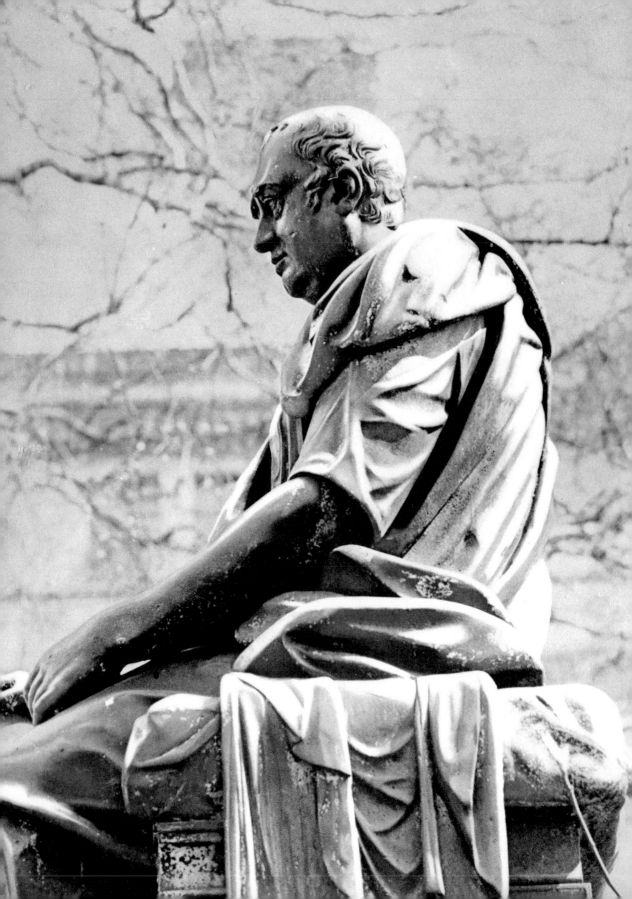

Charles James Fox

1749–1806
Sculptor: Richard Westmacott
Unveiled 1816 in Bloomsbury Square

'The most brilliant and accomplished debater the world ever saw' (according to Burke), the radical parliamentarian is shown seated wearing the robes of a Roman senator, and holding a scroll of Magna Carta in his right hand.

This statue is a successful example of Westmacott's Neo-classical style.

Born the younger son of Lord Holland, Fox early showed promise of the brilliant mind that was to make him the parliamentary scourge of the younger Pitt. He was also a prodigious card-player in his youth, gambling at Almack's Club night after night. When Lord Holland was told that his son was going to be married he replied that he was glad to hear there was a prospect of Charles going to bed for one night at least.

William Pitt

1759–1806
Sculptor: Francis Chantrey
Erected 1831 in Hanover Square

Chantrey insisted, at risk of losing the commission, on placing his over-life-size bronze figure of the great Prime Minister on a pedestal 16 feet high. Perhaps he himself had doubts about this, for in a letter to Sir John Soane in 1831 he wrote: 'When you have nothing better to do, pray drive through Hanover Square and look at my Pitt. Is it high enough, or is it too high? An honest opinion from a friend is worth having.' Soane's reply is not recorded, but the pedestal received a great deal of criticism at the time. Contemporary critics also thought that Pitt appeared to be stepping defiantly out of an unnecessary amount of drapery rather than advancing one foot in debate as was intended.

The statue exemplifies Chantrey's gift for realistic portraiture: it is a lively and original piece of sculpture designed within the Neo-classical tradition.

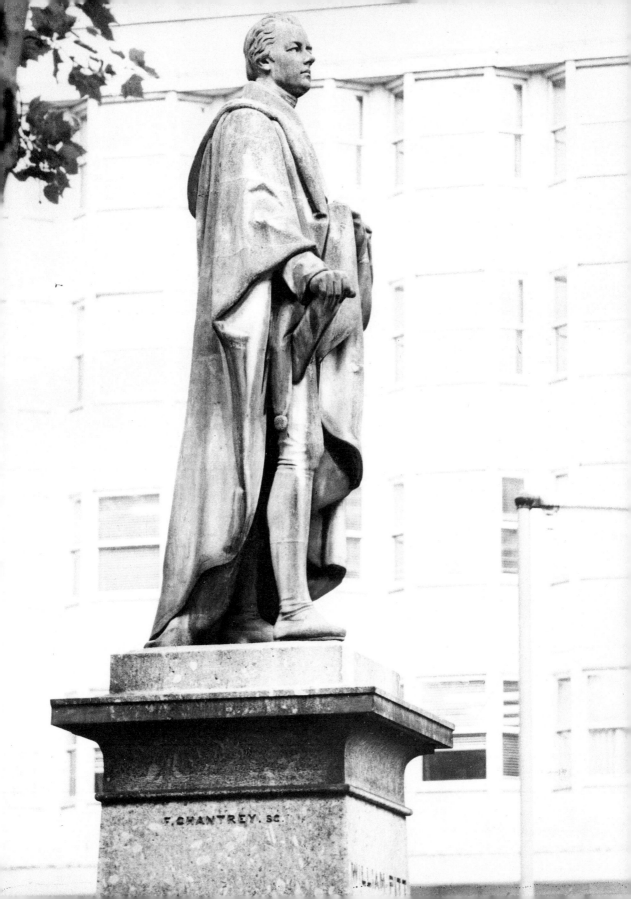

F.CHANTREY. SC.

WILLIAM PITT

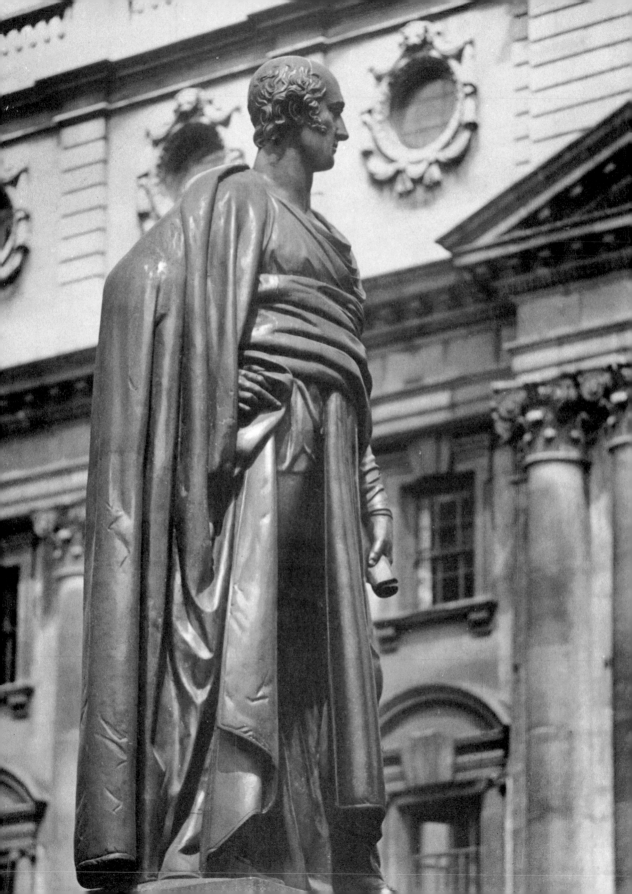

George Canning

1770–1827
Sculptor: Richard Westmacott
Erected in Parliament Square 1832

Another example of Westmacott's Neo-classical style, the large bronze figure of Canning, like Fox, is shown in the dress of a Roman Senator. A brilliant orator and wit, Canning as Prime Minister was the first exponent of popular and liberal diplomacy in foreign affairs—strategies which were later continued by Palmerston, who was his protégé.

The statue cost 7,000 guineas and was first placed in Old Palace Yard before being moved in 1867 to its present site. While the figure was in Westmacott's studio, it fell over and killed another sculptor called Gahagan who had come to view it.

There is also a statue of Lord Palmerston on the east side of Parliament Square.

Sir Robert Peel

1788–1850
Sculptor: Matthew Noble
Unveiled 1855 in Parliament Square

Peel was born a Tory, and many of the social and parliamentary reforms with which he is associated he had bitterly opposed in his youth. He was in Parliament for more than forty years, and the present statue was intended to show him in characteristic pose addressing the House of Commons.

Efforts to commemorate Peel, who died after a fall from his horse at Hyde Park Corner, were beset with difficulties. Two bronzes by Marochetti were in turn erected and discarded as unsuitable: the second was melted down to provide the bronze for Matthew Noble's figure.

Another statue of Peel (by William Behnes) stands in the Postmen's Park in the City.

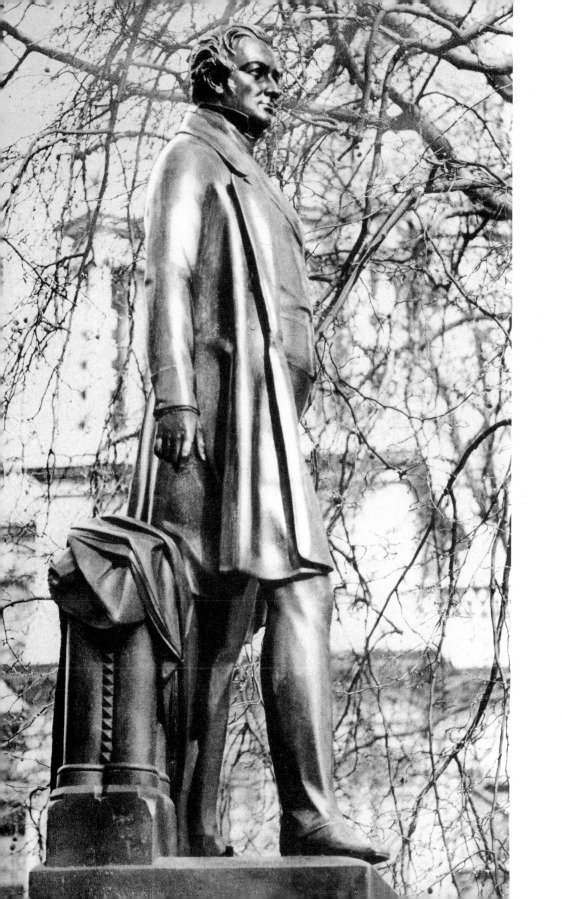

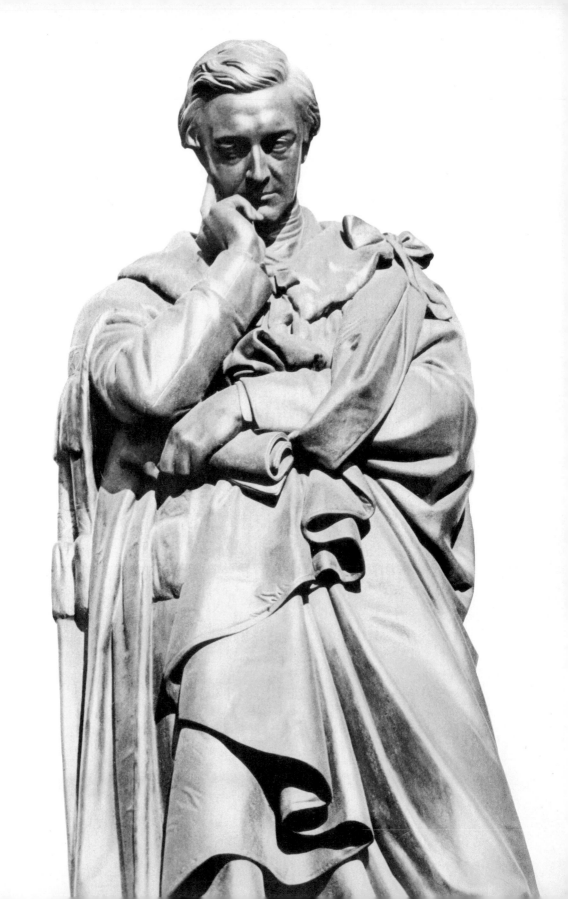

Sidney Herbert, Lord Herbert of Lea

1810–1861
Sculptor: J. H. Foley
Erected 1915 in Waterloo Place

Originally placed in front of the War Office in 1867, the bronze statue of Lord Herbert (paid for by public subscription) was moved to the Crimea Memorial in 1915 to form a pair with his fellow-worker, Florence Nightingale.

Lord Herbert was War Minister during the Crimean War. He was an enthusiastic supporter of Miss Nightingale's schemes for nursing those wounded in that war.

He is portrayed in his peer's robes, standing over his armorial motto, *Ung je servirai*. The granite pedestal has bas-reliefs on three sides representing Florence Nightingale at the Herbert Hospital, volunteers on the march, and the production of the first Armstrong gun at Woolwich.

Henry Holland, 3rd Baron Holland

1773–1840

Sculptors: G. F. Watts and Edgar Boehm

Erected in Holland House Garden, Kensington, in 1872

Despite the reputations of its two sculptors, the seated bronze statue of Lord Holland has been described as unremarkable. Perhaps the two Victorian artists were not much in sympathy with this robust Regency figure. The monument was commissioned with £2,600 left over from Holland's memorial in Westminster Abbey.

Lord Holland, a nephew of Charles James Fox, became a Whig statesman. Fox acted as a father to him—Lord Holland inherited his father's title while still a boy.

An inscription on a nearby fountain describes him:

> Nephew of Fox and friend of Grey
> Be this my deed of Fame
> That those who knew me best may say
> He tarnished neither name.

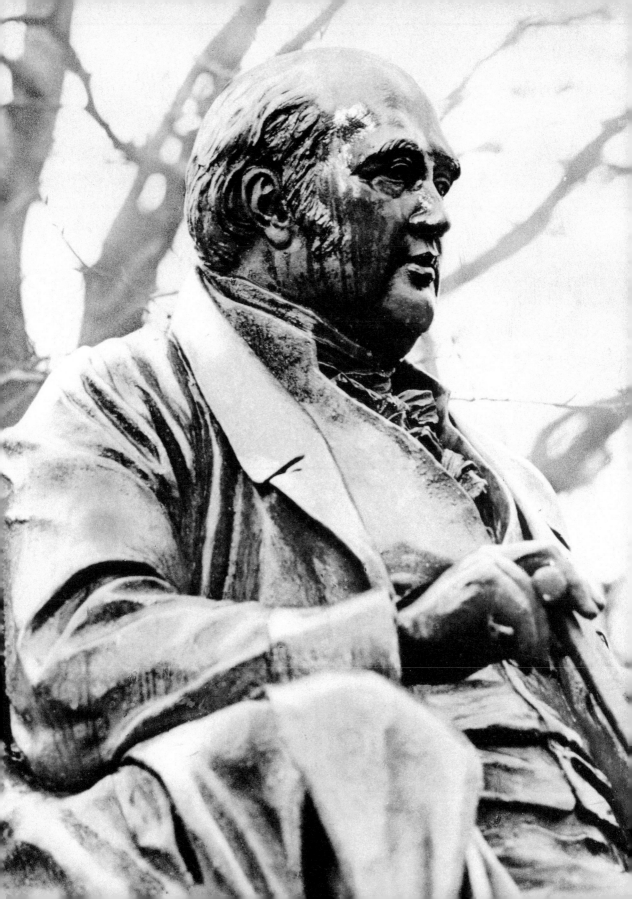

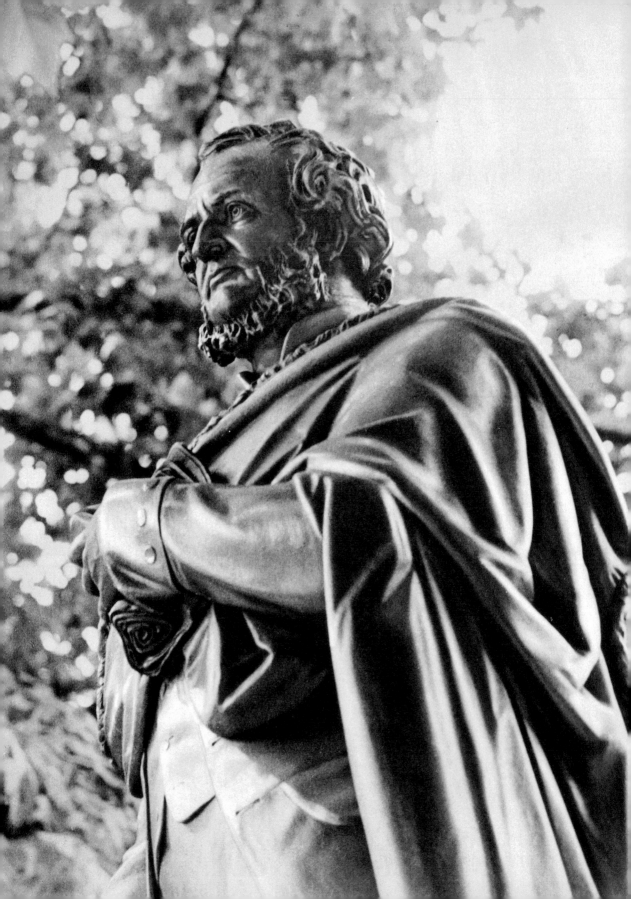

Edward George Stanley, 14th Earl of Derby

1799–1869
Sculptor: Matthew Noble
Unveiled in 1874 by Disraeli in Parliament Square

This bronze figure is more successful than the statue of Peel by the same sculptor (page 85). Lord Derby is portrayed in his peer's robes addressing the House of Lords. The pedestal of grey granite is decorated with bas-reliefs by Horace Montford, representing Derby speaking in the House of Commons on the slave question; at a meeting of the cabinet; at a meeting of the Lancashire Relief Committee; and being inaugurated as Chancellor of Liverpool University.

Disraeli said of this man that 'he abolished slavery, he educated Ireland and he reformed Parliament', achievements, as yet, not fully accomplished. Derby was Prime Minister three times, finally resigning in 1868. On one occasion he refused a request from the Greek government that he should become King of Greece.

Benjamin Disraeli, Earl of Beaconsfield

1804–1881

Sculptor: Mario Raggi

Unveiled on 15 April 1883 in Parliament Square

The anniversary of Disraeli's death is now known as Primrose Day. Flowers are heaped round the elaborate pedestal of his statue on this day each year.

The best of the statues of Prime Ministers in Parliament Square, this bronze figure is said to be a good likeness of Disraeli, who wears Cabinet Minister's uniform under his peer's robes, which he holds up to reveal his sword-hilt and Order of the Garter.

Disraeli was the first English Prime Minister to be of Jewish origin —although he was baptised into the Church of England. He first took office in 1868, and then again from 1874 to 1880. A highly cultivated man, his novels mercilessly and wittily exposed the social affectations of his time.

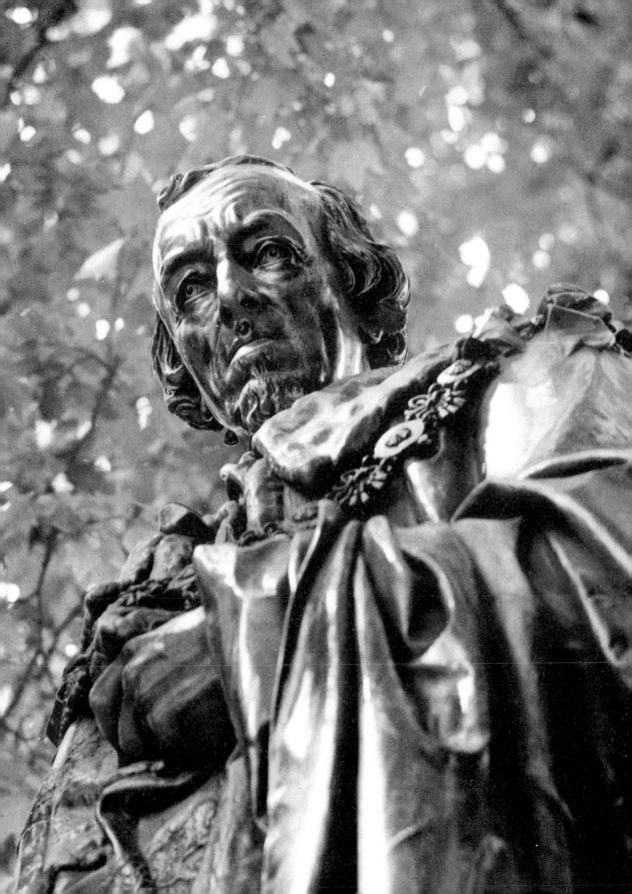

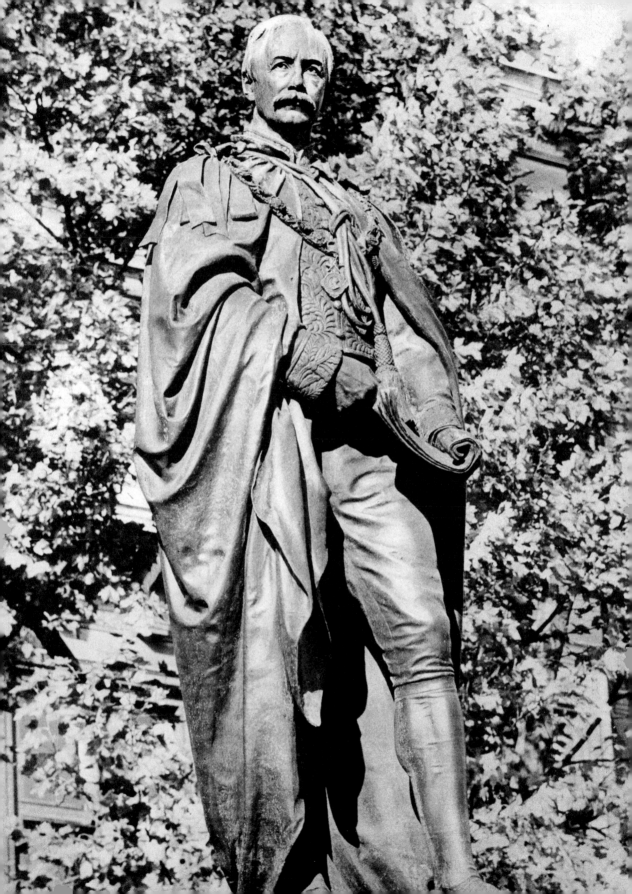

Sir Bartle Frere

1815–1884
Sculptor: Thomas Brock
Unveiled by the Prince of Wales in 1891 in Victoria Embankment Gardens

A well-modelled bronze figure depicts the man who was High Commissioner of South Africa during the Zulu and Boer Wars of 1879–81. Frere wears civil service uniform with open robes of the Star of India and stands over an allegorical bronze figure in high relief. The cost, subscribed by the public, was £3,000.

During his career as a British administrator, Frere in 1872 obtained from the Sultan of Zanzibar a treaty for the abolition of slavery throughout his dominions. He was Governor of Bombay as well as of Cape Colony and the first High Commissioner for South Africa. He is buried in St. Paul's Cathedral.

William E. Forster

1818–1886
Sculptor: H. Richard Pinker
Unveiled in 1890 in Victoria Embankment Gardens

The strong character of 'Buckshot Forster', Chief Secretary for Ireland under Gladstone, is conveyed in this bronze figure by the simple attitude and well-defined textures.

The statue is inscribed:

> To his wisdom and courage England owes the establishment throughout the land of a national system of elementary education.

William Forster was a member of the House of Commons from 1861 until his death. He was appointed Vice-President of the Council in Gladstone's first Ministry and framed the Education Act of 1870. He was Chief Secretary for Ireland in Gladstone's second Ministry.

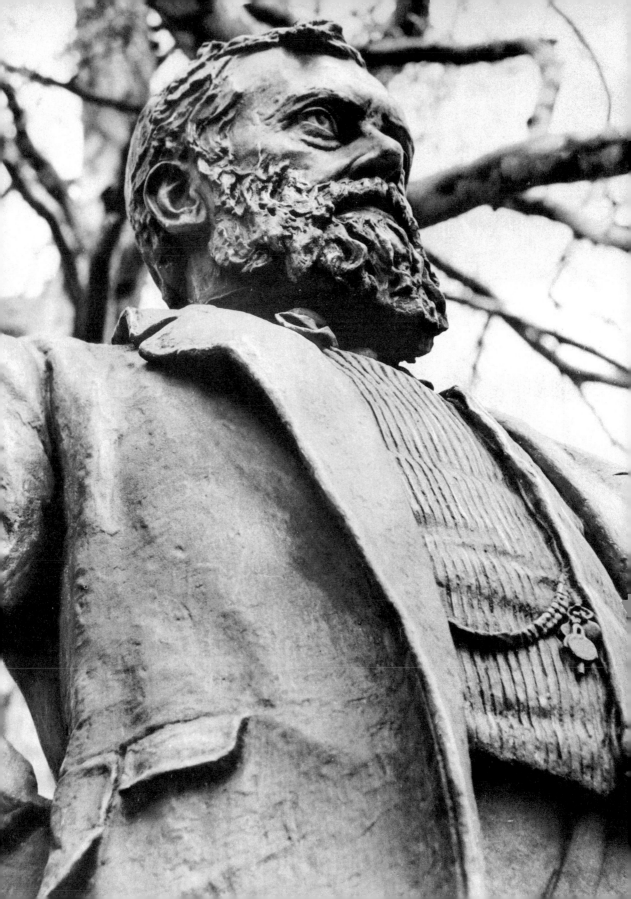

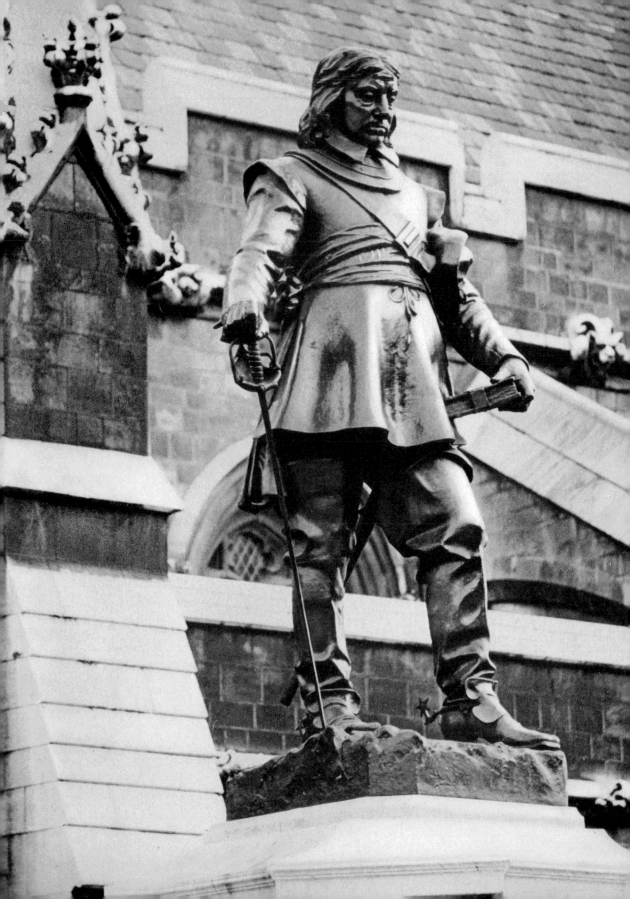

Oliver Cromwell

1599–1659
Sculptor: Hamo Thornycroft
Erected 1899 in Old Palace Yard

An extravagance of the Victorian period, the bronze figure of Cromwell was presented (anonymously) by Lord Rosebery. It cost him £5,000. Wearing leather coat and high boots, Cromwell stands on a pedestal of Portland stone with a bronze lion at his feet.

Cromwell faces the King Henry VII Chapel in Westminster Abbey, where he was first buried with his mother and sister over 200 years before the statue was erected. After the Restoration his body was disinterred and hung on the gallows at Tyburn, and reburied there on 30 January 1661. The embalmed head was left on a pike above Westminster Hall, near where the statue now stands, until it was blown down in a storm.

Cromwell became Lord Protector of the Commonwealth in 1653, three years after his decisive victory over King Charles II at Worcester. He ruled England until his death of Tertian fever in 1659.

W. E. Gladstone

1809–1898
Sculptor: Hamo Thornycroft
Unveiled in 1905 at the junction of the Strand and the Aldwych

This monument to William Gladstone maintains a high level of craftmanship throughout its composition. It is on the right scale for its surroundings, and the dignified pose of the bronze figure of the Liberal Prime Minister contrasts well with the lively groups of Brotherhood, Aspiration, Education and Courage around the base. The boroughs Gladstone represented in Parliament are commemorated on bronze panels between the groups.

After the death of Palmerston, Gladstone assumed leadership of the Liberal Party and eventually became Prime Minister four times. At the time of his third Ministry in 1886 he was defeated when his measures for Home Rule for Ireland failed to pass the House of Commons.

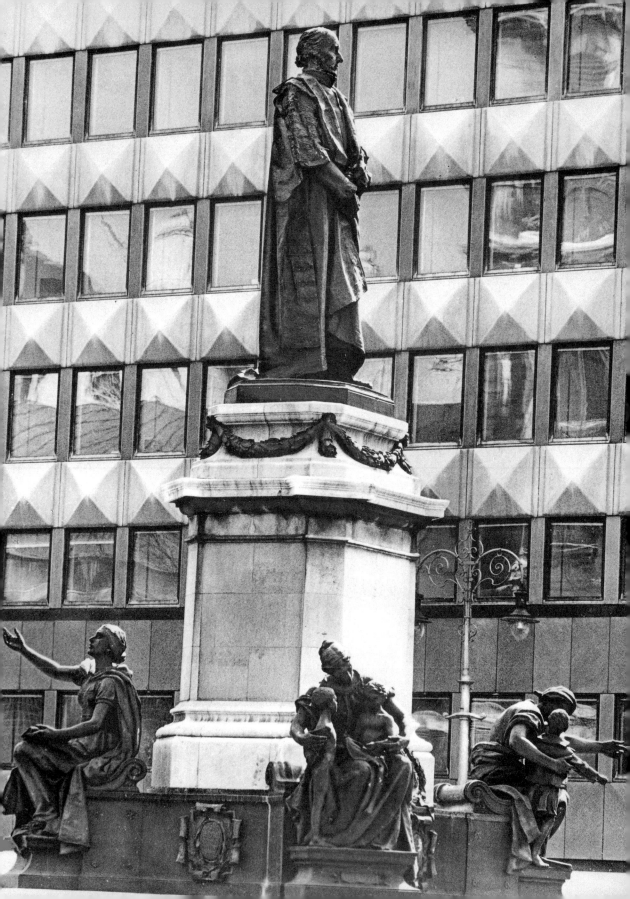

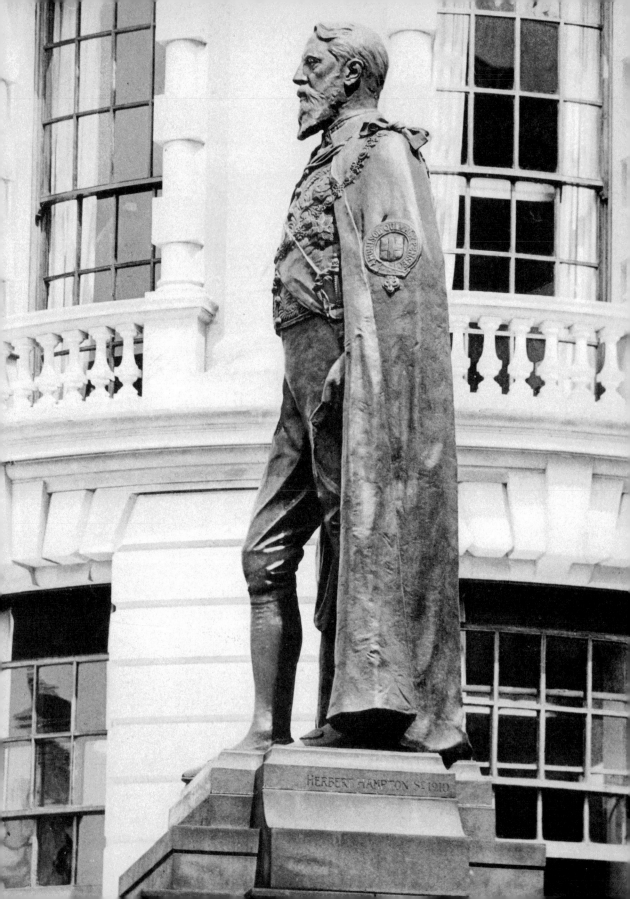
HERBERT HAMPTON S° 1910

The 8th Duke of Devonshire

1833–1908
Sculptor: H. Hampton
Erected in 1910, in Whitehall—Horse Guards Avenue

Friends of the Duke erected this statue to commemorate his 'sterling qualities'. It is known that the Duke disliked ostentation, yet he is represented in full Court dress and knee breeches.

Better known politically as Lord Hartington, his courtesy title, he held office under various Liberal governments, and in 1886, under his guidance, the Liberal Unionist Party was formed with Mr. Joseph Chamberlain in opposition to Gladstone's policy of Home Rule for Ireland. In 1891 Lord Hartington became the Eighth Duke of Devonshire.

George Washington

1732–1799
Sculptor: Jean Antoine Houdon
Placed outside the National Gallery in 1921

The life-size bronze of President Washington is a replica of the statue in the Capitol at Richmond, Virginia. It was presented by the Commonwealth of Virginia to the English people in 1921. Washington is portrayed holding a tasselled cane and leaning on a tall pile of fasces— a bundle of rods with an axe in the middle. Behind his feet is a ploughshare.

Washington was Commander-in-Chief of all the Colonial Forces in America when he was unanimously elected first President of the United States.

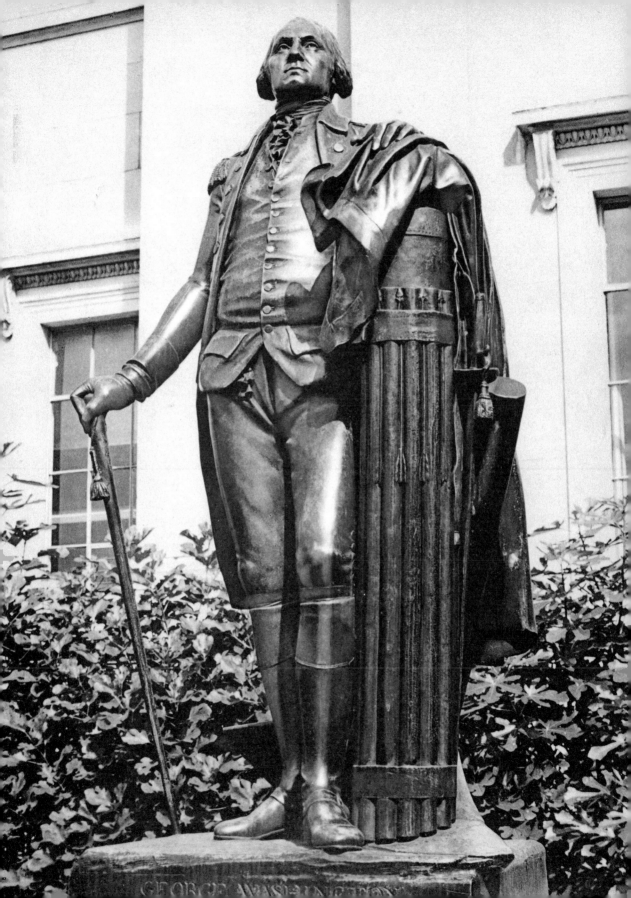

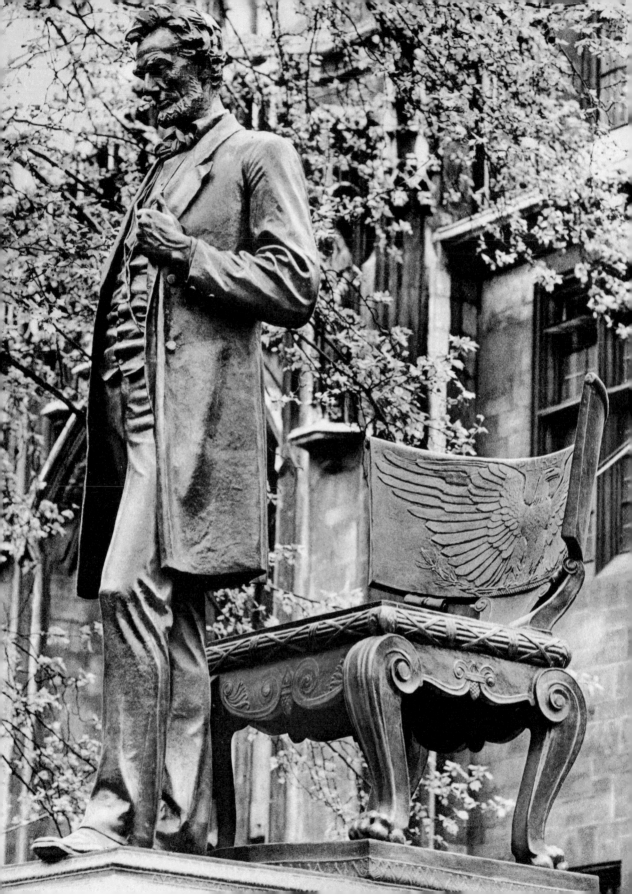

Abraham Lincoln

1809–1865

Sculptor: Augustus Saint-Gaudens

This replica of a statue in Lincoln Park, Chicago, was presented to the British nation by the United States Government and unveiled in Parliament Square in 1921

Lincoln stands in a characteristic pose in front of the large classical presidential chair, on a pedestal decorated with thirty-two stars.

Osbert Sitwell deplored the action of the United States Government in his book on London statues, saying: 'The growth of gifts of this kind . . . is a fresh menace to London.'

Franklin D. Roosevelt

1882–1943

Sculptor: W. Reid Dick

Unveiled by Mrs. Roosevelt in April 1948, in Grosvenor Square, in the presence of King George VI and Queen Elizabeth

Roosevelt was the thirty-second President of the United States of America, and the only man to be elected President three times.

A stone at the base of the pedestal supporting the bronze figure of Roosevelt records how contributions were made 'in small sums from people in every walk of life throughout the United Kingdom who wished to remember him'. The stone walls surrounding the basins on each side of the memorial are inscribed with Roosevelt's four famous freedoms: Freedom from Want, Freedom from Fear, Freedom of Speech, Freedom of Worship.

There is also a bust of President John F. Kennedy, uninteresting sculpturally, erected by readers of the *Sunday Telegraph* in the Marylebone Road, near Regent's Park.

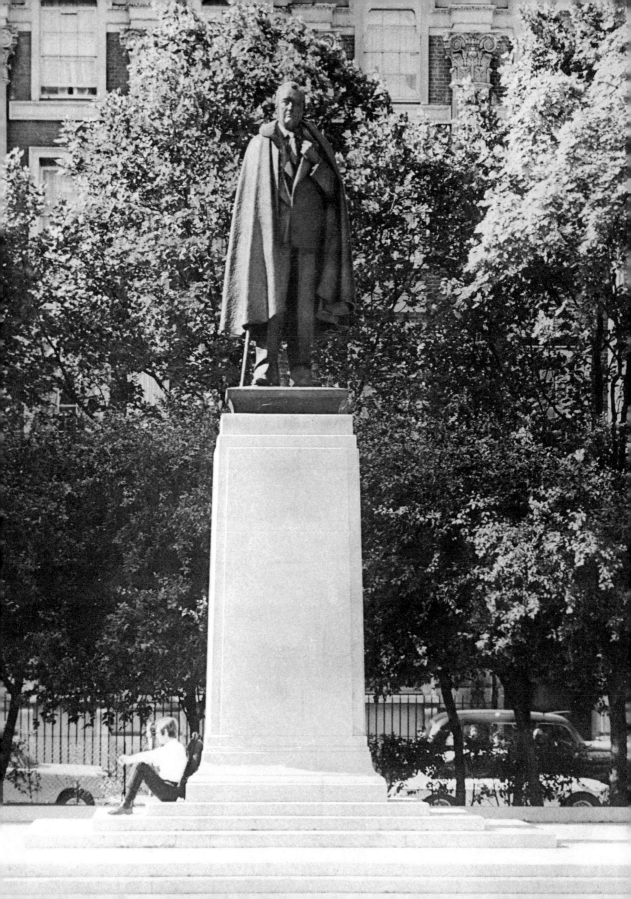

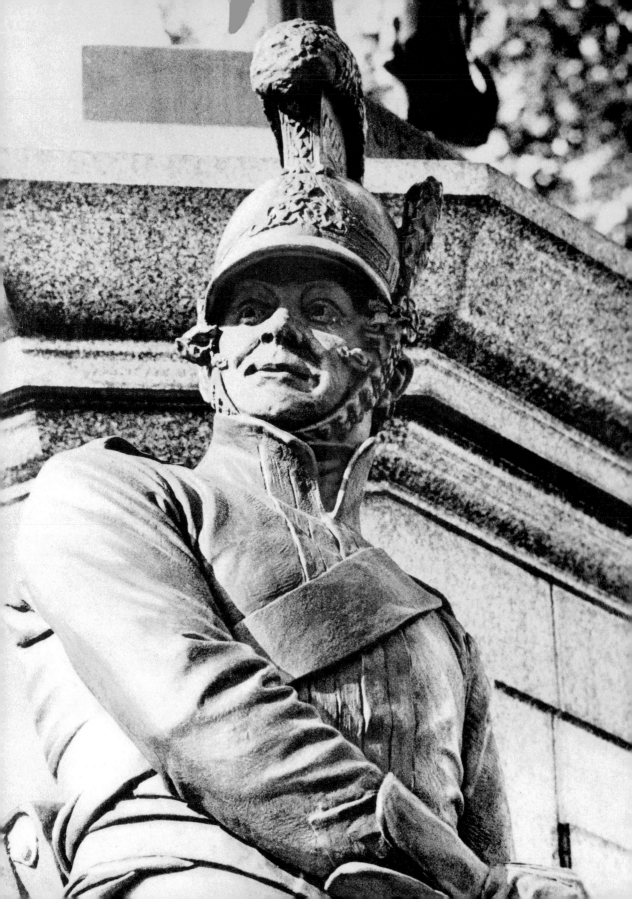

Commanders

Statues of Naval and Military commanders were not only portraits of the men themselves but memorials to their great achievements. Sculptors had to tackle the technical problems of depicting armour, horses and uniforms accurately, while at the same time portraying each commander's personality.

Some sculptors were inhibited by these technical problems, others evaded them and yet others overcame them with magnificent results. Approaches differed: Chantrey's equestrian bronze of the Duke of Wellington simplifies the dress, while Boehm's memorial to the same man excels in its representation of uniforms.

Many of these works commemorate generals who served in great European and Colonial campaigns, yet whose exploits in battles, sieges and forced marches are now almost forgotten. Others are still household names.

Detail of one of the four guardsmen on each corner of the memorial to the Duke of Wellington at Hyde Park Corner

H.R.H. Edward Augustus, Duke of Kent

1767–1820

Sculptor: S. Gahagan

Erected in Park Crescent Garden (facing Portland Place), between 1820 and 1827, 'by the supporters of the numerous charities which he so zealously and successfully patronised'.

The Duke of Kent is shown in Field-Marshal's uniform and peer's robes with the collar of the Garter. It was said that he appeared to be raising his robes in order to slip away quickly.

Edward was the fourth son of King George III and the father of Queen Victoria. He carried out such drastic reforms while Governor of Gibraltar that the troops mutinied. He was the first to abandon flogging in the British Army.

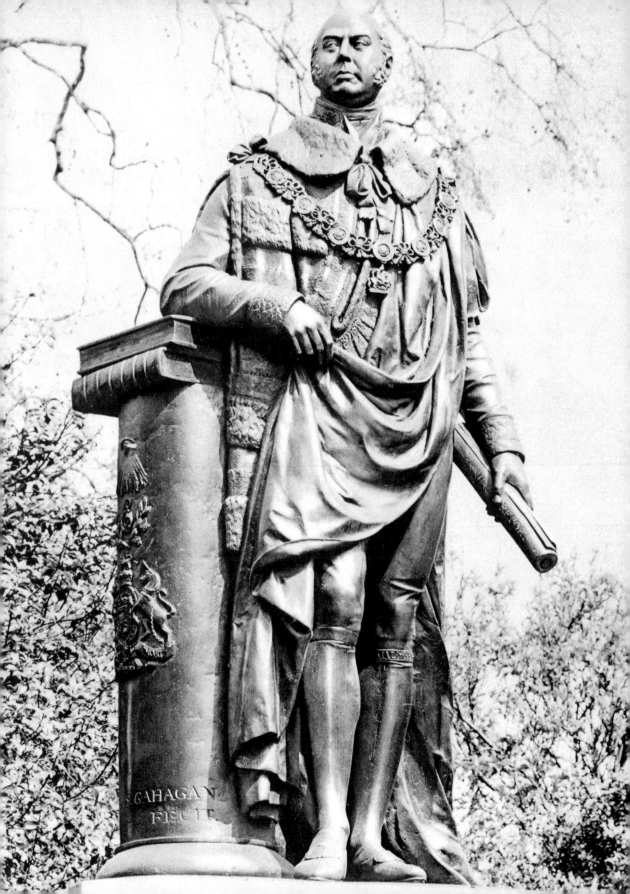

GAHAGAN
FECIT

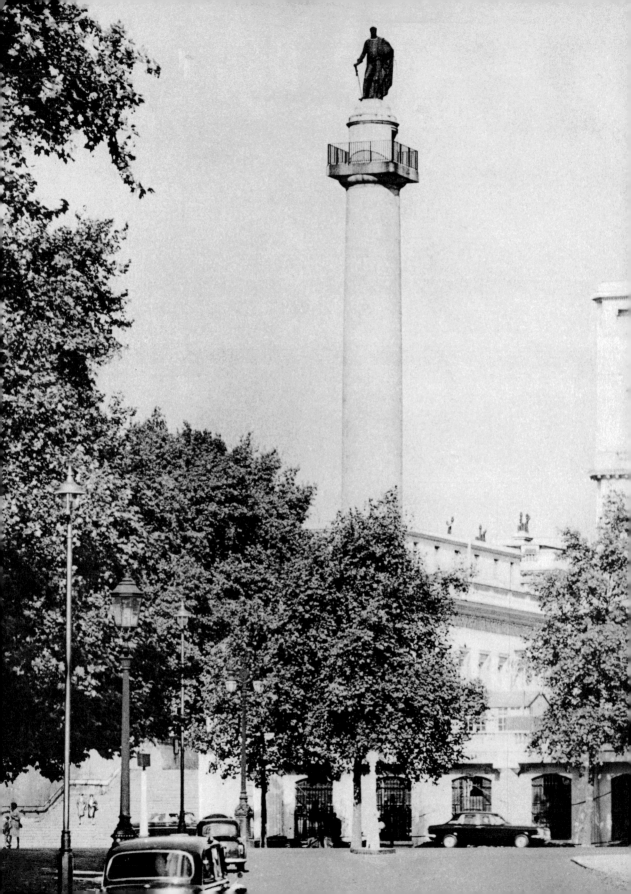

H.R.H. Frederick Augustus, Duke of York and Albany

1763–1827
Sculptor: Richard Westmacott; designed by Matthew Wyatt
Completed in 1834 and erected in Carlton House Terrace

A Tuscan column 112 feet high supports a bronze statue of the Duke of York. Little detail is distinguishable from the ground other than the folds in the large cloak. The statue was formerly crowned by a lightning conductor which led people to say that it looked like a bird-cage on top of a barge-pole. Some contemporary critics asked why the statue was placed on top of a column so that only chamber-maids in surrounding attics could see the statue, while others suggested that the Duke was elevated in order to rise above his debts. *Punch* suggested that

> Small reason have the Royal Family
> Their kinsman's position to deplore;
> He now stands higher in the public eye
> Than he ever stood before.

The Duke of York, the second son of King George III, suffered criticism because of his connection with a disastrous expedition to the Helder in 1799 (for which he was not responsible) and the scandal associated with the alleged sale of commissions by his friend, Mrs. Anne Clark, while he was Commander-in-Chief from 1798–1809.

The monument was paid for by the subscription of a day's pay from every officer and man in the Army.

Arthur Wellesley, Duke of Wellington

1769–1852

Sculptor: Designed by Chantrey and completed on his death by Henry Weekes

Erected in 1844 in front of the Royal Exchange

The statue was unveiled in the presence of the Duke in recognition of his assistance to the City of London Corporation in having a bill passed in Parliament for rebuilding London Bridge.

This equestrian bronze is similar to that of King George IV in Trafalgar Square by the same sculptor. The Duke, in the interest of simplicity, is not wearing uniform and is portrayed without boots, stirrups or saddle, sitting only on a cloth and holding a single rein. The cost was £10,000 and the bronze came from French guns captured by Wellington and given by the Government. It is one of the few statues in London unveiled in the presence of the person it commemorates.

Arthur Wellesley, Duke of Wellington, distinguished himself in a military career begun in India, which led to his successful campaigns in the Spanish Peninsula and his great victories as Commander of the British Forces over Napoleon. After his military career was over, he entered political life, and became Prime Minister in 1827.

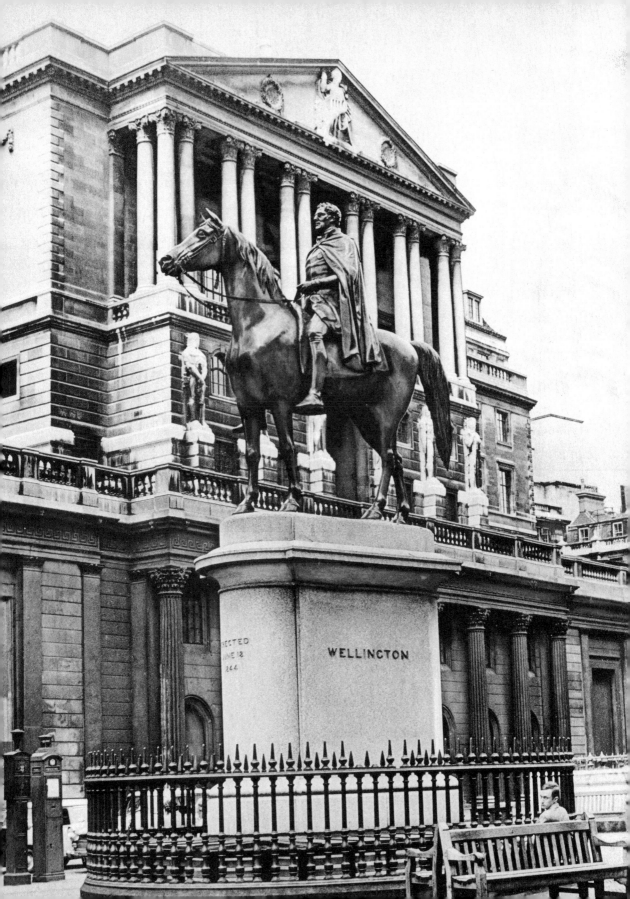

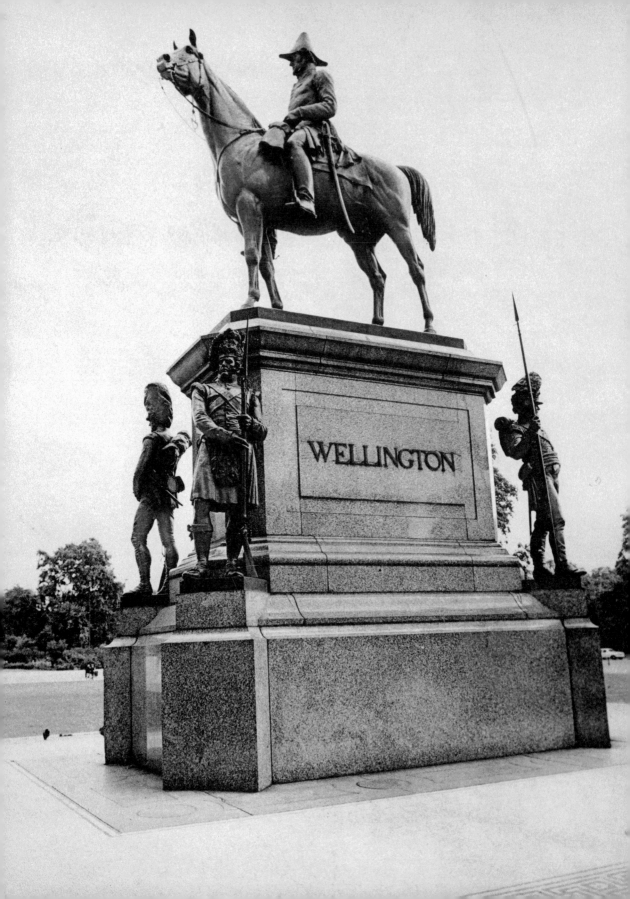

WELLINGTON

Arthur Wellesley, Duke of Wellington

1769–1852

Sculptor: Edgar Boehm, R.A.

Presented to the Duke by the nation in 1888: at Hyde Park Corner, facing Apsley House, the London home of the Duke of Wellington

The Duke is shown mounted on his favourite horse, Copenhagen. Four fine figures of guardsmen—a Grenadier, a Highlander, a Welch Fusilier, and an Inniskilling Dragoon—surround the grey granite platform. The figure of the Duke is less effective than the guardsmen, and does not portray the Duke's usual riding position sitting far back with short stirrups. The memorial was much approved of by the public although the sculptor did not care for it. It replaced a notoriously bad statue by Wyatt, which was moved from Burton's Arch to Aldershot in 1883.

Tennyson, the Poet Laureate, described Wellington in his 'Ode on the Death of the Duke of Wellington':

> Let his great example stand,
> Colossal seen of every land.
> And keep the soldiers firm, the statesmen pure,
> The path of duty be the way to glory.

Rear-Admiral Sir John Franklin

1786–1847
Sculptor: Matthew Noble
Erected in 1856 in Waterloo Place

The memorial to Sir John Franklin cost £1,950, voted by Parliament. The bronze statue stands opposite that of Captain Scott, the Antarctic explorer. Franklin, the earlier Polar explorer, lost his life in a bid to discover the North-West Passage. He is shown telling his crew that the Passage has been discovered.

It took fourteen years to solve the mystery of Franklin's movements after he disappeared searching for the North-West Passage, A log of his last journey was discovered by Captain McClintock in 1859 in a cairn at Point Victory on King William Island. Franklin's ships were last seen in Baffin Bay in July 1845, two months before they were frozen and trapped for years by ice coming through McClintock Channel. Two years later, in June, Franklin was dead with twenty-four other officers and men. The ships were not finally deserted until April 1848, when the remaining men on the expedition died attempting to walk back over the ice.

Franklin entered the Navy as a midshipman and served at Copenhagen and Trafalgar in 1801. He was knighted for his part in the Arctic Expeditions between 1818 and 1827. From 1836 to 1843 he was Governor of Tasmania.

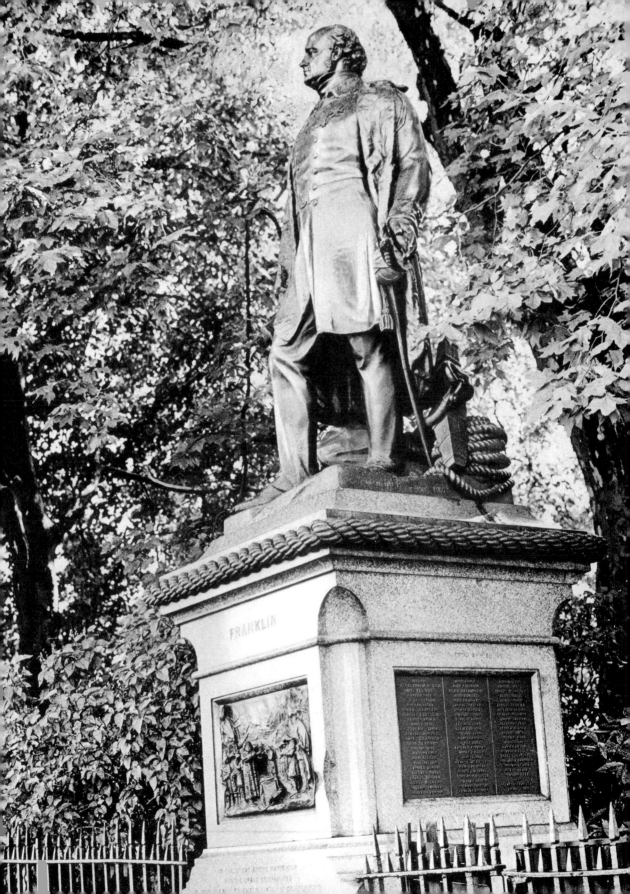

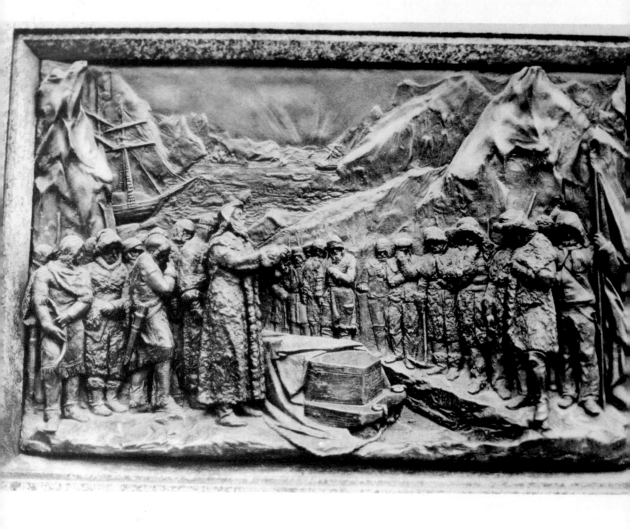

The illustration opposite shows a relief on the front of the pedestal, depicting Franklin's body being committed to the ice. A relief on the back charts the Arctic regions, giving the positions of the ships at the time of his death. Bronze panels on either side give the names of the officers and crew who died on the expedition.

Horatio Nelson, First Viscount

1758–1805

Sculptors: Statue by E. H. Baily. Monument designed by W. Railton
Bronze lions by Sir Edwin Landseer

Erected in Trafalgar Square, which was laid out to house the memorial

Lord Nelson's column was designed in 1839 but the project was not completed till 1867, when the four large lions were added to the base. The fluted Devon granite column (which has been called 'a Roman candle') is a stylobate based on a Corinthian column of the temple to Mars Ultor in Rome. The total height in the original design was 203 feet high but it was reduced to 170 feet 6 inches in the interests of public safety. The statue itself is 16 feet high and weighs 16 tons, made from 3 pieces of stone from the Buccleuch Estate in Scotland.

The Admiral is portrayed in full-dress uniform standing beside a capstan. The bronze capital is cast from guns recovered from the *Royal George*, and the four great bronze panels on the base were cast from captured French cannon. These panels represent:

1. On the north side, the battle of the Nile by W. F. Woodington shows Nelson wounded in the head refusing special treatment from the surgeon. 'No, I will take my turn with my brave fellows.'

2. On the east side, Nelson sealing a dispatch in the Battle of Copenhagen. By J. Termouth.

3. On the west side, Nelson receiving the sword of the defeated Spanish Admiral in the Battle of St. Vincent. By M. C. Watson.

4. On the south side, the death of Nelson by J. E. Carew.

The lions by Landseer are 20 feet long and 11 feet high on their granite pedestals. Only two were modelled—the other two are replicas—as the heads and tails turn different ways.

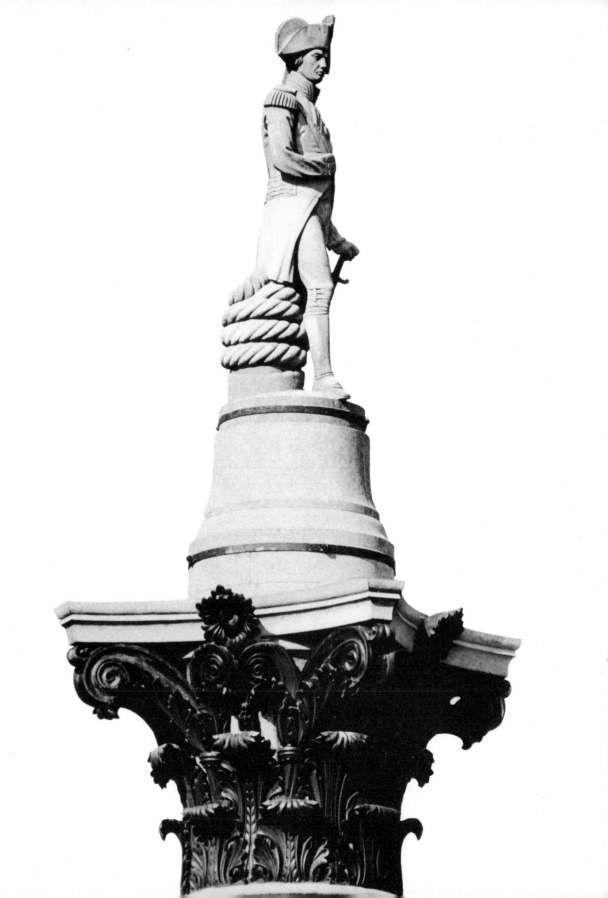

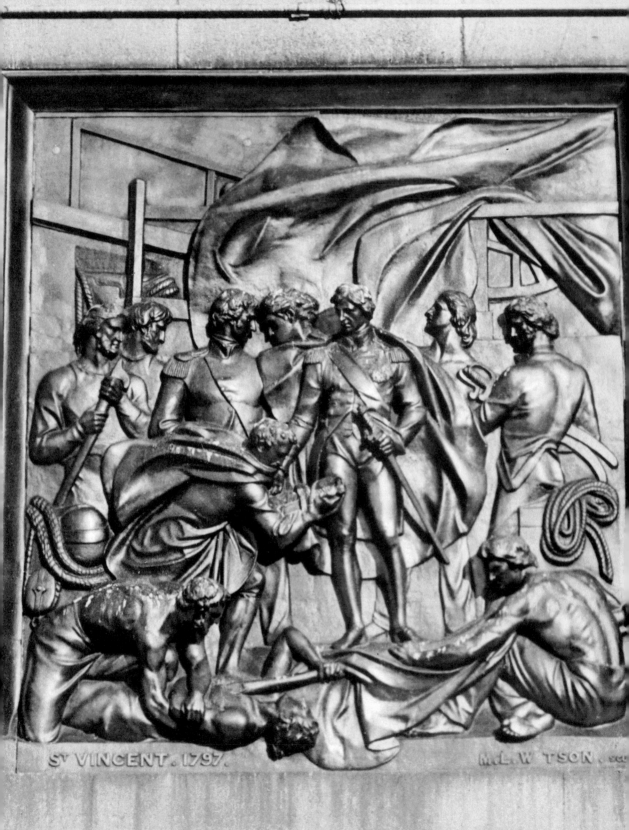

ST VINCENT. 1797. M. L. WATSON.

The total cost of the monument was £47,500, including £18,000 for the lions. £20,000 was raised by public subscription, the remainder by Parliament.

The monument is decorated on Trafalgar Day, 21 October, each year. Its base is often used as a platform for public meetings. The public usually gathers here on great occasions, and the cracks in the granite base were caused by bonfires lit by Australian troops on the night of Armistice Day in 1918.

The unusual combination of a statue on top of a column and lions 'couchant' was chosen to commemorate Lord Nelson's great naval victories. After Copenhagen in 1801, when Nelson destroyed the Danish ships and batteries, he was created a Viscount. His last engagement took place off Cape Trafalgar in 1805; he was wounded by a bullet and died on board his flag ship *Victory*. He is buried in St. Paul's Cathedral, and his funeral carriage can still be seen in the crypt there.

Field-Marshal Lord Clyde

1792–1863
Sculptor: Carlo Marochetti
Erected in 1867 in Waterloo Place

Lord Clyde, the man who suppressed the Indian Mutiny, is shown holding his helmet in his left hand, his right thumb hooked in his telescope strap, and standing on a red granite pillar. Britannia, holding an olive branch, sits on the back of a lion at the foot of the pedestal.

The monument is a fine example of a Victorian period piece and forms a pair with Sir John Franklin on the opposite side of Waterloo Place.

Lord Clyde, known as 'Old Careful' by his men, held the Chief Command during the Indian Mutiny in 1857–8. He relieved Havelock and Outram at Lucknow and crushed the rebellion. Clyde was the son of a Scottish cabinet-maker who rose to the rank of Field-Marshal and was created a baron. He served in Spain under Wellington, in North China, in the Second Sikh War and commanded the Highland Brigade in the Crimean War.

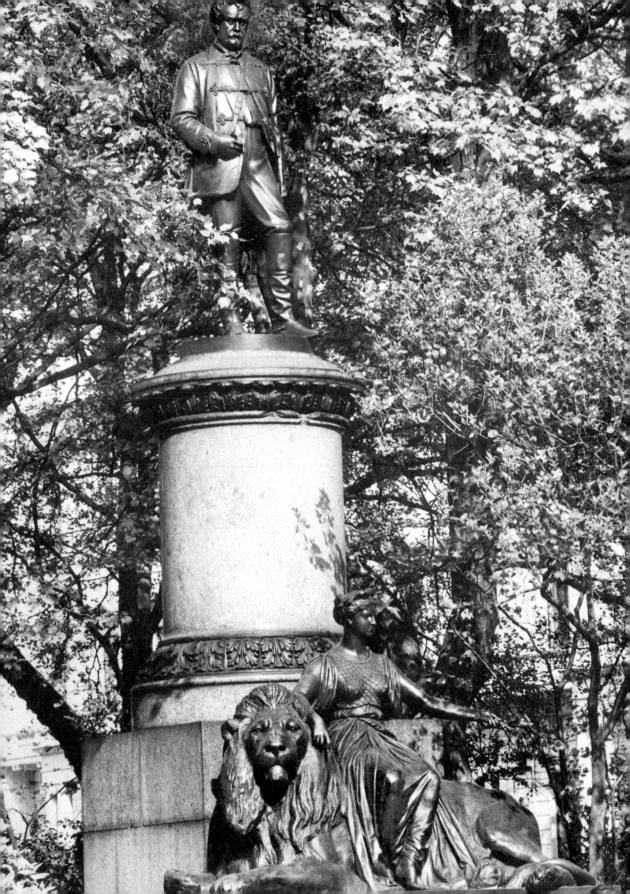

General Sir James Outram

1803–1863

Sculptor: Matthew Noble

Unveiled in New Victoria Embankment Gardens in 1871

Outram is dressed in uniform frock-coat, and although his sword hangs incorrectly the silhouette of the figure is striking. At the four corners of the stone pedestal are trophies of Indian Arms.

In Afghanistan, Outram was present at the capture of Ghazni, but he escaped disguised as a native and rode 350 miles to Karachi. Later, in the Indian Mutiny, he joined Havelock with reinforcements at Cawnpore and fought under him until the siege of Lucknow was relieved two months later by Sir Colin Campbell (Lord Clyde). Outram received a baronetcy and is buried in Westminster Abbey.

There is a bronze statue to Sir Henry Havelock by William Behnes in Trafalgar Square. Havelock died of dysentery a week after Lucknow was relieved. His statue was erected in 1861 with the inscription:

> Soldiers, your labours, your privations, your sufferings and your valour will not be forgotten by a grateful country.
>
> H. Havelock

Gordon of Khartoum

1833–1885
Sculptor: Hamo Thornycroft
Unveiled in 1888 on the Victoria Embankment

The sculptor used an unconventional pose for this bronze figure of Gordon of Khartoum, which is one of the most successful portrait statues of the Victorian period. Gordon is wearing informal patrol clothing, and is standing with a foot on a broken mortar. The statue's base and the pedestal are decorated with typical Victorian bronze reliefs including Charity, Justice, Faith and Fortitude.

Gordon served in the Crimean War, in China and in Egypt. In 1884 he was sent by the British Government to withdraw the garrisons held in the Sudan. He was held in siege in Khartoum and defended the city for ten months, before being killed two days before the relief force came in sight of the city, in January 1885.

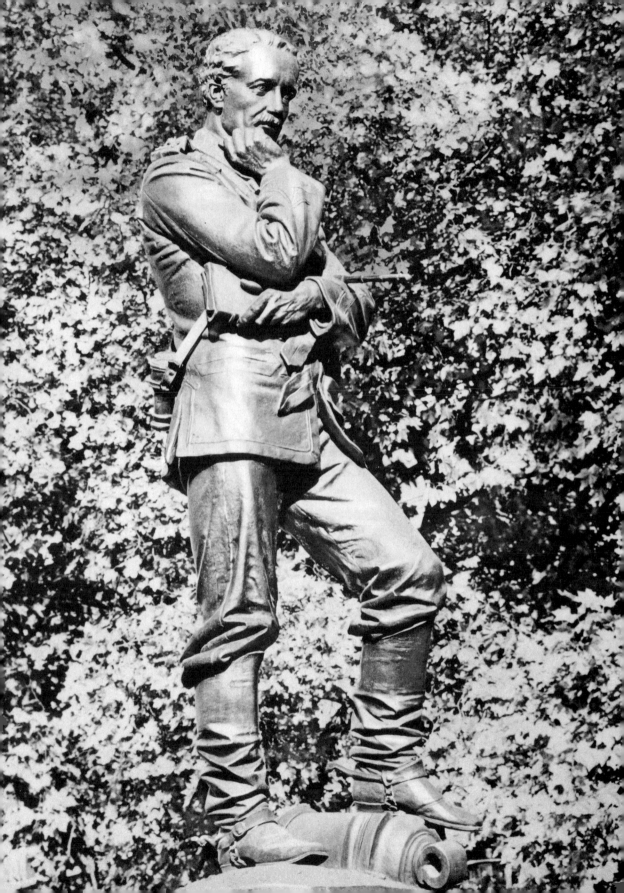

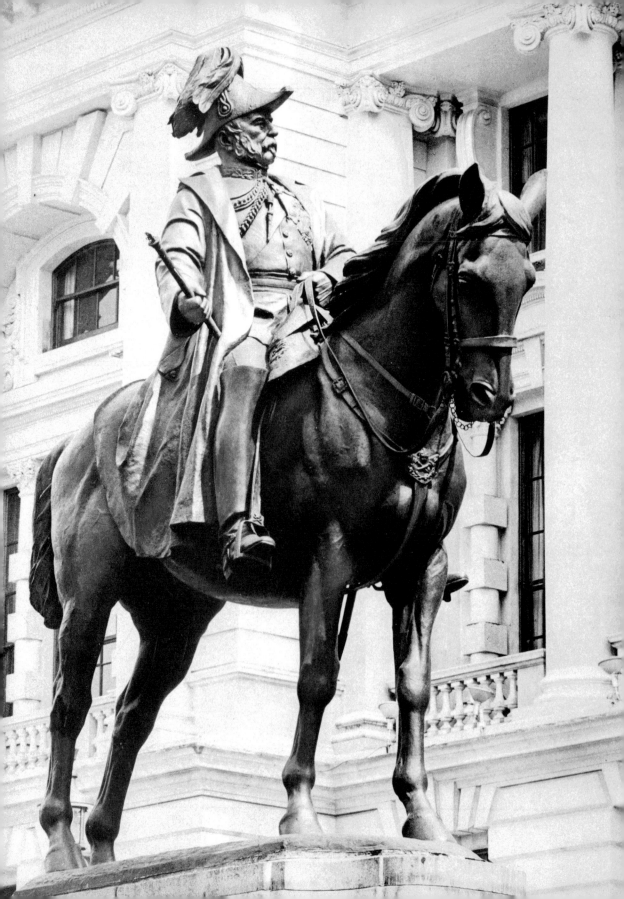

Field-Marshal H.R.H. The Duke of Cambridge

1819–1904
Sculptor: Adrian Jones
Unveiled in 1907 outside the War Office in Whitehall

The portrayal of movement is so effective in this equestrian bronze that it appears to swagger down Whitehall on top of the traffic! Adrian Jones was a Veterinary Captain in the 3rd Hussars, and used his special knowledge of horses in his realistic sculpture. Two bronze reliefs on the pedestal, representing men of the 17th Lancers and Grenadier Guards, are by John Belcher. The Duke of Cambridge was Colonel-in-Chief of both Regiments.

At the Battle of Alma in the Crimean War the Duke led a division of Guards and Highlanders, but later at Inkerman he had his horse shot under him and was slightly wounded.

The Duke of Cambridge was the grandson of King George III and Commander-in-Chief of the British Army, 1856–95. He is remembered for the remark: 'All change is for the worst.'

Captain Cook

1728–1779

Sculptor: Thomas Brock

Unveiled by H.R.H. Prince Arthur of Connaught on behalf of the British Empire League on 7 July 1914, outside the Admiralty, at the east end of the Mall

Captain Cook, in naval uniform, stands in front of a capstan with a telescope in his right hand and his left hand holding a scroll. The pedestal bears the inscription 'Circumnavigator of the globe, Explorer of the Pacific Ocean, he laid the foundation of the British Empire in Australia and New Zealand'.

In 1768 Captain Cook set out as Lieutenant in command of the *Endeavour* in an expedition to the Pacific to observe an eclipse of the Planet Venus. He circumnavigated New Zealand and surveyed the east coast of Australia. He continued westward, rounded the Cape of Good Hope and reached England after nearly three years at sea. For this achievement he was promoted to the rank of Commander.

In 1776 he went again to the Pacific in search of a north-west passage. He discovered the Sandwich Islands in 1778 and was killed by the natives of Hawaii on 14 February 1779. In 1874 an obelisk was erected on the spot where he fell. Cook's statue was erected over a hundred years after his death, at a time when England was becoming more conscious of the part he had played in the foundation of the Empire.

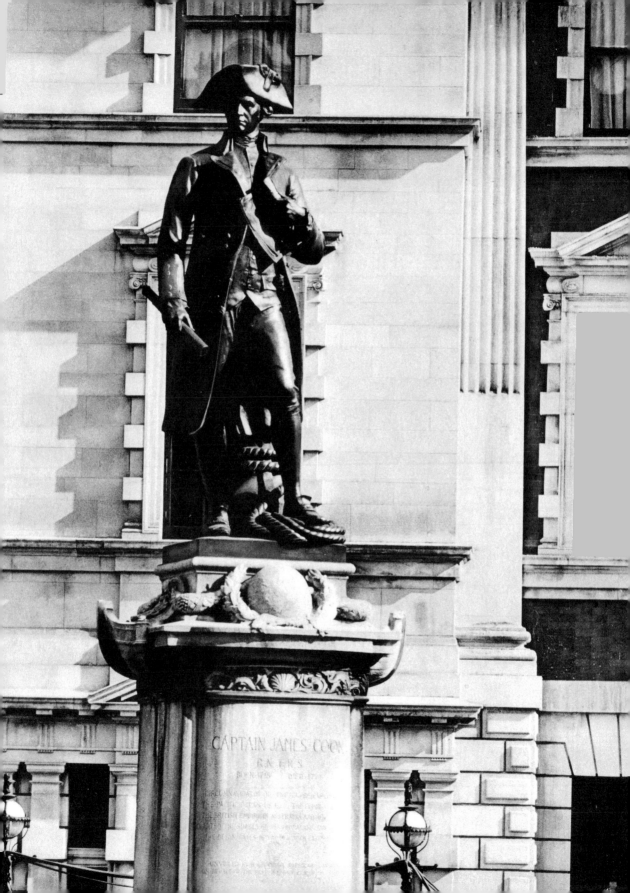

CAPTAIN JAMES COOK
R.N. F.R.S.

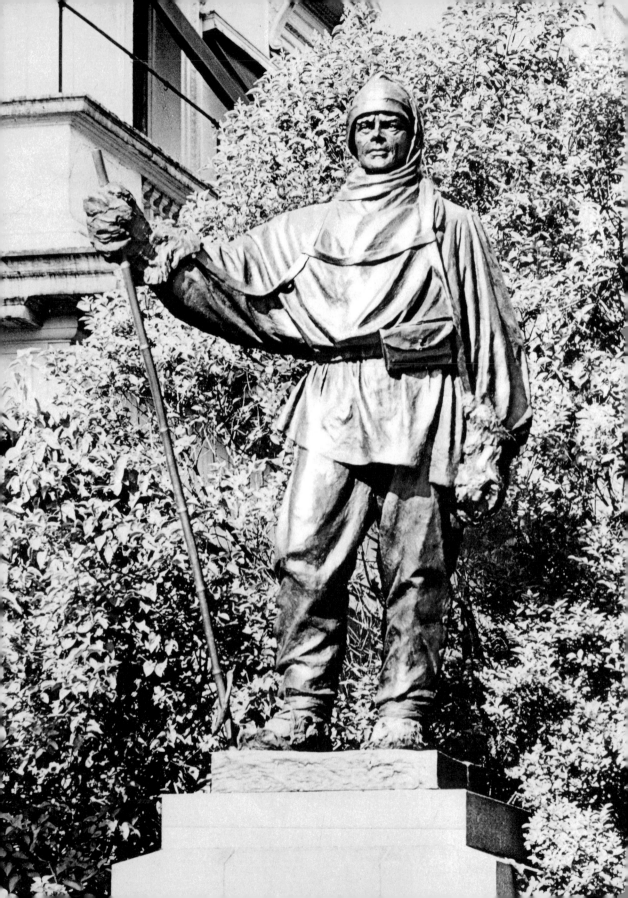

Captain Scott

1868–1912
Sculptor: Lady Scott
Erected in Waterloo Place in 1915

A rugged bronze figure subscribed by officers of the Royal Navy portrays Captain Scott wearing his polar kit, a loose garment of gaberdine, and holding a ski-ing stick in his right hand.

The pedestal bears these words from the last entry in his diary:

> Had we lived I should have had a tale to tell of the hardihood, endurance and courage of my companions, which would have stirred the hearts of Englishmen. These rough notes and our bodies must tell the tale.

Captain Scott commanded the National Antarctic Expedition. He sailed in the *Discovery* to the Antarctic in 1901 and returned in 1904, having established the true position of the South Pole. For this achievement he was created Captain and Commander of the Victorian Order. He commanded a second Antarctic Expedition in 1912, only to find, on reaching the South Pole, that Roald Amundsen had preceded him a month before. On the return journey Scott and his party died in a blizzard.

Clive of India

1725–1774
Sculptor: John Tweed
Erected in 1916 in King Charles Street, near the former India Office

Clive is portrayed in a strong natural pose, on a stone pedestal decorated with bas-reliefs depicting his India campaigns.

Clive originally went to India as a clerk in the East India Company. Later he marched in the Company forces upon Arcot, the capital of the Carnatic. He took the town, withheld a siege of fifty days, put the enemy to rout, broke the power of the French and became master of the region. In 1757 he defeated Suraj-ud-Dowlah, the Nawab of Bengal, after the infamous outrage of the Black Hole of Calcutta. Clive was given a peerage and became Governor-General of Bengal.

Later he was accused of abusing his power, in a debate in the House of Commons, and although no censure was carried, he committed suicide. The statue was not cast until 1912 and was erected 138 years after his death.

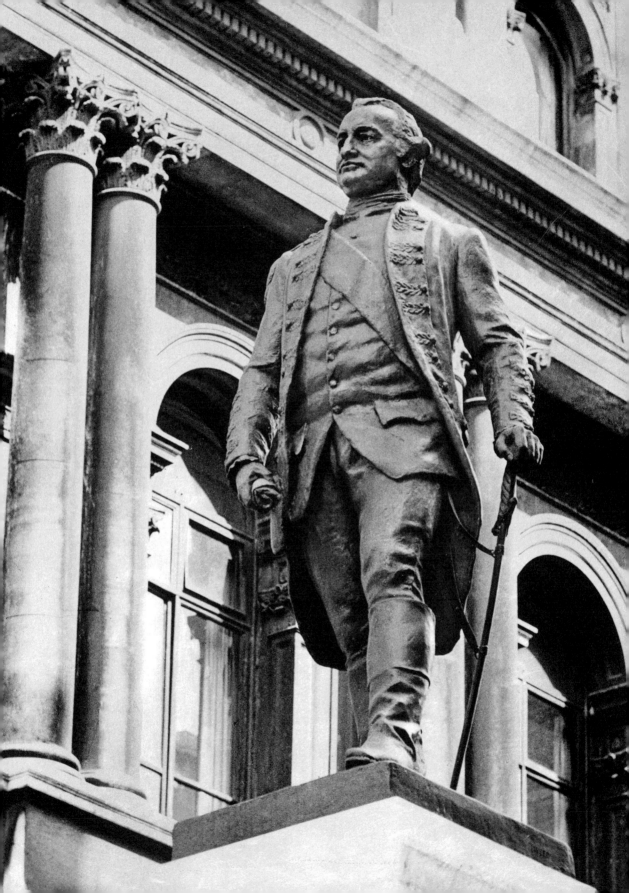

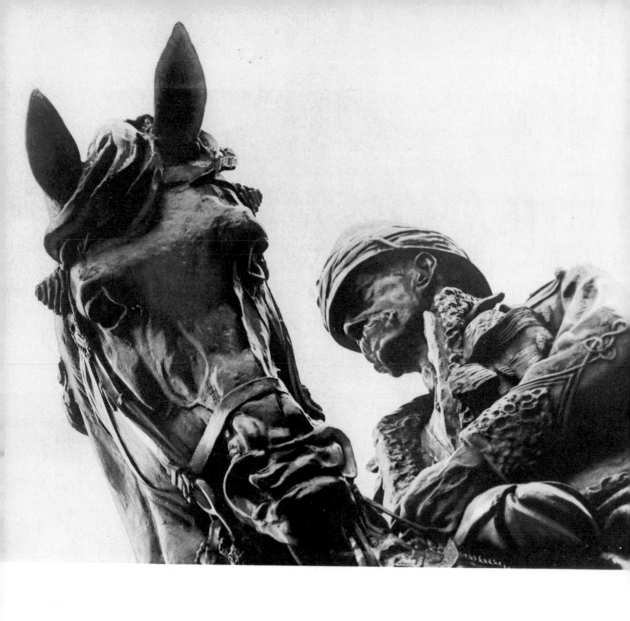

Field-Marshal Earl Roberts

1833–1914
Sculptor: Harry Bates
Erected in 1924 in Horse Guards Parade

A smaller replica of the great bronze in Calcutta shows the Field-Marshal wearing Indian field-kit, sun helmet and poshteen, and holding back his Arab charger. The statue was erected by Parliament.

Roberts was present at the siege of Delhi and the relief of Lucknow. He also won the Victoria Cross. In 1880 he captured Kabul and marched to the relief of Kandahar, covering 312 miles in twenty-two days. He became Commander-in-Chief in India, and later in Ireland, and finally Commander-in-Chief of the British Army 1900–04. Created a Baron and Earl Roberts of Kandahar, in 1897 he published his book *Forty-One Years in India*.

Field-Marshal Earl Kitchener

1850–1916

Sculptor: John Tweed

Unveiled in 1926 by the Prince of Wales in Horse Guards Parade

A bronze figure of Kitchener shows him standing bareheaded in plain khaki uniform, in an attitude of deep thought. The profile is said to be a good likeness of the Field-Marshal.

Kitchener commanded the Khartoum Expedition in 1898, and in the Boer War of 1899–1900 he was Chief-of-Staff to Lord Roberts. Later he was Commander-in-Chief in India. He was created Earl of Khartoum and Aspall in 1914. Kitchener died when the cruiser *Hampshire* was sunk after hitting a German mine in 1916.

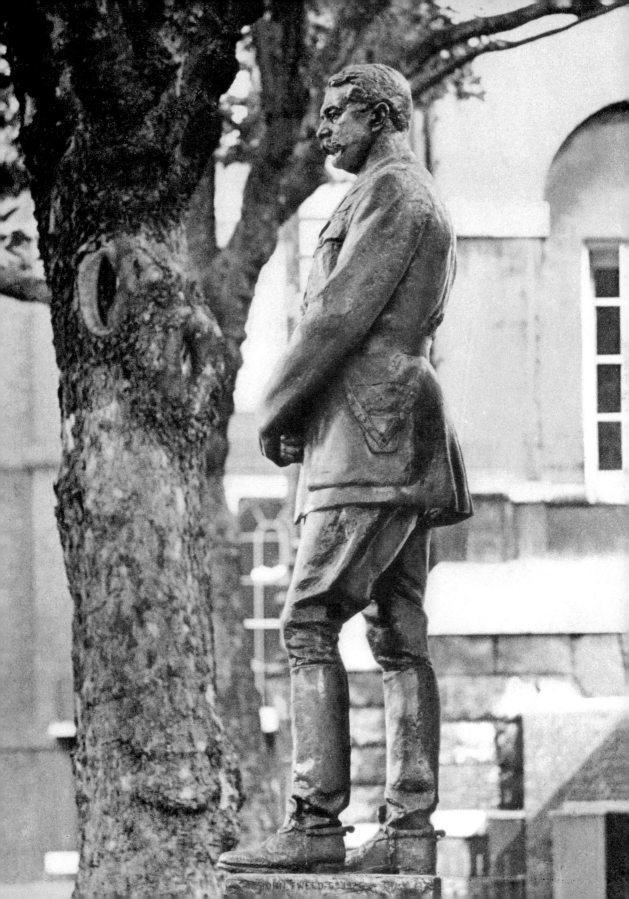

Arts

People distinguished in the arts gave the commemorative sculptors great opportunities. They were able to use so many symbols of the subject's talent, and books, scrolls, musical instruments and costumes all proliferate, as well as simple portrait figures and busts.

Detail of mask, lyre and music score from the base of the memorial to Sir Arthur Sullivan

William Hogarth

1697–1764

Sculptor: J. Durham

Placed in the south east corner of Leicester Square Gardens when they were laid out in 1874

The sculptor based this fine marble bust on the 18th century original by Roubiliac in the National Portrait Gallery. The copy has some of the vitality of the original.

Hogarth's works include the satirical series *Marriage à la Mode*, now in the National Gallery, and *The Rake's Progress* and *The Election* both in the Soane Museum.

Other busts in Leicester Square are of Sir Isaac Newton, John Hunter, the surgeon, and Sir Joshua Reynolds, all of whom lived nearby.

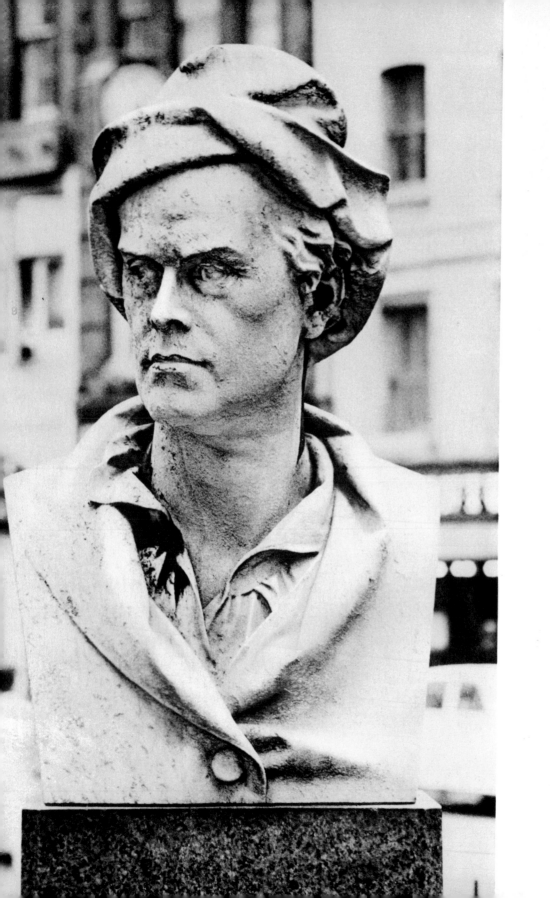

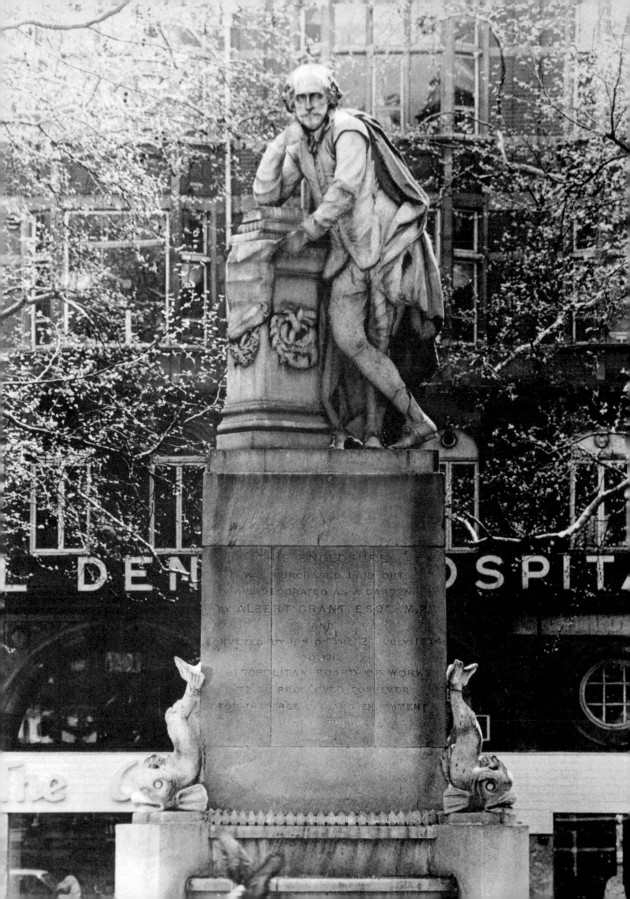

William Shakespeare

1564–1616

Sculptor: Fontana, after Scheemakers

Placed in Leicester Square Gardens when they were laid out in 1874

The white marble figure of Shakespeare, standing on a base designed by John Knowles, is a copy by Fontana of Scheemakers's 1740 memorial to the playwright in Westminster Abbey. Shakespeare is leaning on three books, pointing to a scroll on which is engraved:

There is no darkness but ignorance

The original baroque design for Scheemakers's statue was attributed to William Kent. Shakespeare is shown in costume that is vaguely Elizabethan, although his tight breeches were not fashionable at the time of his death. Scheemakers in turn used as his model the portrait in the National Portrait Gallery because it was thought to have been painted by Shakespeare's fellow-actor, Richard Burbage.

John Stuart Mill

1806–1873
Sculptor: Thomas Woolner
Erected in 1878 in Victoria Embankment Gardens

The famous philosopher is portrayed in bronze. He rises from a stool placed on a low pedestal. The life-like image is easily visible, in contrast to many other figures in the Embankment Gardens which are difficult to see because their pedestals are too high.

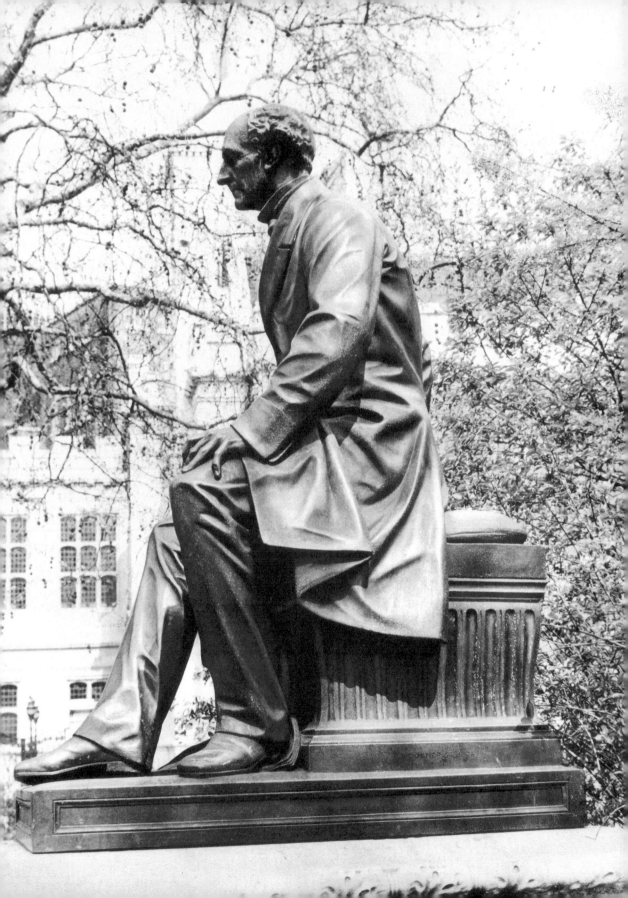

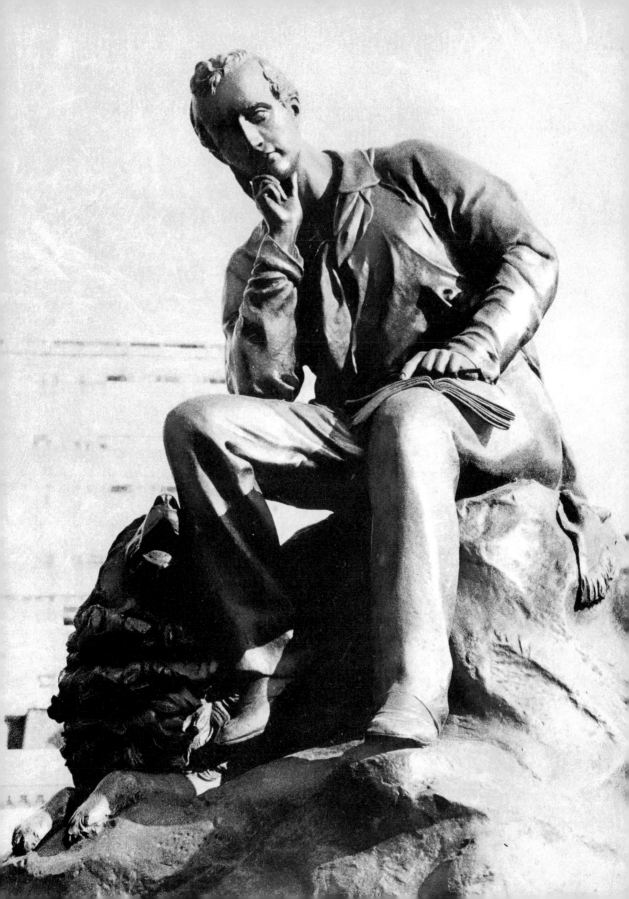

Lord Byron

1788–1824
Sculptor: Richard Belt
Unveiled in 1880 in Park Lane on a site which has now become a traffic-island

This bronze group is an unsatisfactory representation of Lord Byron with a dog.

His friend Trelawney stated: 'It does not in the remotest degree resemble Byron either in face or figure.'

The bronze is mounted on a red granite base supplied by the Greek Government. The public subscribed the cost of £3,500 for the statue, which was unveiled by Lord Houghton in 1880.

In the competition held for this statue, Rodin (who greatly admired the poet) was an entrant. One cannot help speculating on how much more distinguished his statue must have been, and wondering what led to its rejection.

Thomas Carlyle

1795–1881
Sculptor: Edgar Boehm
Unveiled in 1882 by Professor Tyndall in Chelsea Embankment Gardens

The well-made bronze figure portrays Carlyle seated in an armchair deep in thought, with a pile of books underneath his chair.

Carlyle lived nearby in 24 Cheyne Row. A marble medallion in profile, designed by Voysey, commemorates the house. Carlyle's reputation was made in 1837 with the publication of his work on the French Revolution. He also spent thirteen years working on a history of Frederick II of Prussia, *Frederick the Great*.

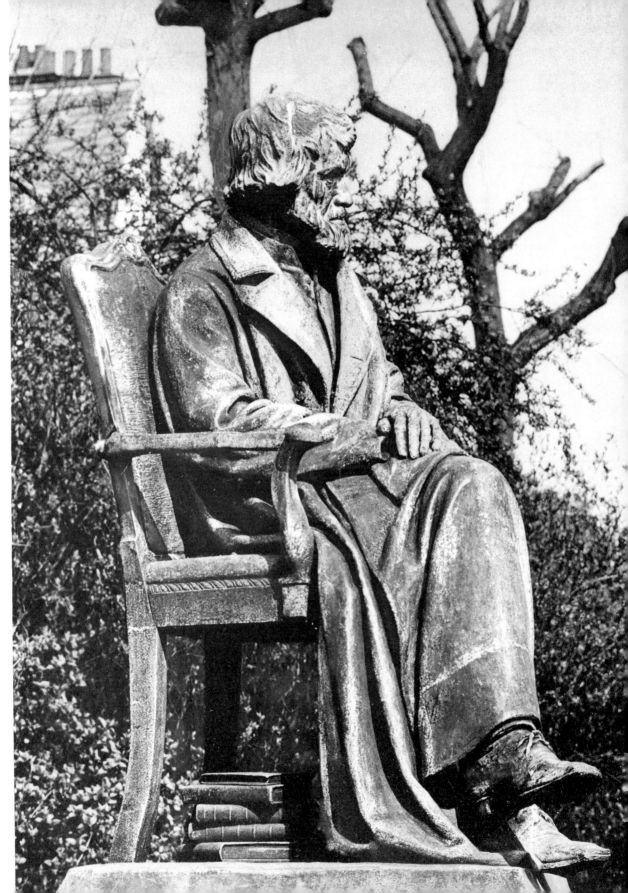

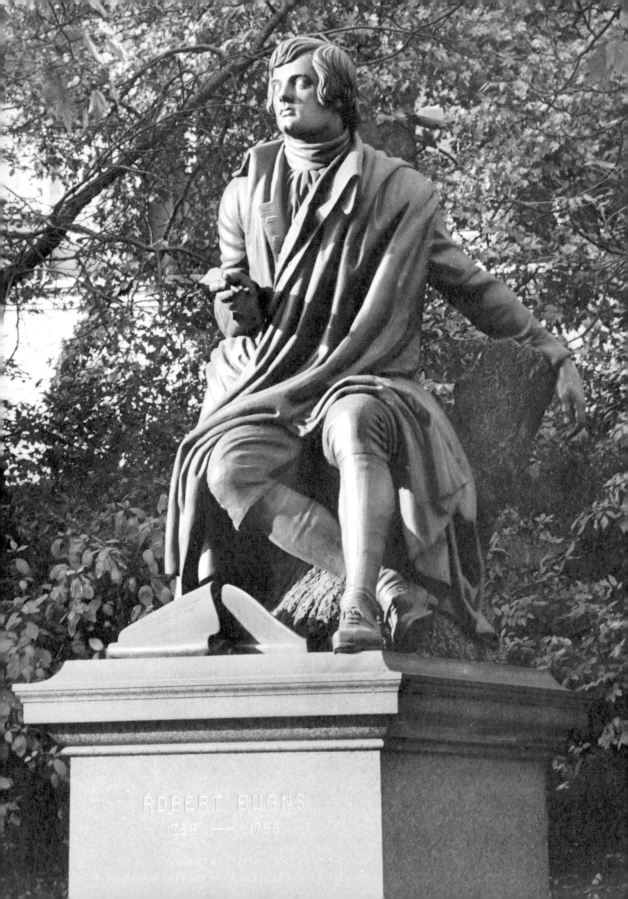

ROBERT BURNS
1759 — 1796

Robert Burns

1759–1796
Sculptor: John Steel
Unveiled by Lord Rosebery in 1884 in Victoria Embankment Gardens. Presented by Mr. John Gordon Crawford

A smooth, over-life-size figure of the poet shows him seated on a tree-stump. A scroll and a broken ploughshare are at his feet and an inscription on the granite pedestal tells in Burns's own words how the Muse inspired him while he was ploughing.

David Daiches describes him in his biography as 'this brilliant and troubled peasant, assaulted on all sides by old traditions and new gospels, who almost single-handed created a glorious Indian Summer for native Scottish Literature. . . .'

> In sober moods, I am a priest;
> A hero when I's tipsy, O;
> But I'm a king and everything,
> When wi' a wanton Gipsy, O.

Sarah Siddons

1755–1831

Sculptor: Leon Chavalliaud

Unveiled in 1897 on Paddington Green by Sir Henry Irving

The memorial to the great actress is a nostalgic white marble statue placed near the cemetery where she is buried. Sarah Siddons is portrayed as the Tragic Muse, wearing classical dress and holding a dagger. The statue is thought to be based on a portrait by Sir Joshua Reynolds in the National Portrait Gallery.

Sarah Siddons was regarded as the greatest tragic actress on the English stage—a position which she held unrivalled for thirty years. She acquired an ample fortune on which she retired in 1812.

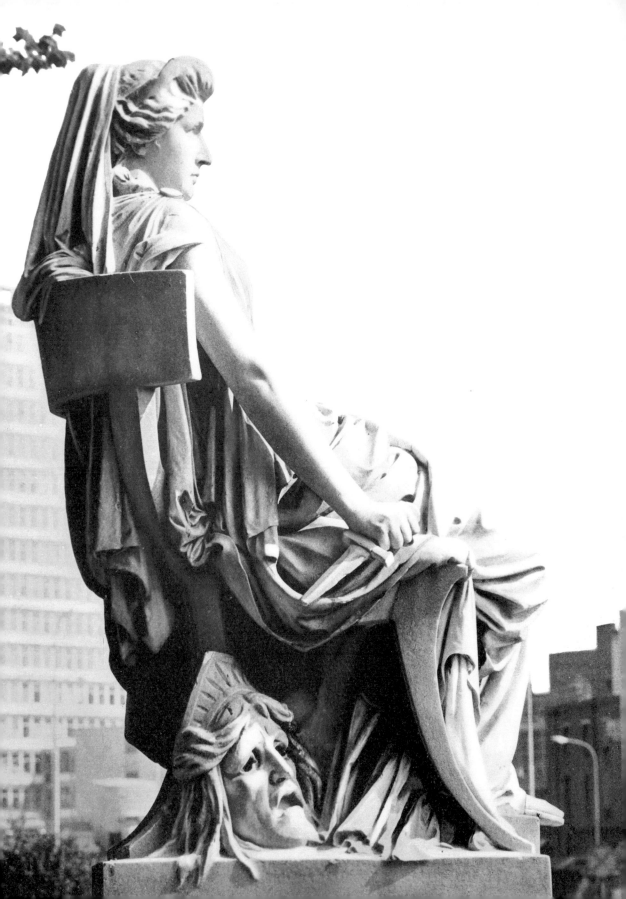

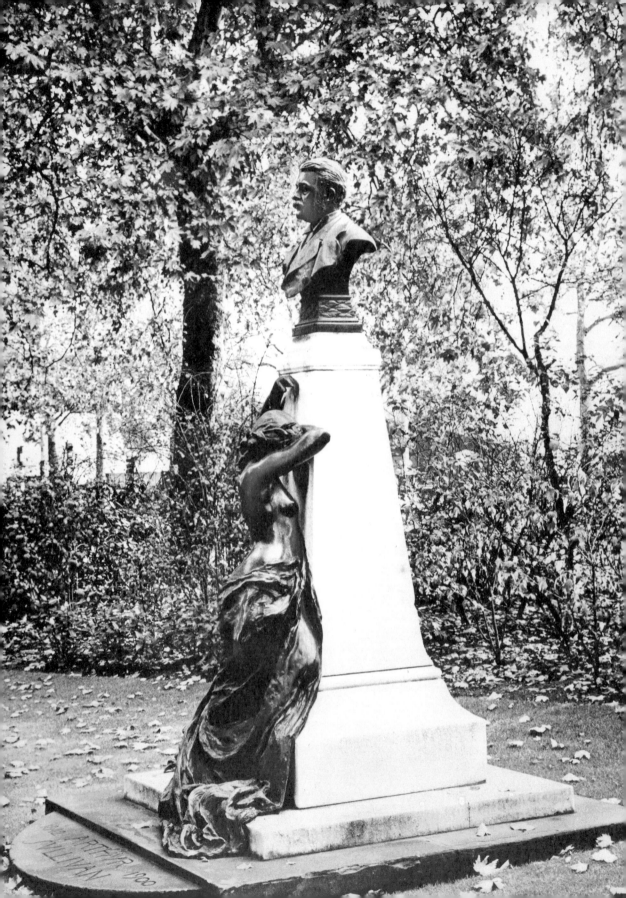

Sir Arthur Sullivan

1842–1903
Sculptor: W. Goscombe John
Unveiled in 1903 in Victoria Embankment Gardens by H.R.H. Princess Louise

A weeping figure of Music clings to the tall white pillar on which stands the bust of Sir Arthur Sullivan. John was commissioned to do only the bust but added the figure and detail at the base, a mask, open score and a lyre in bronze (see page 146).

Sullivan wrote church music, songs and oratorios but is best known for the series of light operas in which he collaborated with W. S. Gilbert. Gilbert is also commemorated on the Embankment by a bronze bas-relief by George Frampton. It bears the inscription:

His foe was Folly, and his weapon Wit.

Onslow Ford

1852–1901

Sculptor: A. C. Lucchesi and Onslow Ford himself

Erected by his friends in 1903 at the corner of Abbey Road and Grove End Road

The complete monument was designed by J. W. Simpson and includes a bronze replica of Onslow Ford's own figure of the Muse from the base of the Shelley Memorial at Oxford—a small figure listening to the harp. The monument also includes a medallion portrait of the sculptor by A. C. Lucchesi. It is the only monument to a sculptor in London, so it is appropriate that it includes Ford's own work.

Ford was a late Victorian academic sculptor who first exhibited at the Royal Academy in 1875.

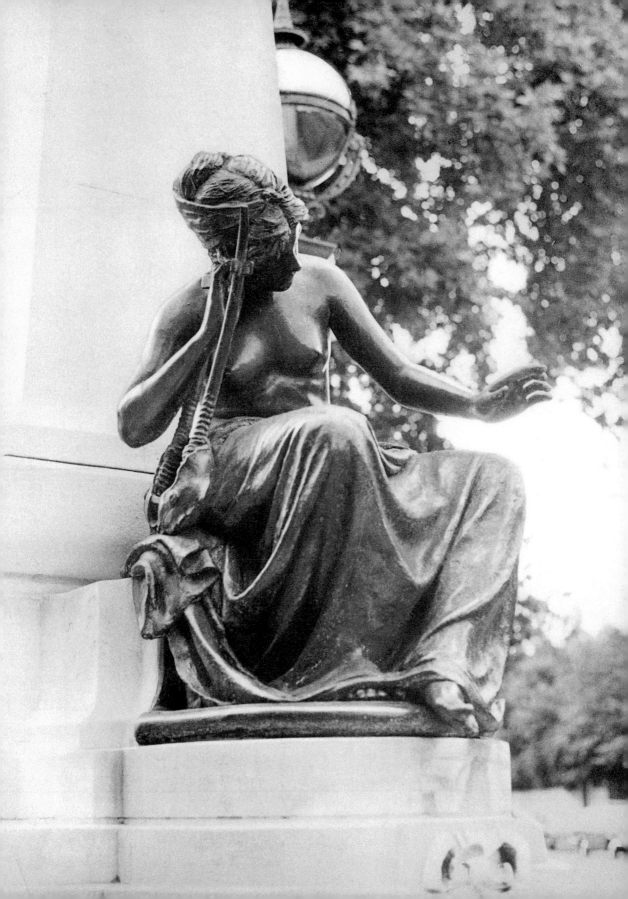

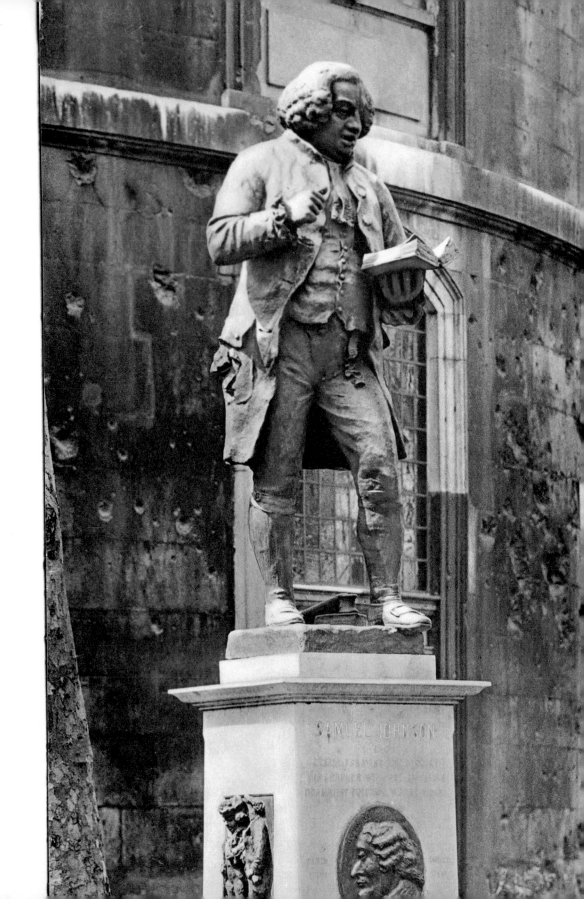

Dr. Samuel Johnson

1709–1784

Sculptor: Percy Fitzgerald

Fitzgerald presented the statue to the Rector of St. Clement's Dane who erected it in 1910 behind the church facing Fleet Street

The over-life-size bronze shows Dr. Johnson wearing a bob-wig; it is mounted on a pedestal of black Belgian granite. A medallion of Johnson's biographer, Boswell, and two scenes from the Doctor's life decorate the pedestal, which is inscribed:

> Samuel Johnson, L.L.D.; Critic, Essayist, Philologist, Biographer, Wit, Poet, Moralist, Dramatist, Political Writer and Talker.

Although the face of the statue is life-like, the figure fails to represent Johnson's size or awkwardness.

Johnson lived nearby and used to attend services in St. Clement's Dane. He died at the age of seventy-six and is buried in Westminster Abbey alongside the poets whose lives he recorded.

Sir Henry Irving

1838–1905

Sculptor: Sir Thomas Brock

Erected in Charing Cross Road by English actors and actresses and those connected with the theatre in this country and unveiled by John Hare on 5 December 1910

Sir Henry Irving is the only actor represented by a statue in London. The finely modelled bronze figure portrays him wearing the gown of a Doctor of Literature.

Irving was associated with the theatre for over thirty years. He is buried in Westminster Abbey.

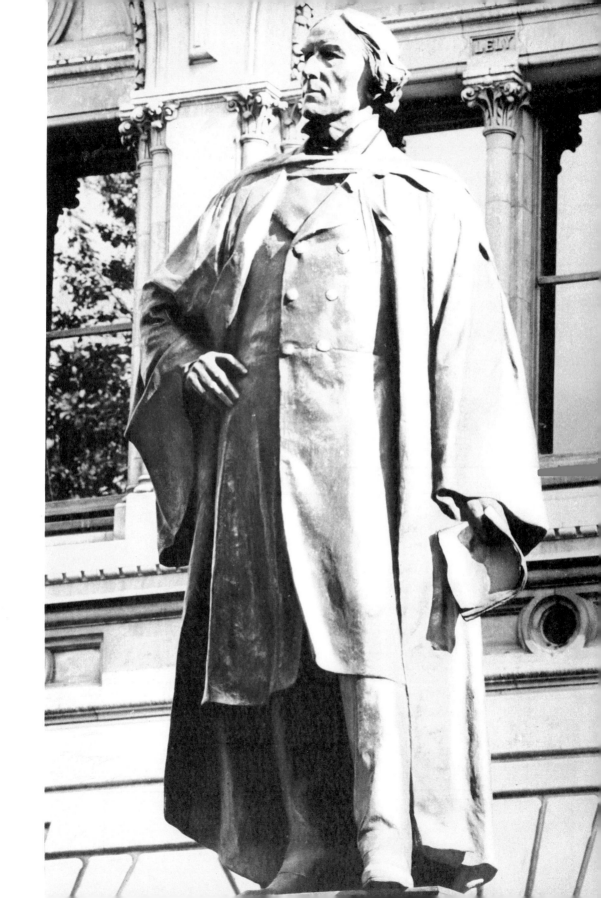

Public Service

Memorials which commemorate the lives of people whose social achievements made them outstanding usually emphasise themes of love. The results can be amusing, like the statue of a little girl erected to the memory of Lady Henry Somerset, or slightly ridiculous as in the use of symbolism on the monument to Edith Cavell. A most delightful example of this genre is the memorial to Mrs. Ramsay MacDonald.

Detail of a sculpture from the Memorial Seat to Mrs. Ramsay MacDonald

Sir Hans Sloane

1660–1753

Sculptor: Michael Rysbrack

Erected in 1737 in the Apothecaries Garden, Chelsea

An interesting white marble figure represents Sloane in full-bottomed wig and doctor's gown.

Sloane was a physician and the owner of the Manor of Chelsea. He gave the garden to the Apothecaries Society on the condition that 2,000 botanical specimens, dried and preserved, were sent in yearly instalments of fifty to the Royal Society, of which he was President.

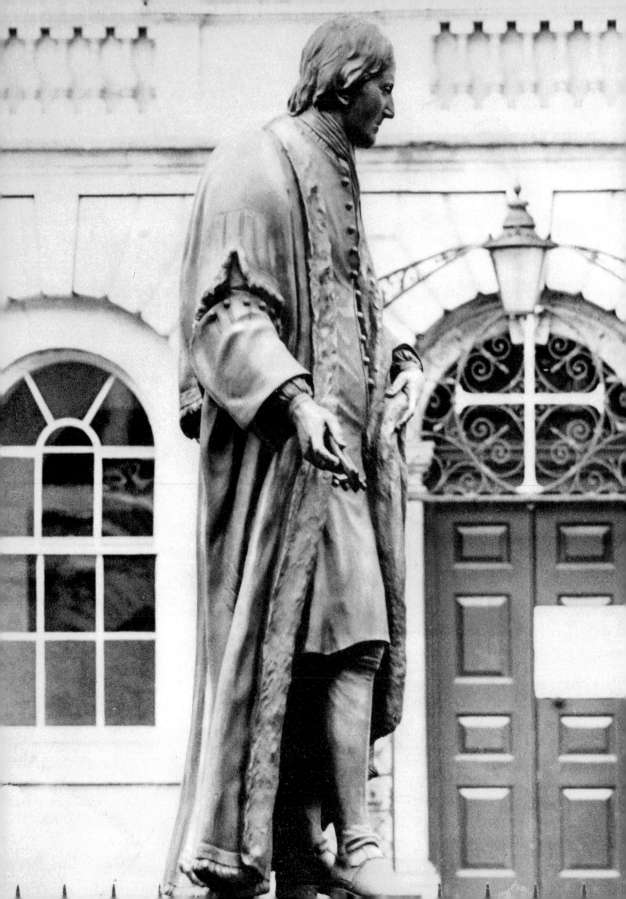

Thomas Guy

1644–1724
Sculptor: Peter Scheemakers
Erected in Guy's Hospital forecourt in 1734

The founder of Guy's Hospital is represented by a bronze figure wearing a livery gown with a small scroll in his right hand. Round the low stone pedestal are bas-reliefs of Christ healing the sick and of the Good Samaritan. The pedestal also bears Guy's motto:

Dare quam accipere

Thomas Guy was M.P. for Tamworth (1695–1707). He acquired a large fortune dealing in South Sea stock with which he founded the hospital, built almshouses and supported various charities.

Edward Jenner

1749–1823
Sculptor: W. Calder-Marshall
Erected in 1862 in Kensington Gardens at the head-waters of the Serpentine

The man who discovered vaccination is portrayed by a seated bronze figure, originally erected in Trafalgar Square, adjacent to the College of Physicians, in 1858. Its new position was undecided for some time and a contemporary poem in *Punch* ended:

> 'I saved you many million spots
> And now you grudge one spot to me'

Punch also asked the question: 'Surely the inventor of vaccination has the best possible right to make experiments on various spots?'

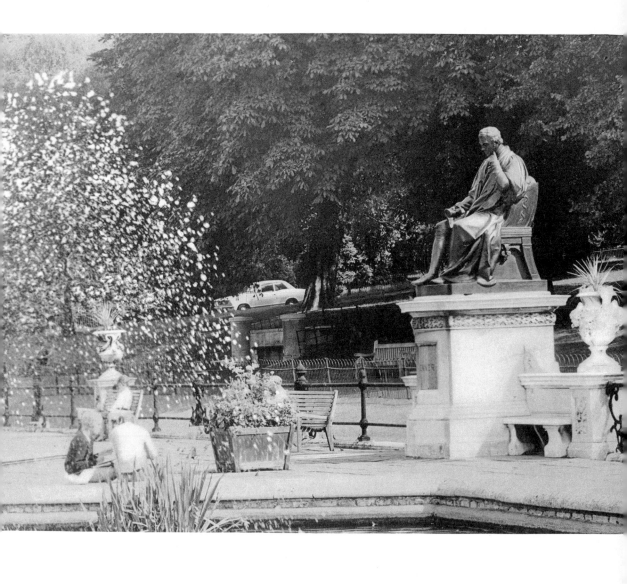

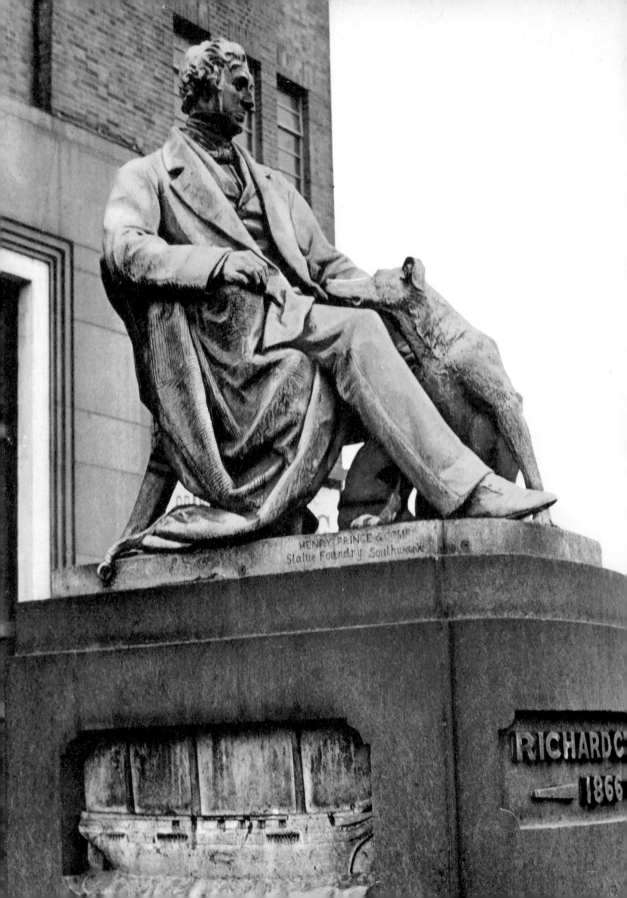

HENRY PRINCE & COMP
Statue Foundry Southwark

RICHARDC
1866

Richard Green

1803–1863
Sculptor: Edward Wyon
Unveiled in 1866 outside the Public Baths in East India Dock Road

The seated bronze figure of Green with his dog is mounted on a pedestal decorated with bas-reliefs of a ship built for the China trade and a frigate built for the Spanish.

Richard Green and his father were shipbuilders who built whalers, East Indiamen and immigrant ships for the gold rush to Australia, as well as ships for trade with China. Green founded the Sailors' Home at Poplar and was known in the East End for his generosity.

In 1967 a ten-year-old boy was trapped by the statue after he had climbed over it. His leg slipped between Green and the bronze dog, and he could not pull it out. Fifteen firemen were called to the rescue and had to cut off the dog's ear to free the boy.

Isambard Kingdom Brunel

1806–1859
Sculptor: Carlo Marochetti
Erected in 1877, Victoria Embankment

The bronze figure of Brunel by Marochetti was stored for some years before being erected on a pedestal designed by Norman Shaw. Brunel was the foremost of the Victorian industrial engineers.

A bronze figure of another great Victorian engineer, Robert Stephenson (also by Marochetti), stands outside Euston Station.

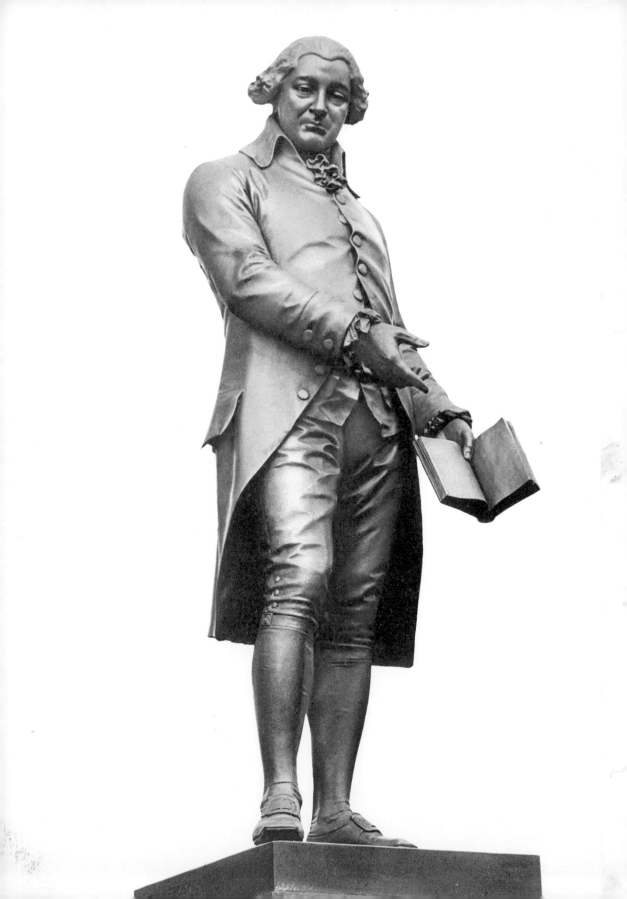

Robert Raikes

1735–1811
Sculptor: Thomas Brock
Unveiled in 1880 in Victoria Embankment Gardens

Thomas Brock sculpted a number of highly competent portrait figures, of which this bronze of Robert Raikes is a good example. He portrayed Raikes teaching from a book in his left hand. The cost of £1,200 was subscribed by Sunday School teachers and scholars.

Robert Raikes, the proprietor of the *Gloucester Journal*, founded a Sunday School for the education of neglected children. The school was so successful that the idea spread throughout the country.

William Tyndale

1484–1536
Sculptor: Edgar Boehm
Unveiled in 1884 in Victoria Embankment Gardens

William Tyndale, the pre-Reformation reformer and translator of the Greek New Testament into English, is portrayed wearing doctor's robes, with his right hand laid on his Testament.

The inscription states that he died a martyr at Vilvorde in Belgium. His last words were: 'Lord, open the King of England's eyes.'

Within one year of Tyndale's death, Henry VIII commanded that a bible in the vernacular should be placed in every English church.

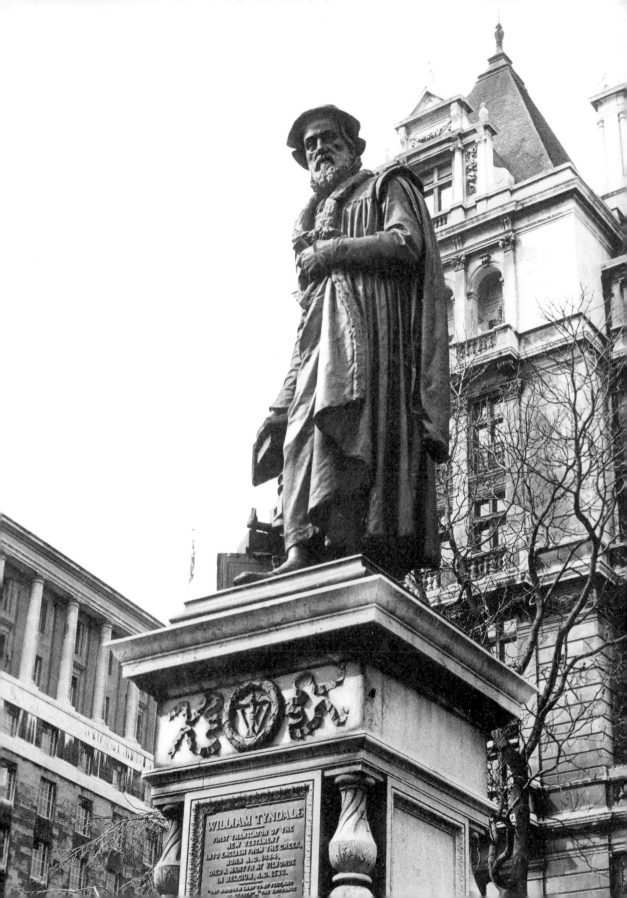

WILLIAM TYNDALE
FIRST TRANSLATOR OF THE
NEW TESTAMENT
INTO ENGLISH FROM THE GREEK.
BORN A.D. 1484.
DIED A MARTYR AT VILVORDE
IN BELGIUM, A.D. 1536.

Cardinal Newman

1801–1890
Sculptor: Leon Chavalliaud
Erected in 1896 in front of the Oratory, Brompton Road

A white marble figure stands inside a baldechino on a base of brown Portland stone. The Italianate monument is surmounted by a madonna and child. Newman is portrayed in his Cardinal's robes, his Cardinal's hat in his right hand. The statue was erected by general subscription.

Newman founded a congregation of the Oratory near Birmingham in 1847 and in London in 1850. Pope Leo XIII created him Cardinal of St. George in Velabro in 1879.

Lady Henry Somerset

1835–1896
Sculptor: G. E. Wade
Unveiled in 1897 in Victoria Embankment Gardens

The memorial fountain was subscribed for by the children of the Loyal Temperance Society. Lady Somerset was a member of that movement. A little bronze girl stands on a roughly chiselled granite rock holding out a basin with both hands.

The inscription reads:

I was thirsty, and ye gave me to drink.

FROM CHILDREN
OF THE LOYAL TEMPERANCE LEGION
IN MEMORY OF WORKDONE
FOR THE TEMPERANCE CAUSE BY
LADY HENRY SOMERSET

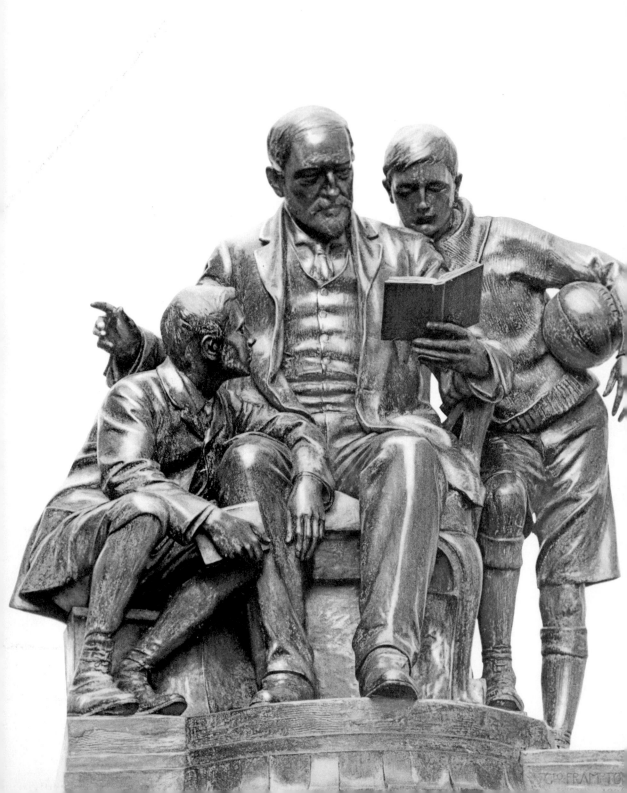

Quintin Hogg

1845–1903
Sculptor: George Frampton
Unveiled in 1906 in Langham Place, Upper Regent Street

The bronze group of Hogg, sitting and reading a book to two boys, is outside the Polytechnic he founded. The monument is also a memorial to his family.

Hogg was a businessman who took up philanthropic work among boys. He founded the Youths' Christian Institute and purchased the Royal Polytechnic Institution in Regent Street as its successor.

Sir Wilfred Lawson

1829–1906

Sculptor: David McGill

Unveiled in 1909 in Victoria Embankment Gardens

Bronze figures of Temperance, Peace, Fortitude and Charity surround the base of the monument to the advocate of Temperance and reform. Sir Wilfred Lawson was also known for his support of radical proposals including disarmament.

The inscription reads:

A true patriot, a wise orator, a valiant and far-seeing reformer; he spent a long life as the joyous champion of righteousness, peace, freedom, temperance.

Florence Nightingale

1820–1910

Sculptor: Arthur Walker

Erected in 1915 alongside the statue of Lord Herbert and the Crimea Memorial in Waterloo Place

Arthur Walker's statue shows simplicity and dignity: Florence Nightingale stands in a straightforward pose holding a lamp. The bronze figure is mounted on a pedestal similar to Lord Herbert's and is decorated with four bas-reliefs representing a conference of nurses, the transport of wounded men, a visit to a hospital and an interview with military leaders.

Florence Nightingale was awarded the Order of Merit for her services during the Crimean War in 1854.

Edith Cavell

1865–1915
Sculptor: G. Frampton
Unveiled by Queen Alexandra in 1920, in Charing Cross Road

A white marble statue of Edith Cavell stands against a 25-foot granite block which supports a half-figure of a woman with a child, representing Humanity's protection of the small states.

An angry lion in relief on the monument (not visible in the picture) was designed to personify the outrage British people felt when this nurse was shot for helping refugees to escape through Belgium.

This conglomeration of different parts in the memorial is an example of sculptural assembly popular in the first decades of the twentieth century.

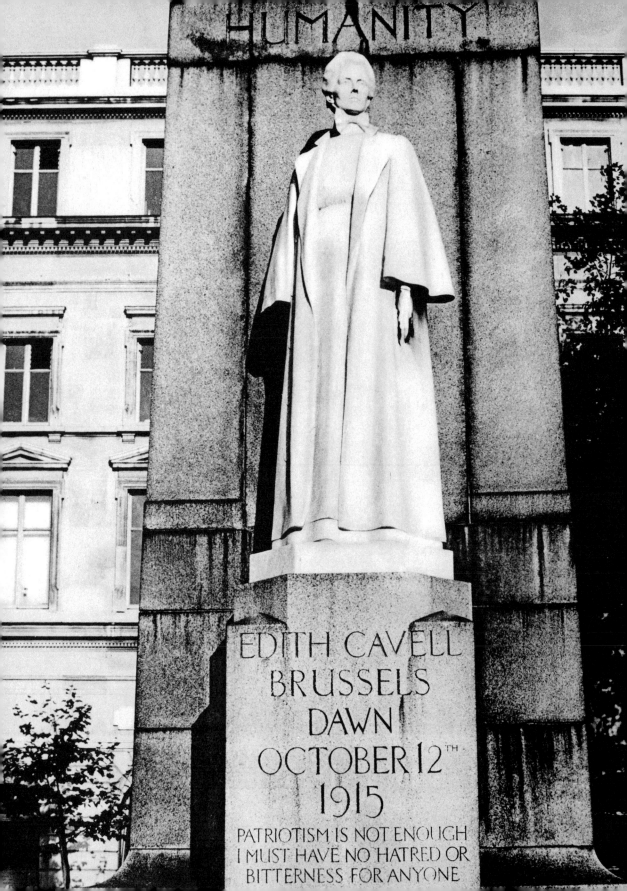

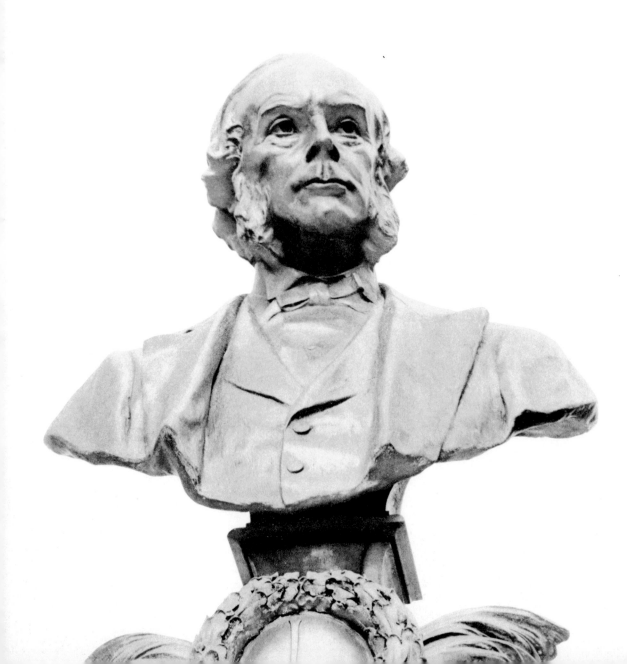

Lord Lister

1827–1912
Sculptor: Thomas Brock
Erected in 1924 in Upper Portland Place

Lord Lister is commemorated by a large bronze bust on a tall stone pedestal decorated by a bronze relief of a woman and a boy holding a coronal. The whole composition is reminiscent of the late Victorian period and can be compared to the more effective memorial to Sir Arthur Sullivan.

For introducing antisepsis into surgery, Lister was awarded many foreign honours as well as being one of the original members of the Order of Merit.

Mrs. Ramsay MacDonald

1870–1911
Sculptor: R. R. Goulden
Erected in Lincoln's Inn Fields (1914)

This lively bronze group is mounted on a large stone seat. The wife of the first Labour Prime Minister is shown with nine bouncing babies to commemorate her social work.

The inscription states:

> She was the daughter of John and Margaret Gladstone. She was born in Kensington in 1870. Was married to J. Ramsay MacDonald in 1896 and lived with him at 3 Lincoln's Inn Fields. Here her children were born and here she died in 1911. She brought joy to those with whom she lived and worked. Her heart went out in Fellowship to her fellow women and in love to the children of the people whom she served as a citizen and helped as a sister. She quickened Faith and zeal in others by her life and took no rest from doing good.

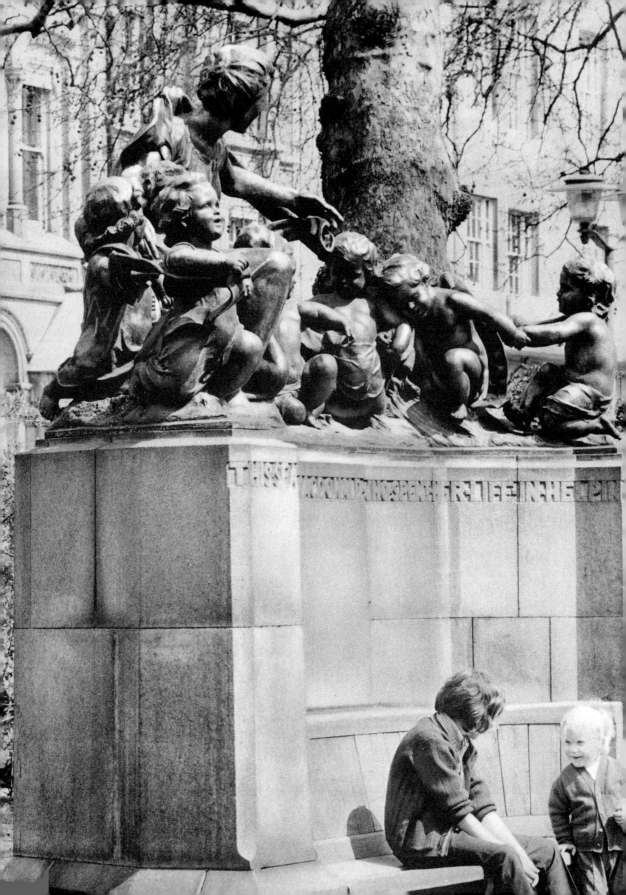

War Memorials

Only a small number of the many war memorials in London have been chosen for this book. Some are grandiose, with a lofty use of allegory—but often the most successful memorials are those which depict the ordinary private soldier without pomp or circumstance.

Detail of figure of David from Machine Gun Corps Memorial

Crimea

Sculptor: John Bell

Completed in 1859 and erected in Waterloo Place 'To the memory of 2162 officers and men of the Brigade of Guards who fell during the war in Russia 1854–6'.

Three bronze figures cast from Russian guns represent men of the Grenadier, Scots Fusilier, and Coldstream Guards. The men are wearing the short caped greatcoats in which they fought. They are guarding a heavily draped figure of Honour who is extending her arms wide to distribute coronals. The monument forms a group with Florence Nightingale and Lord Herbert and is lit by its own street-lamps.

In 1861 *Punch* suggested that instead of the battle names of Alma, Sebastopol, and Inkerman the inscription should read, 'Fever, Dysentery and Cholera'.

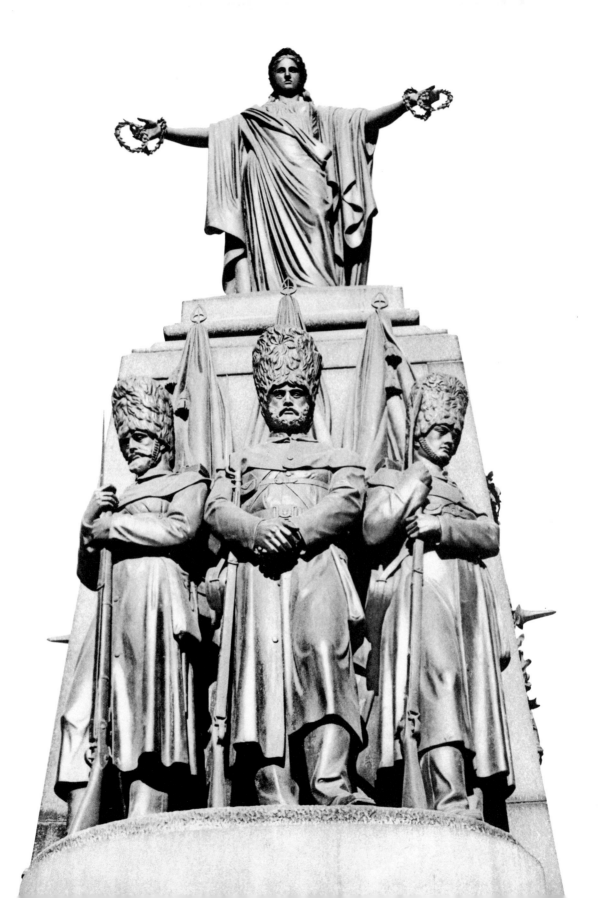

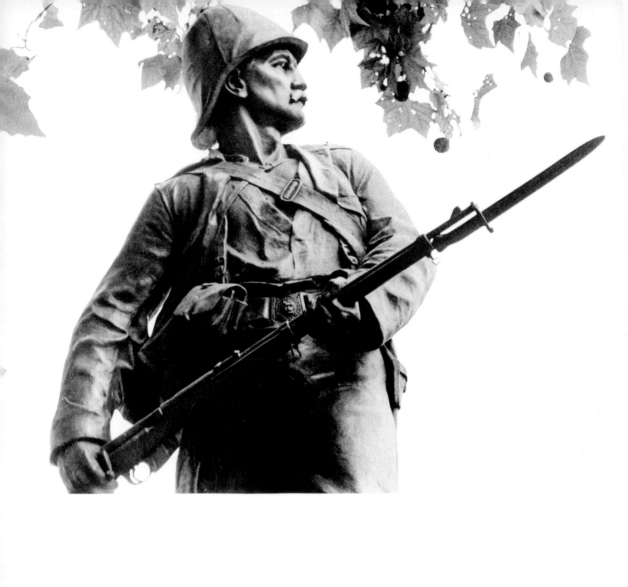

Royal Marines

Sculptor: Adrian Jones

Erected by the Royal Marines to commemorate those who died in South Africa and China, 1899–1900

Unveiled in 1903 at the east end of the Mall

The bronze group portrays a Marine standing over a wounded soldier, guarding him with rifle and bayonet. The bronze reliefs on the Portland stone base showing scenes of an incident at Grashan, South Africa, and of an attack on the Peking Legation, were designed by T. Graham Jackson.

Royal Artillery (Boer War)

Sculptor: W. R. Colton

Erected by the officers and men of the Royal Artillery in memory of their honoured dead in South Africa, 1899–1902

Unveiled in 1910 in St. James's Park overlooking the Mall

A bronze winged figure of Peace subduing a horse, the Spirit of War, stands on a Portland stone base decorated with a relief showing the mounted Artillery. The long curved back wall and short pillars terminating the granite platform are an Edwardian development of Victorian sculptural composition. The most successful part of the arrangement is the figure of Peace which is well detailed but too high to be seen properly.

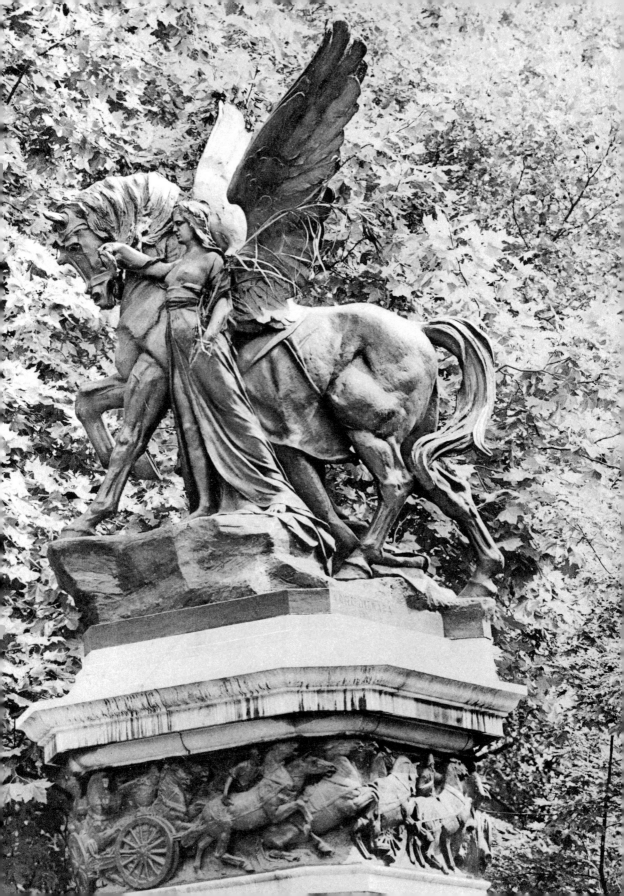

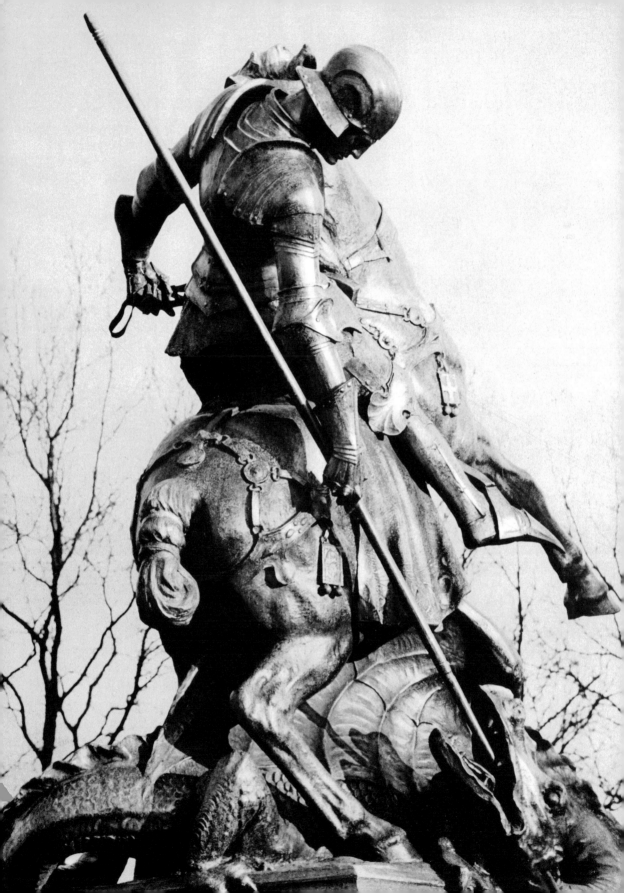

The Marylebone Memorial

Saint George and the Dragon
Sculptor: C. L. Hartwell
Erected outside Nuffield Lodge, St. John's Wood, in 1937

Nuffield Lodge, formerly known as Grove House, was the home of Sigismund Goetze, who died there at the age of seventy-three in 1939. He was a painter, and his work can be seen in the house. Goetze presented the bronze figure of Saint George and the Dragon to the parish of St. Marylebone as a memorial to the dead of the First World War. It is inscribed:

A frank offering for the sacrifices and services of the men and women of St. Marylebone for their country 1914–1918.

Machine Gun Corps

Sculptor: Derwent Wood

Unveiled by the Duke of Connaught in 1925 at Hyde Park Corner

The nude bronze figure of David is probably the most simple war memorial in London. David stands leaning on a large medieval sword on a low stone base of Mazzona marble, bearing the inscription:

> Saul hath slain his thousands, but David his ten thousands

On either side of the base are bronze Vickers machine-guns supporting wreaths. On the back of the monument is inscribed a brief history of the regiment. The statue is reminiscent of, and almost a cross between, the famous Renaissance Davids by Donatello and Michelangelo in Florence.

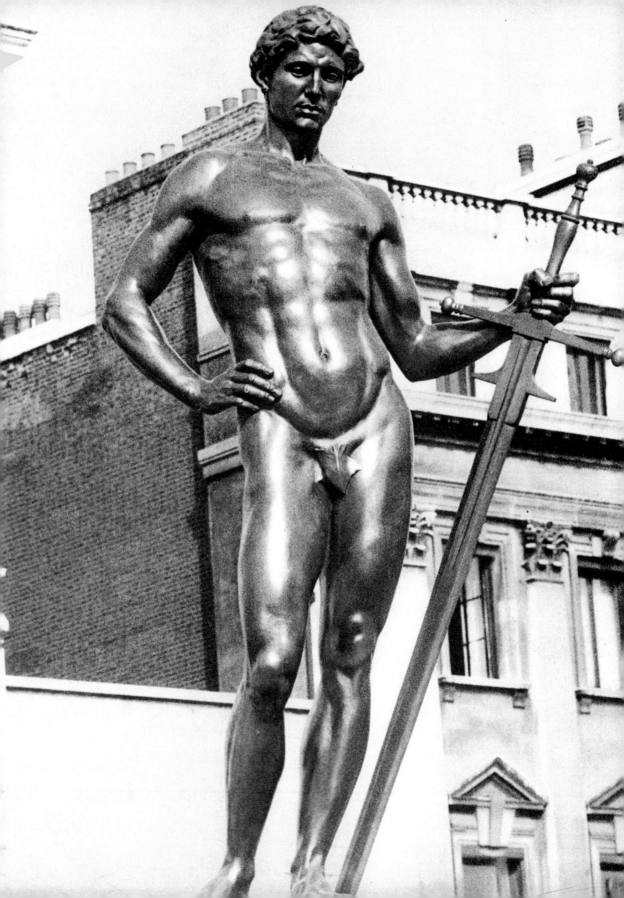

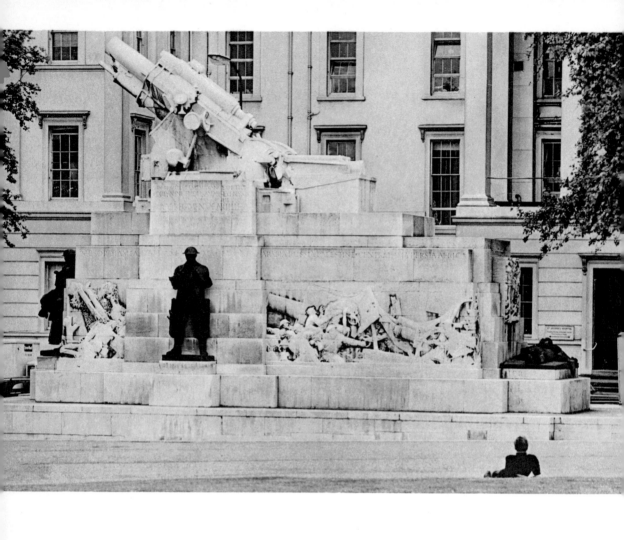

Royal Artillery (First World War)

Sculptor: C. Sargeant Jagger

Base by Lionel Pearson

Unveiled at Hyde Park Corner by the Duke of Connaught on 18 October 1925, to commemorate 50,000 lives lost in the First World War

The committee which commissioned the memorial wished to commemorate the 'Might of the Artillery'. The controversy which broke out when the monument was unveiled was mainly over its size and the representation of a 9·2 inch howitzer in stone, when a real gun might have been more effective.

Scenes of artillery in action are carved on the massive stone pedestal, which is guarded by bronze figures in battle-kit. A dead gunner lies on his back at the rear.

This heavy, massive monument is close to the Victorian tradition of sculptural collage. The sculptor preferred a stone gun to a real one, which he thought would kill the white stone of the base. The dissimilar elements in the composition proved shocking to the public at the time.

Guards Division

Sculptor: Gilbert Ledward
Architect: H. C. Bradshaw
Unveiled in 1926 in Horse Guards Parade by the Duke of Connaught at a parade of 14,000 ex-guardsmen

A rectangular obelisk 38 feet high faced with five bronze figures of guardsmen standing at ease commemorates the 2,007 officers and 61,544 other ranks who died in the Guards Division during the First World War.

The stiffly posed guardsmen at the base of the obelisk, cast from German guns, represents from right to left: the Grenadiers, Scots, Welch, Irish and Coldstream Guards.

The total cost of the memorial was £22,000. The obelisk bears a long inscription by Rudyard Kipling.

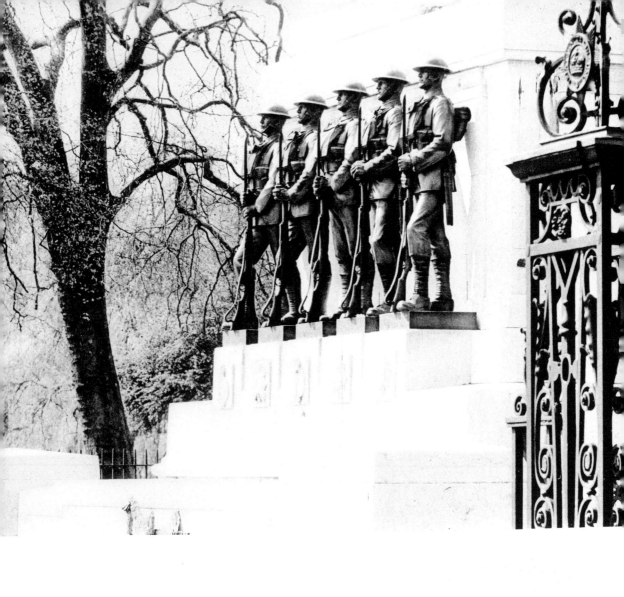

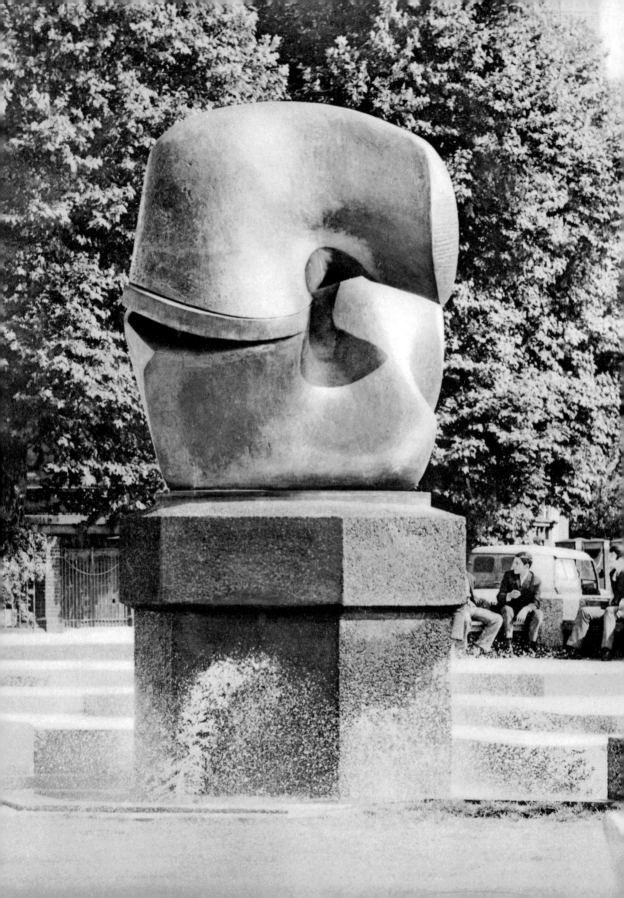

Monuments

Apart from the 'Royalty' section, this group spans the longest period of history in the book. In it we can trace a changing tradition: purely representational sculpture was gradually superseded by a taste for allegory and other abstractions, until now the emphasis is no longer on the commemorative value of sculpture. Works were commissioned to commemorate great events and to enhance a particular site in London.

Bronze sculpture entitled 'Locking piece' by Henry Moore erected on the Embankment near the Tate Gallery

The Monument

The Monument was designed by Sir Christopher Wren, the large bas-relief is by Caius Gabriel Cibber and the dragons and stone-work of the base are by Edward Pierce

Erected off King William Street in 1675–6

The Great Fire, which destroyed much of the City of London, started on 2 September 1666 in Pudding Lane, 202 feet from the Monument. For that reason the Portland stone monument was built 202 feet high, which totals 40 feet for the base, 120 feet for the fluted Doric column, and 42 feet for the flaming gilt bronze vase at the top. There is a staircase inside the column of 345 steps. The bas-relief in front of the pedestal represents the desolation of the City after the Fire, with King Charles II and Time coming to her assistance (see page 20).

The monument was erected by Act of Parliament. A later inscription was added in 1681 blaming the Fire of London on the Papists. King James II had it erased but King William III recut it. Pope refers to this when he wrote:

> Where London's Column, pointing at the skies
> Like a tall bully, lifts the head and lies.

The inscription was erased in 1831. The total cost was £13,700 and the cage was erected on the top to prevent accidents and suicides.

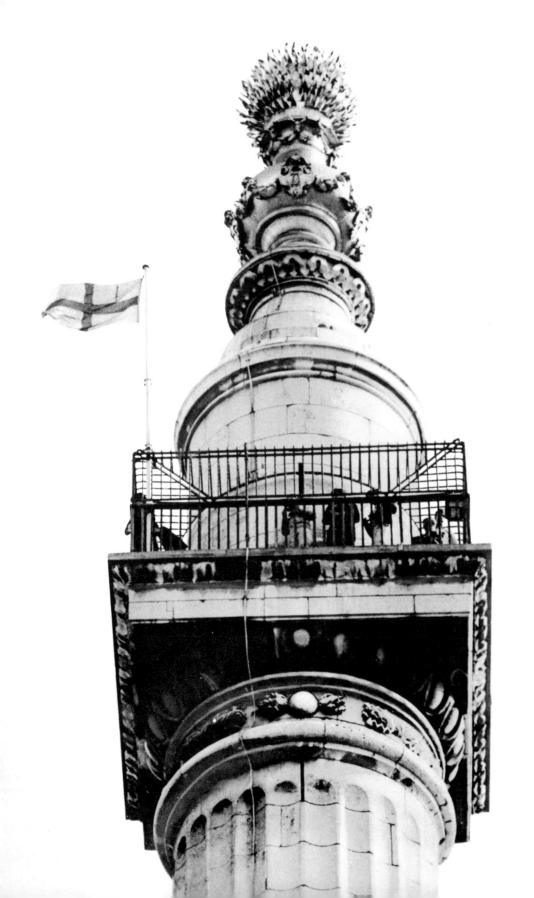

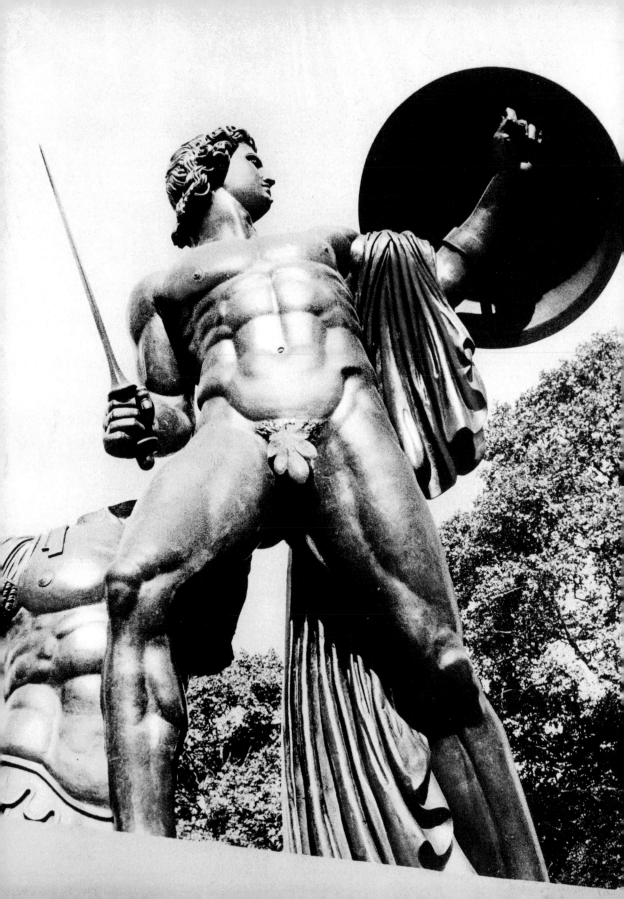

Achilles Memorial

Sculptor: Richard Westmacott

Unveiled 18 June 1822 on the site chosen by King George IV in Hyde Park near Apsley House

Inscribed by the women of England to Arthur, Duke of Wellington and his brave companions in arms.

The 20-foot-high bronze figure is an adaptation of one of the antique horse-tamers on the Monte Cavallo in Rome. It was cast from 24-pound French guns taken at Vittoria, Salamanca, Toulouse and Waterloo. It was admired as the largest bronze cast for 1,800 years, and it was so big that the railings around Hyde Park had to be dismantled to allow the statue into the Park. It is known as the 'Ladies' Trophy' as the women who subscribed to the memorial complained of its indecency. When the statue was unveiled it revealed a completely naked man and its size and high elevation shocked the ladies present. A fig-leaf was added at a later date.

Charing Cross

Sculptor: Thomas Earp, designed by E. M. Barry

The Victorian version of the original Gothic cross, erected in 1863, only slightly resembles the thirteenth-century cross it replaced. It is 70 feet high, and is built of Portland and Mansfield stone, and Aberdeen granite.

The original was one of twelve crosses erected by King Edward I to commemorate the resting-places of Queen Eleanor's body on the journey from Lincolnshire, where she died, to Westminster Abbey, where she is buried. Eight figures of Eleanor are positioned two-thirds of the way up the cross. Four represent her as a queen, four as a 'Christian'.

Cleopatra's Needle

Erected on Victoria Embankment in 1878

This ancient pink granite obelisk is one of two erected by Thothmes III at Heliopolis about 1,500 B.C., and late taken to Alexandria. It was 'given' to England by the Egyptian ruler, Mehemet Ali, in 1819, and brought to England by Erasmus Wilson. The story of its loss at sea and subsequent recovery is inscribed on the base. The two great bronze male sphinxes at its base were designed by G. Vulliamy and modelled by C. H. Mabey.

The obelisk is 68 feet high. When it was erected a newspaper of the day, a set of 1878 coins and Bradshaw's railway guide were enclosed in the base. The obelisk did not have any special association with Cleopatra.

Boadicea

Died *c.* A.D. 60
Sculptor: Thomas Thornycroft
Erected at the end of Westminster Bridge in 1902

This energetic Victorian group achieves both balance and simplicity. Contemporary critics unfairly complained of the lack of reins, driver or proper harness, and maintained that, despite these difficulties, Boadicea was expressionless. The sculptor laboured for fifteen years over this statue. The Prince Consort encouraged him by lending horses as models; he intended to place it over the Hyde Park entrance. However in 1885 Thomas Thorneycroft died, and the plaster group was not presented to the nation by the sculptor's son until ten years later. Finally the L.C.C. cast the statue and erected it on its present site in 1902.

Boadicea (or Boudicca) was the queen of the Iceni and widow of King Prastagus. On his death about A.D. 60 the king left his kingdom jointly to his two daughters and the Emperor Nero. When the Roman procurator seized the kingdom Boadicea was whipped and her daughters raped. The Queen took revenge and led a rebellion, burning to the ground the Roman towns of Colchester, St. Albans and London. The revolt was put down by the Roman governor Suetonius Paulinus, who returned from Anglesey to subdue the Britons. Boadicea took poison to avoid capture.

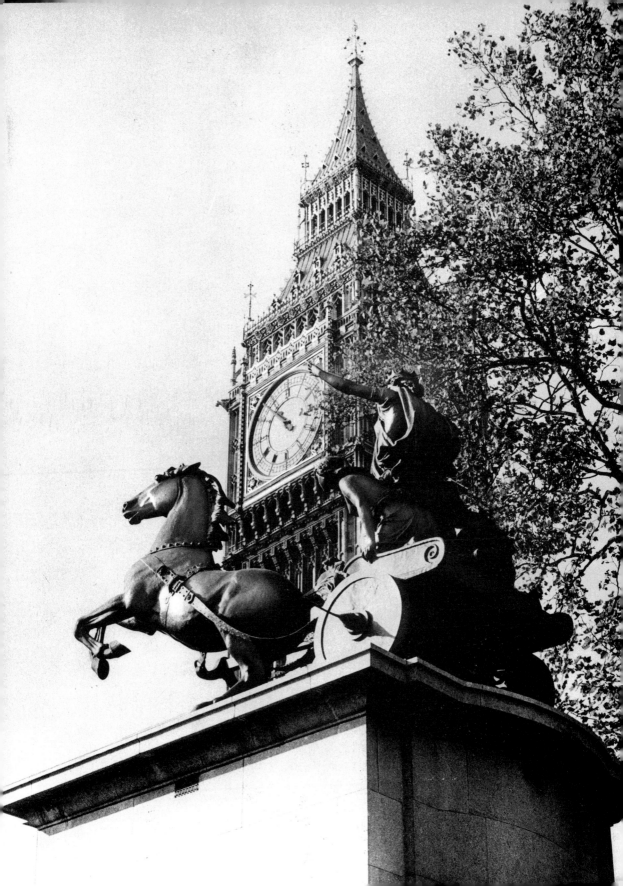

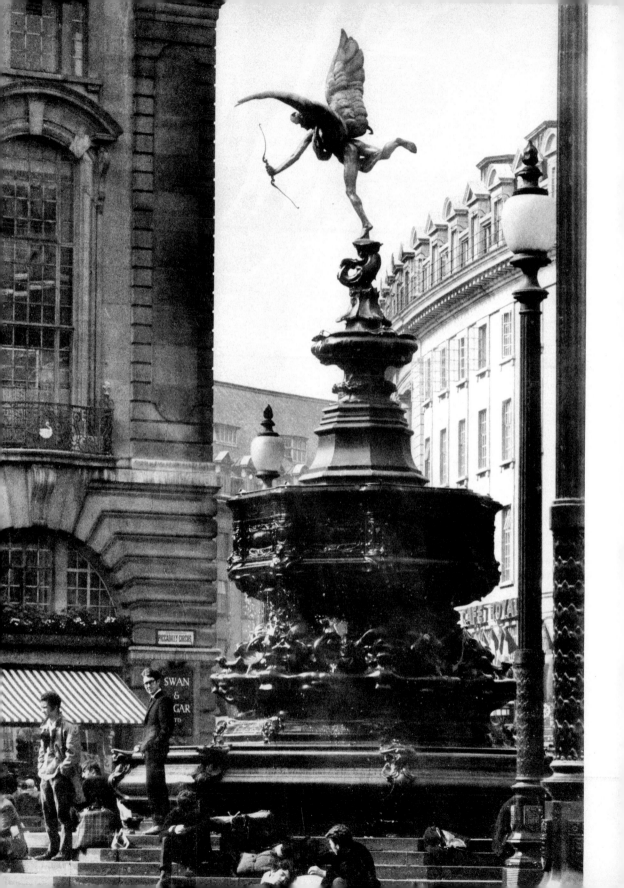

Eros

Sculptor: Alfred Gilbert
Erected in Piccadilly Circus

A well-balanced figure of Eros shooting an arrow stands on top of this large bronze octagonal fountain. The four basins are decorated in the style of art nouveau. Aluminium was used for the first time in casting the figure of Eros.

The statue commemorates the Seventh Earl of Shaftesbury (1801–85), who was a tireless philanthropist and social reformer.

The tribute on the memorial was written by his political opponent, W. E. Gladstone:

> During a life of half a century he devoted the influence of his station, the strong sympathies of his heart, and the great powers of his mind to honouring God by serving his fellow men. . . .

Physical Energy

Sculptor: G. F. Watts

Erected in 1904 in Kensington Gardens

The bronze equestrian figure is a replica of part of the Cecil Rhodes Memorial at Groote Schuur,* Cape Town. The sculptor achieved rugged simplicity by heavy modelling and the elimination of unnecessary detail. He sculpted a similar but clothed figure of Lupus Grosvenor for Eaton Hall, Cheshire.

*Cecil Rhodes lived at Groote Schuur, which is now the official residence of the President of South Africa.

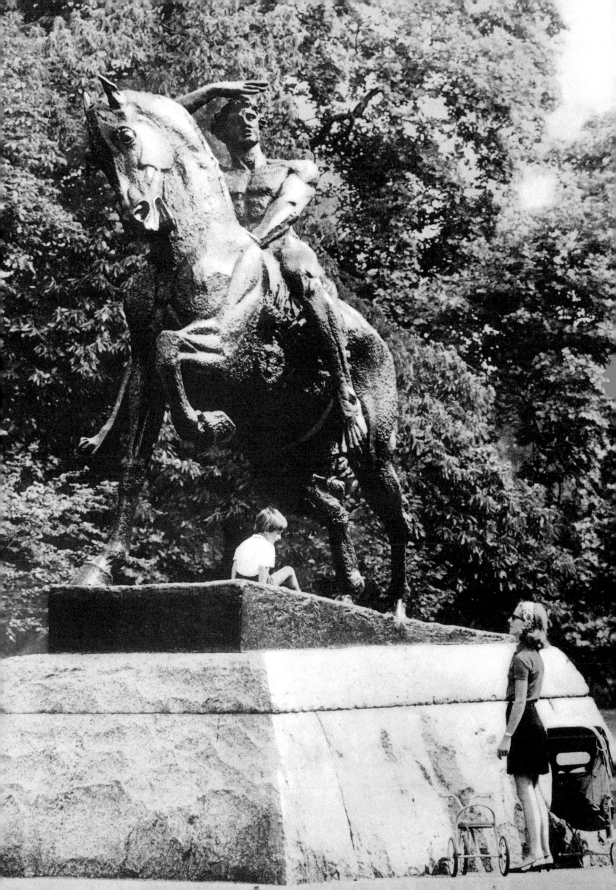

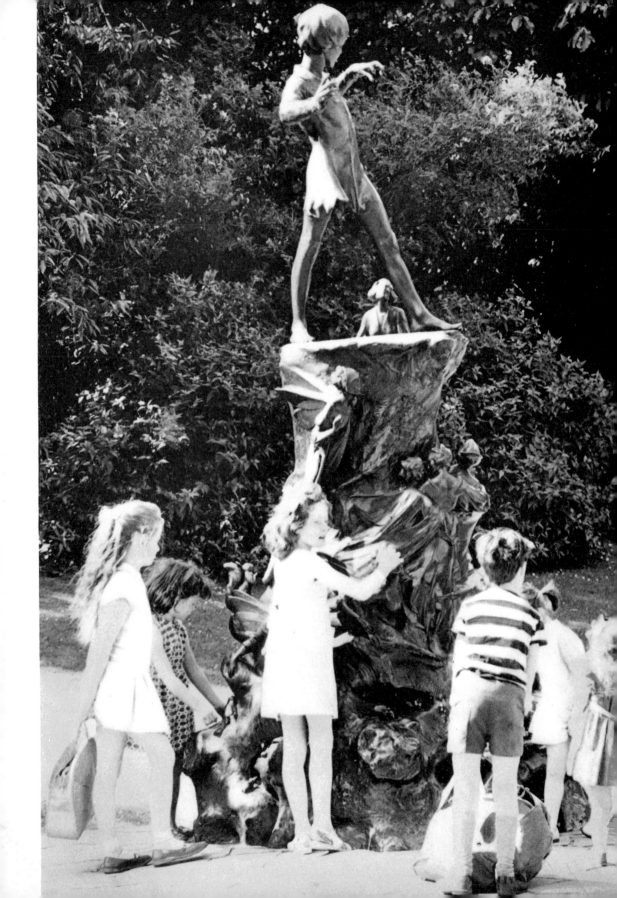

Peter Pan

Sculptor: George Frampton

Erected in 1912 in Kensington Gardens, and paid for anonymously

Peter Pan stands on a rock surrounded by fairies, rabbits, hares, squirrels, mice and birds. The scene is taken from Barrie's *Little White Bird*, a story about Kensington Gardens. The sculpture is situated where Peter Pan landed for his nightly visit to the Gardens and is decorated in the *art nouveau* style.

The Quadriga

Sculptor: Adrian Jones

Erected in 1912 on top of Burton's Arch at Hyde Park Corner

In this energetic bronze group Peace is shown alighting on a chariot drawn by four magnificent horses. The figure of Peace was criticised for being too large, but its high position puts it in perspective. The statue was presented to the nation by Lord Michelham as a mark of his respect for King Edward VII. The cost of the sculpture was £17,000 and it replaced the large, notoriously bad equestrian bronze of the Duke of Wellington by Wyatt.

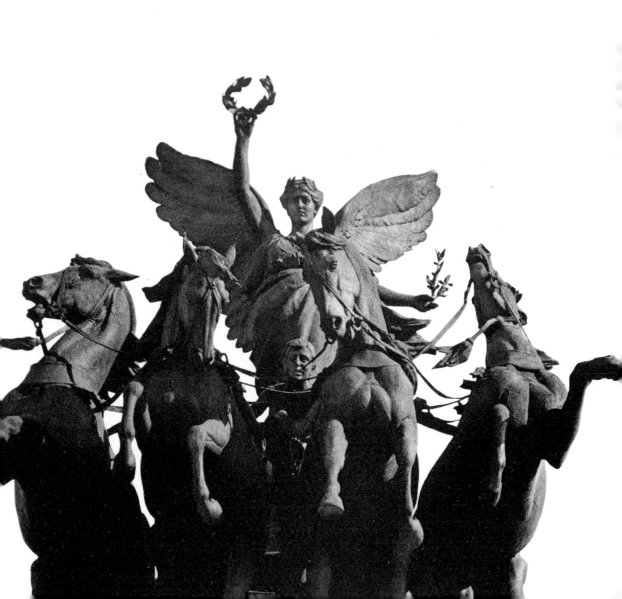

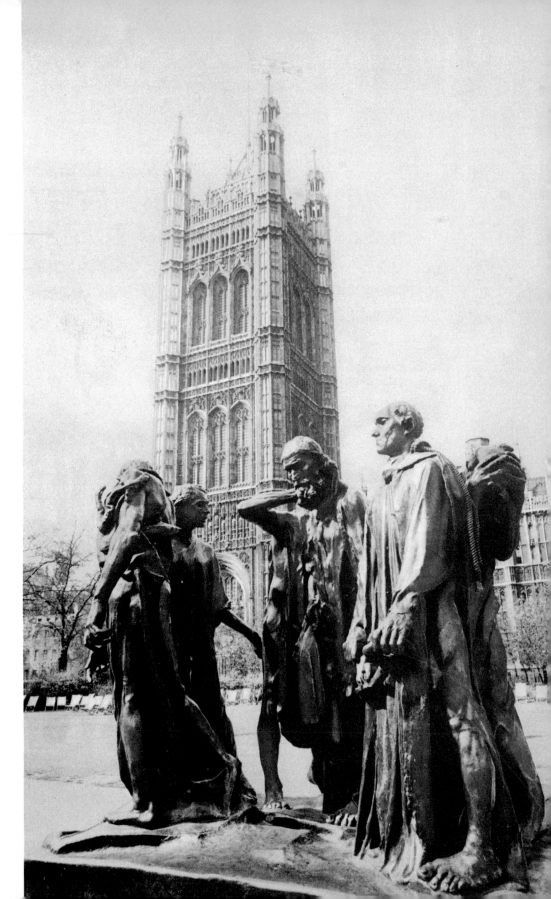

The Burghers of Calais

Sculptor: Auguste Rodin

Erected in 1915 in Westminster Palace Gardens

The National Arts Collection Fund presented the nation with this bronze cast of Rodin's sculpture, one of the most successful examples of Rodin's work.

The group shows the six burghers who surrendered themselves to King Edward III in 1347 at the siege of Calais in order to save the lives of their townspeople. They were spared at the request of Edward's Queen, Philippa of Hainault. Calais remained in British hands until 1558.

'La Délivrance'

Sculptor: Emile Guillaume
Erected at Church End, Finchley

Presented by Lord Rothermere and unveiled by Lloyd George in
1927 to commemorate the second Battle of the Marne in 1918, which
led to the defeat of Germany.

A nude bronze figure of a woman, 8 feet high, extending her arms
and holding a sword in her right hand, stands tiptoe on a hemisphere
of bronze. This is a replica of the sculptor's work first exhibited in
the Paris Salon.

LA DELIVRANCE

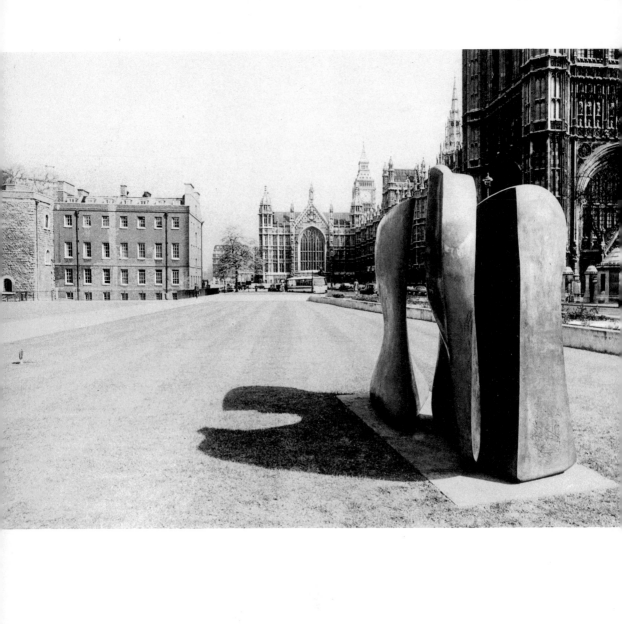

Knife-Edge Two-Piece

Sculptor: Henry Moore

Erected in the Westminster Public Garden, near the Houses of Parliament, and unveiled in 1967

The sculpture, considered to be one of Henry Moore's finest works, was given to the nation by the artist and the Contemporary Art Society. It is the second cast of the work, which was made in 1962.

List of Sculptors

Where a subject is commemorated by more than one sculpture, the relevant site is indicated in brackets

BACON, JOHN	*George III, King William III*
BAILEY, E. H.	*Lord Nelson*
BARRY, E. M.	*Designed the replica of Charing Cross executed by Thomas Earp*
BATES, HARRY	*Lord Roberts*
BEHNES, WILLIAM	*Sir Robert Peel (Postmen's Park)*
BELL, JOHN	*Crimean War Memorial*
BELCHER, JOHN, *Architect*	*Duke of Cambridge, Pedestal*
BELT, RICHARD	*Lord Byron, Replica of Bird's marble memorial of Queen Anne*
BIRD, FRANCIS	*Queen Anne (St. Paul's Cathedral)*
BOEHM, EDGAR	*Thomas Carlyle, Lord Holland (with G. F. Watts), William Tyndale, Duke of Wellington (Hyde Park Corner)*
BROCK, SIR THOMAS	*Victoria Memorial, Captain Cook, Henry Irving, Bartle Frere, Lord Lister, Robert Raikes*
BURTON, DECIMUS, *Architect*	*Burton's Arch (Hyde Park Corner)*
CHANTREY, SIR FRANCIS	*King George IV, Duke of Wellington, William Pitt*
CHAVALLIAUD, LEON	*Sarah Siddons, Cardinal Newman*
COLTON, WILLIAM R.	*Bronze figure of Peace on Royal Artillery Memorial (Boer War)*
DICK, SIR WILLIAM REID	*President Roosevelt, King George V*

245

DURHAM, JOSEPH	*William Hogarth (after Roubiliac)*
EARP, THOMAS	*Replica of Charing Cross*
EPSTEIN, JACOB	*General Smuts, Bowater House Group*
FITZGERALD, PERCY	*Samuel Johnson*
FOLEY, JOHN H.	*Figure of Prince Albert in the Albert Memorial, Lord Herbert (Crimea Memorial)*
FONTANA	*William Shakespeare, copied from Scheemakers*
FORD, ONSLOW	*Replica of Ford's bronze figure of a Muse from the base of the Shelley Memorial placed on his own memorial*
FRAMPTON, GEORGE	*Quintin Hogg, Edith Cavell, Peter Pan*
GAHAGAN, SEBASTIAN	*Duke of Kent*
GIBBONS, GRINLING	*King James II, King Charles II, Decorations on base of the statue of King Charles I*
GIBSON, JOHN	*William Huskisson*
GILBERT, ALFRED	*Eros (Earl of Shaftesbury)*
GOULDEN, R. R.	*Mrs. Ramsay MacDonald*
GUILLAUME, EMILE	*'La Délivrance', Church End, Finchley*
HAMPTON, HENRY	*8th Duke of Devonshire*
HOUDON, JEAN ANTOINE	*Replica of statue of George Washington*
JAGGER, C. SARGEANT	*Royal Artillery (First World War)*

JOHN, WILLIAM GOSCOMBE	*Sir Arthur Sullivan*
JONES, ADRIAN	*Duke of Cambridge, The Quadriga, Royal Marines*
LANDSEER, EDWIN	*Bronze lions at base of Nelson's Column*
LEDWARD, GILBERT	*Five bronze figures on Guards Division*
LUTYENS, EDWARD, *Architect*	*King Edward VII pedestal*
LE SUEUR, HUBERT	*King Charles I*
PRINCESS LOUISE	*Queen Victoria, Kensington Gardens*
LUCHESSI, A. C.	*Onslow Ford*
MCGILL, DAVID	*Sir Wilfred Lawson*
MACKENNAL, B.	*King Edward VII*
MAROCHETTI, CARLO	*King Richard I, Lord Clyde, Isambard Kingdom Brunel*
CALDER MARSHALL, WILLIAM	*Edward Jenner, Agriculture—Albert Memorial*
MCMILLAN, WILLIAM	*King George VI*
MOORE, HENRY	*Knife-Edge Two-Piece, Locking Piece*
NOBLE, MATTHEW	*Sir James Outram, Sir John Franklin*
PEARSON, LIONEL, *Architect*	*Royal Artillery (First World War)*
PINKER, H. RICHARD	*William Forster*
RAGGI, MARIO	*Benjamin Disraeli*
RAILTON, W.	*Nelson's Column*
RODIN, AUGUSTE	*Burghers of Calais—replica*
ROUBILIAC, LOUIS FRANCIS	*Original bust of William Hogarth*

247

RYSBRACK, JOHN MICHAEL	*Sir Hans Sloane*
ST.-GAUDENS, AUGUSTUS	*Abraham Lincoln—replica*
SCOTT, GILBERT, *Architect*	*Albert Memorial*
SCOTT, KATHLEEN, LADY	*Captain Scott*
SCHEEMAKERS, PETER	*Thomas Guy*
SHAW, NORMAN, *Architect*	*Isambard Kingdom Brunel's pedestal*
STEEL, JOHN	*Robert Burns*
THORNYCROFT, THOMAS	*Boadicea, Commerce—Albert Memorial*
THORNYCROFT, WILLIAM HAMO	*General Gordon, Oliver Cromwell, W. E. Gladstone*
TWEED, JOHN	*Clive of India, Earl Kitchener*
VAN NOST, JOHN	*King George II*
WADE, G. E.	*Lady Henry Somerset*
WALKER, ARTHUR	*Florence Nightingale*
WATTS, GEORGE F.	*Lord Holland (with Edgar Boehm) Physical Energy*
WEBB, ASTON, *Architect*	*Queen Victoria Memorial*
WESTMACOTT, RICHARD	*Achilles Memorial, 5th Duke of Bedford, George Canning, C. J. Fox*
WOOD, FRANCIS DERWENT	*Machine Gun Corps*
WOOLNER, THOMAS	*John Stuart Mill*
WREN, CHRISTOPHER, *Architect*	*Pedestal for statue of King Charles I, The Monument*
WYATT, MATTHEW	*King George III, Duke of York*
WYON, EDWARD	*Richard Green*

List of Sculpture and Sites

ACHILLES (AND DUKE OF WELLINGTON) MEMORIAL — *Richard Westmacott (1820) (Hyde Park) p. 223*

ALBERT, PRINCE CONSORT

 ALBERT MEMORIAL — *Gilbert Scott, John H. Foley (Kensington Gardens) pp. 56–9*

 PRINCE ALBERT — *Joseph Durham (1863) (Albert Hall) p. 60*

QUEEN ALEXANDRA MEMORIAL — *Sir Alfred Gilbert (1932) (Marlborough Gate) p. 68*

QUEEN ANNE — *Francis Bird (1712); Richard Belt (1866) (St. Paul's Cathedral) p. 43*

BEACONSFIELD, EARL OF — *Mario Raggi (1883) (Parliament Square) p. 92*

BEDFORD, 5TH DUKE — *Richard Westmacott (1809) (Russell Square) p. 76*

BOADICEA (QUEEN) — *Thomas Thornycroft (1902) (Victoria Embankment) p. 228*

BRUNEL, ISAMBARD KINGDOM — *Carlo Marochetti Norman Shaw, Architect (Victoria Embankment) p. 180*

BURGHERS OF CALAIS — *Auguste Rodin (1895) (Victoria Tower Gardens, Westminster) p. 239*

BURNS, ROBERT — *John Steel (Victoria Embankment Gardens) p. 159*

BYRON, LORD — *Richard Belt (Park Lane) p. 155*

CAMBRIDGE, H.R.H. THE DUKE OF — *Adrian Jones (John Belcher, Architect) (Whitehall) p. 135*

CANNING, SIR GEORGE — *Richard Westmacott (1832) (Parliament Square) p. 83*

CARLYLE, THOMAS — *Edgar Boehm (1882) (Chelsea Embankment Gardens) p. 156*

CAVELL, EDITH — *George Frampton (1920) (St. Martin's Place, Charing Cross Road) p. 196*

CHARING CROSS (QUEEN ELEANOR) — *E. M. Barry + Thomas Earp (1863) (The Strand, Charing Cross Station) p. 224*

CHARLES I, KING — *Hubert le Sueur (1633) (Charing Cross) p. 35*

CHARLES II, KING — *Grinling Gibbons, Arnold Quellin (Chelsea Hospital) p. 36*

CLEOPATRA'S NEEDLE — *(Thothmes II, c. 1475 B.C.) Sphinxes: C. H. Mabey (1878) (Victoria Embankment) p. 227*

CLIVE, LORD — *John Tweed (1912) (King Charles's Street) p. 140*

CLYDE, LORD — *Carlo Marochetti (Waterloo Place) p. 128*

COOK, CAPTAIN — *Sir Thomas Brock (The Mall) p. 136*

CRIMEAN WAR MEMORIAL — *John Bell (Waterloo Place) p. 204*

CROMWELL, OLIVER — *William Hamo Thornycroft (1899) (Old Palace Yard) p. 99*

DERBY, LORD — *Matthew Noble (1844) (Parliament Square) p. 91*

DEVONSHIRE, 8TH DUKE — *Henry Hampton (Whitehall) p. 103*

DUKE OF YORK COLUMN — *Richard Westmacott (Waterloo Place) p. 115*

EDWARD VII, KING — *B. Mackennal, S. E. Lutyens, Architect (Waterloo Place) p. 67*

ELIZABETH I, QUEEN — *Anonymous (St. Dunstan's, Fleet Street) p. 32*

EPSTEIN GROUP — *Jacob Epstein (Bowater House, Edinburgh Gate, Hyde Park) p. 14*

FIRE OF LONDON MONUMENT — *Christopher Wren, Caius Cibber (1671–7) (Fish Street Hill, off King William Street) p. 220*

FORD, ONSLOW — *Onslow Ford, A. C. Luchessi (Abbey Road) p. 164*

FORSTER, W. E. — *Sir Thomas Brock (Embankment Gardens) p. 96*

FOX, CHARLES JAMES — *Richard Westmacott (1816) (Bloomsbury Square) p. 79*

FRANKLIN, SIR JOHN — *Matthew Noble (Waterloo Place) pp. 120–3*

FRERE, SIR BARTLE *Sir Thomas Brock (Victoria Embankment Gardens) p. 95*

GEORGE II, KING *John van Nost (1753) (Golden Square, Soho) p. 47*

GEORGE III, KING *Matthew Wyatt (Cockspur Street) p. 48*
John Bacon (Somerset House) p. 51

GEORGE IV, KING *Sir Francis Chantrey (Trafalgar Square) p. 52*

GEORGE V, KING *Sir William Reid Dick (Old Palace Yard) p. 71*

GEORGE VI, KING *William McMillan (Carlton Terrace) p. 72*

GLADSTONE, WILLIAM E. *William Hamo Thornycroft (The Aldwych, The Strand) p. 100*

GORDON, GENERAL *William Hamo Thornycroft (New Embankment Gardens) p. 132*

GREEN, RICHARD *Edward Wyon (1866) (East India Dock Road, Poplar Public Baths) p. 179*

GUARDS DIVISION WAR MEMORIAL *Gilbert Ledward (H. C. Bradshaw, Architect) (St. James's Park) p. 216*

GUY, THOMAS *Peter Scheemakers (Guy's Hospital, Southwark) p. 175*

HAIG, EARL *(Whitehall) p. 13*

HERBERT, LORD (CRIMEA MEMORIAL) *John H. Foley (1867) (Waterloo Place) p. 87*

HOGARTH, WILLIAM — *Joseph Durham (1874) (Leicester Square) p. 148*

HOGG, QUINTIN — *George Frampton (1906) p. 191*

HOLLAND, LORD — *Watts and Boehm (Holland Park) p. 88*

HUSKISSON, WILLIAM — *John Gibson (Pimlico Gardens) p. 24*

IRVING, SIR HENRY — *Sir Thomas Brock (Charing Cross Road) p. 168*

JAMES II, KING — *Grinling Gibbons (National Gallery) p. 39*

JENNER, EDWARD — *William Calder Marshall (Kensington Gardens) p. 176*

JOHNSON, SAMUEL — *Percy Fitzgerald (1910) (St. Clement Dane, The Strand) p. 167*

KENT, DUKE OF — *Sebastian Gahagan (Park Crescent) p. 112*

KNIFE-EDGE TWO PIECE — *Henry Moore (1967) p. 243*

KITCHENER, EARL — *John Tweed (Horse Guards Parade) p. 144*

LA DÉLIVRANCE — *Emile Guillaume (Finchley) p. 240*

LAWSON, SIR WILFRED — *David McGill (Victoria Embankment Gardens) p. 192*

LINCOLN, ABRAHAM, PRESIDENT — *Augustus St.-Gaudens (1921) (Parliament Square) p. 107*

LISTER, LORD — *Sir Thomas Brock (1922) (Portland Place) p. 199*

MACDONALD, MRS. RAMSAY — *R. Goulden (1914) (Lincoln's Inn Fields) p. 200*

MACHINE GUN CORPS MEMORIAL — *Francis Derwent Wood (1925) Hyde Park Corner Island) pp. 202, 212*

MARYLEBONE MEMORIAL — *C. L. Hartwell (1937) p. 211*

MILL, JOHN STUART — *Thomas Woolner (1878) (Victoria Embankment Gardens) p. 152*

NELSON, LORD (COLUMN) — *W. Railton, E. H. Bailey, Edwin Landseer, etc. (1843–) (Trafalgar Square) pp. 124–7*

NEWMAN, CARDINAL — *Leon Chavalliaud (1896) (Brompton Oratory) p. 187*

NIGHTINGALE, FLORENCE, O.M. (CRIMEA MEMORIAL) — *Arthur Walker (1912) (Waterloo Place) p. 195*

OUTRAM, SIR JAMES — *Matthew Noble (Victoria Embankment Gardens) p. 131*

PEEL, SIR ROBERT — *Matthew Noble (1855) (Parliament Square) p. 84*

PETER PAN — *George Frampton (1912) (Kensington Gardens) p. 235*

PHYSICAL ENERGY (CECIL RHODES) — *George F. Watts (Kensington Gardens) p. 232*

PITT, WILLIAM — *Sir F. Chantrey (Hanover Square) p. 80*

QUADRIGA (ON BURTON'S ARCH) — *Adrian Jones (Hyde Park Corner) p. 236*

RAIKES, ROBERT *Sir Thomas Brock (Victoria Embankment Gardens) p. 183*

RICHARD I, KING *Carlo Marochetti (1851) (Old Palace Yard) p. 55*

ROBERTS, EARL *Harry Bates (Horse Guards Parade) p. 143*

ROOSEVELT, F. D., MEMORIAL *Sir William Reid Dick (1948) (Grosvenor Square) p. 108*

ROYAL ARTILLERY MEMORIAL *Lionel Pearson, C. Sargeant Jagger (1925) (Hyde Park Corner) p. 215*

ROYAL MARINES *Adrian Jones (1903) p. 207*

SCOTT, CAPTAIN *Lady Kathleen Scott (Waterloo Place) p. 139*

SHAFTESBURY, EARL (EROS, FOUNTAIN) *Alfred Gilbert (Piccadilly Circus) p. 231*

SHAKESPEARE, WILLIAM *Fontana (after Scheemakers) (1874) (Leicester Square Gardens) p. 151*

SIDDONS, SARAH *Leon Chavalliaud (1897) (Paddington Green) p. 160*

SLOANE, SIR HANS *John Michael Rysbrack (Apothecary Gardens, Chelsea) p. 172*

SOMERSET, LADY HENRY *(Victoria Embankment Gardens) p. 188*

SMUTS, FIELD-MARSHAL JAN *Jacob Epstein (Parliament Square) p. 29*

SULLIVAN, SIR ARTHUR *William Goscombe John (Victoria Embankment Gardens) p. 163*

TYNDALE, WILLIAM *Edgar Boehm (Victoria Embankment Gardens) p. 184*

VICTORIA MEMORIAL *Aston Webb, Sir Thomas Brock (The Mall) p. 63*

VICTORIA, QUEEN *H.R.H. Princess Louise (Kensington Gardens) p. 64*

WASHINGTON, GEORGE, PRESIDENT *Houdon replica (1921) (National Gallery) p. 104*

WELLINGTON, 1ST DUKE *Edgar Boehm (1888) (Hyde Park Corner) p. 119*

WELLINGTON, 1ST DUKE *Sir Francis Chantrey (1844) (Royal Exchange) p. 116*

WILLIAM III, KING *John Bacon, Jr. (1808) (St. James's Square) p. 40*